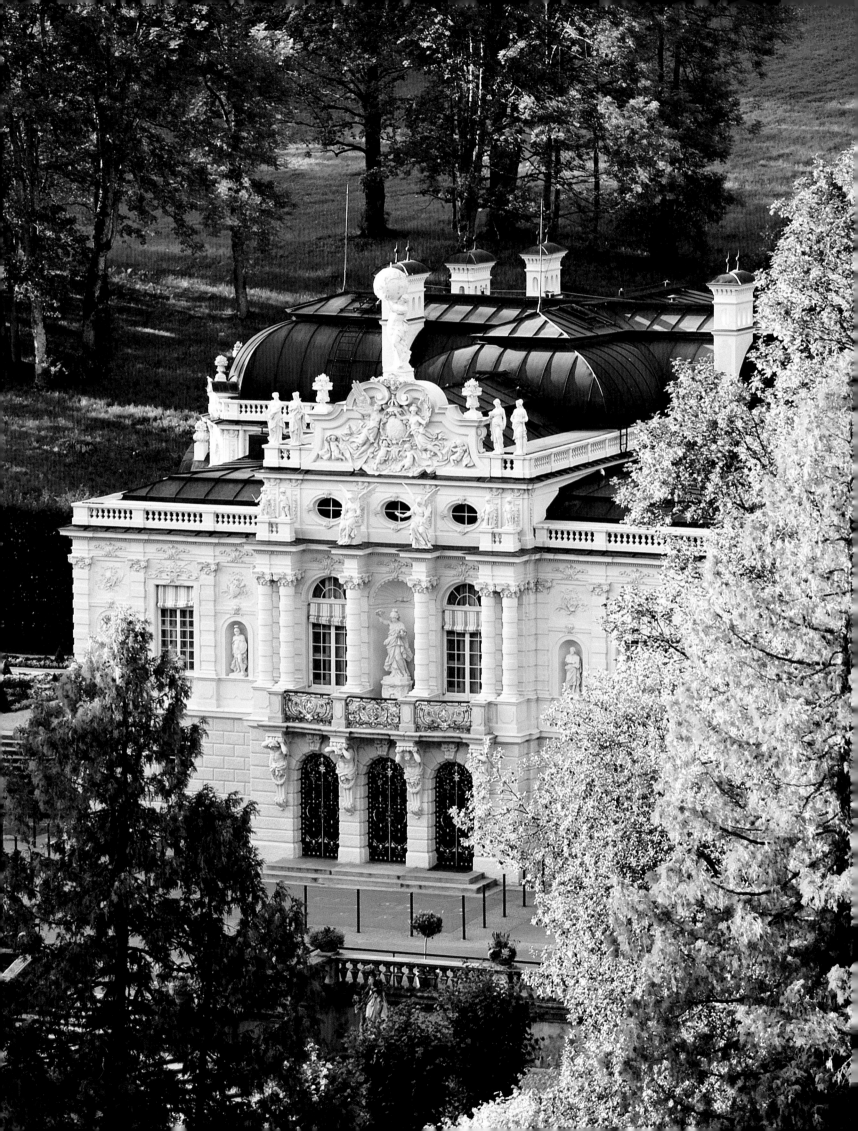

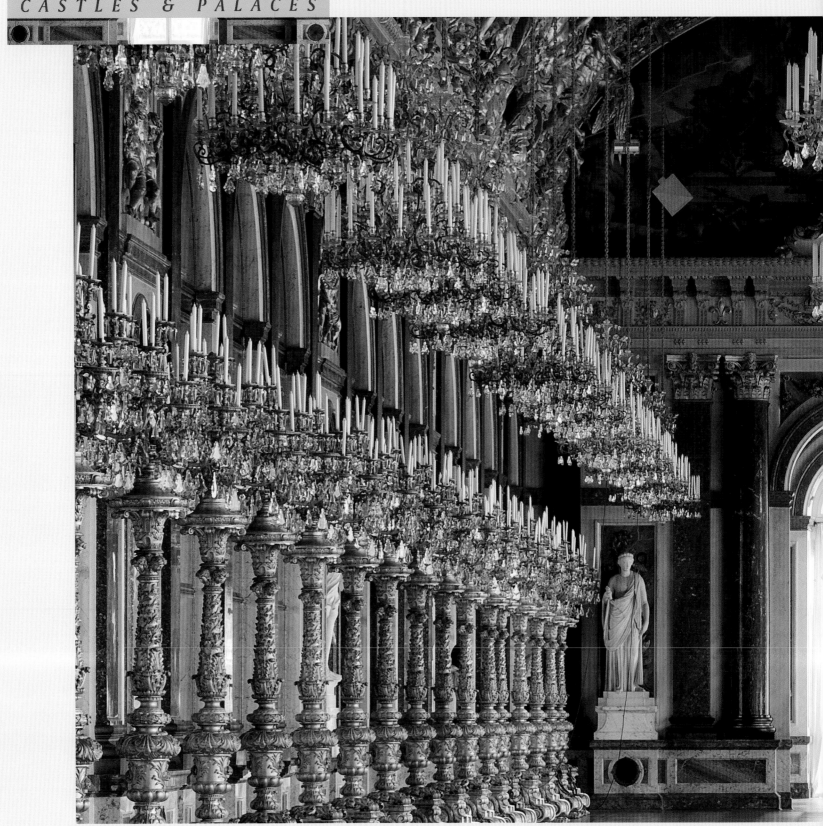

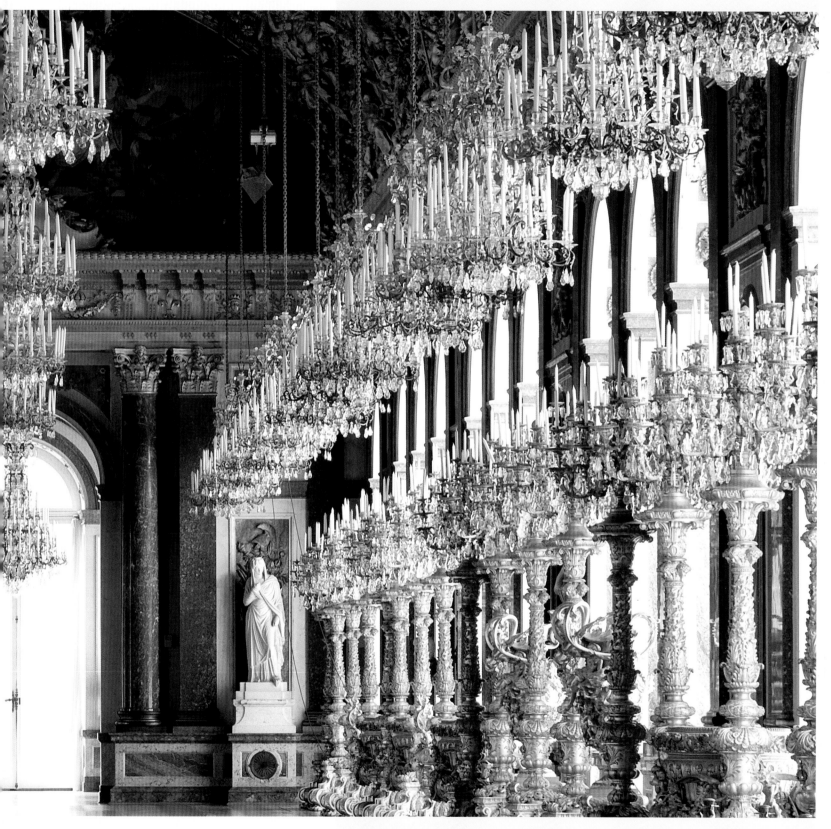

THE CASTLES OF
KING LUDWIG II

PHOTOS BY ERNST WRBA
TEXT BY MICHAEL KÜHLER

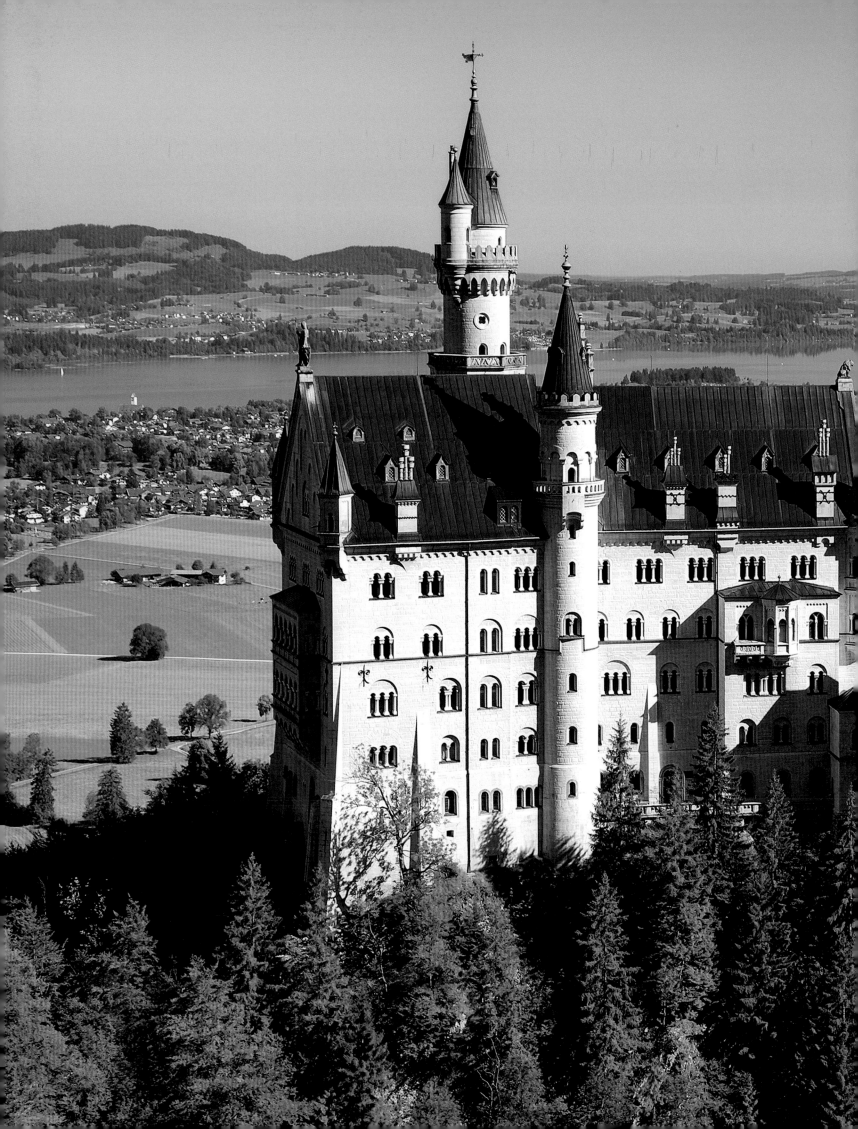

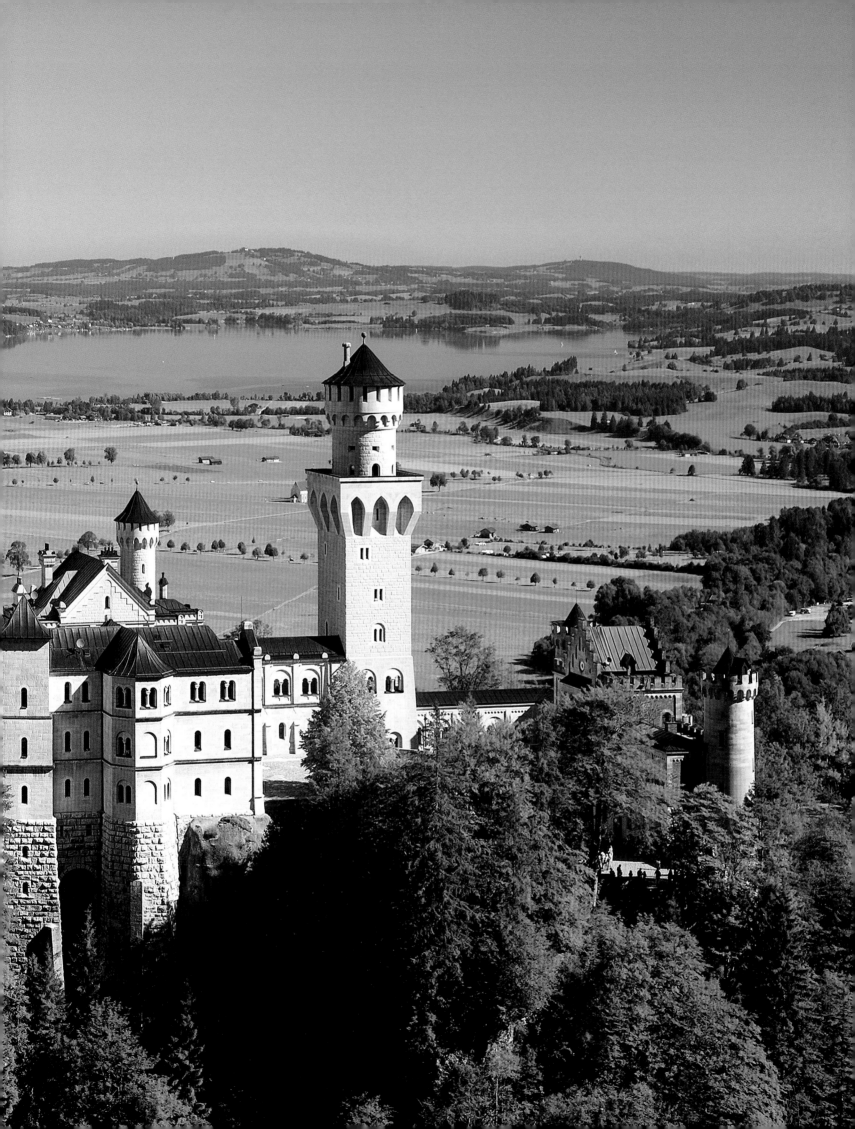

First page:
It seems incredible that the splendid south facade of Schloss Linderhof is supported by nothing more than a framework of wood. King Ludwig II had his father's hunting lodge converted and rebuilt so many times that it was eventually moved. The new wooden 'royal villa' which took its place was subsequently clad in stone, ornamental stucco and a vast array of statues.

Page 2/3:
The Hall of Mirrors at Schloss Herrenchiemsee was once lit by over two thousand candles when the king came on his nightly visits. Unlike its Versailles counterpart, no huge parties were thrown here, the king preferring to bask in the glory of his creation on his own.

Page 3/4:
Magnificent Schloss Neuschwanstein is a glorious and imposing landmark at the point where the Alpine foreland becomes the Bavarian Alps. Beyond it is the Forggensee, a reservoir built in the 20th century on the site of Füssen's ice age basin. In summer Bavaria's fifth largest lake is a popular leisure and recreation area.

CONTENTS

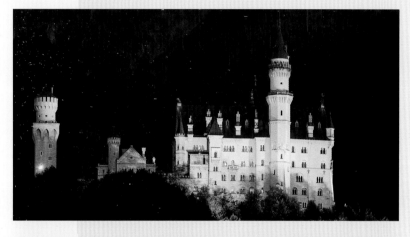

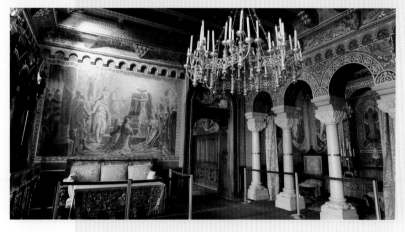

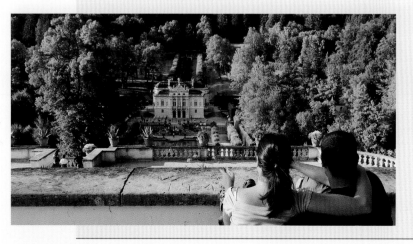

96 BAVARIA'S ANSWER TO VERSAILLES – SCHLOSS HERRENCHIEMSEE

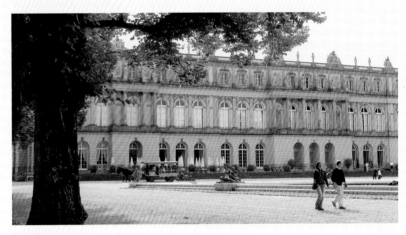

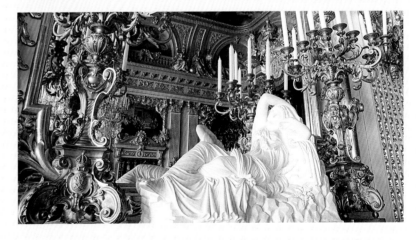

Page 8/9:
Winter on the Alpsee. The Bavarian king may have gazed dreamily upon stark icy landscapes such as these from his west balcony at Neuschwanstein. In the fore-ground is Schloss Hohen-schwangau, the popular summer residence Ludwig's father Maximilian II had built for the family. Ludwig II spent his happiest childhood years here.

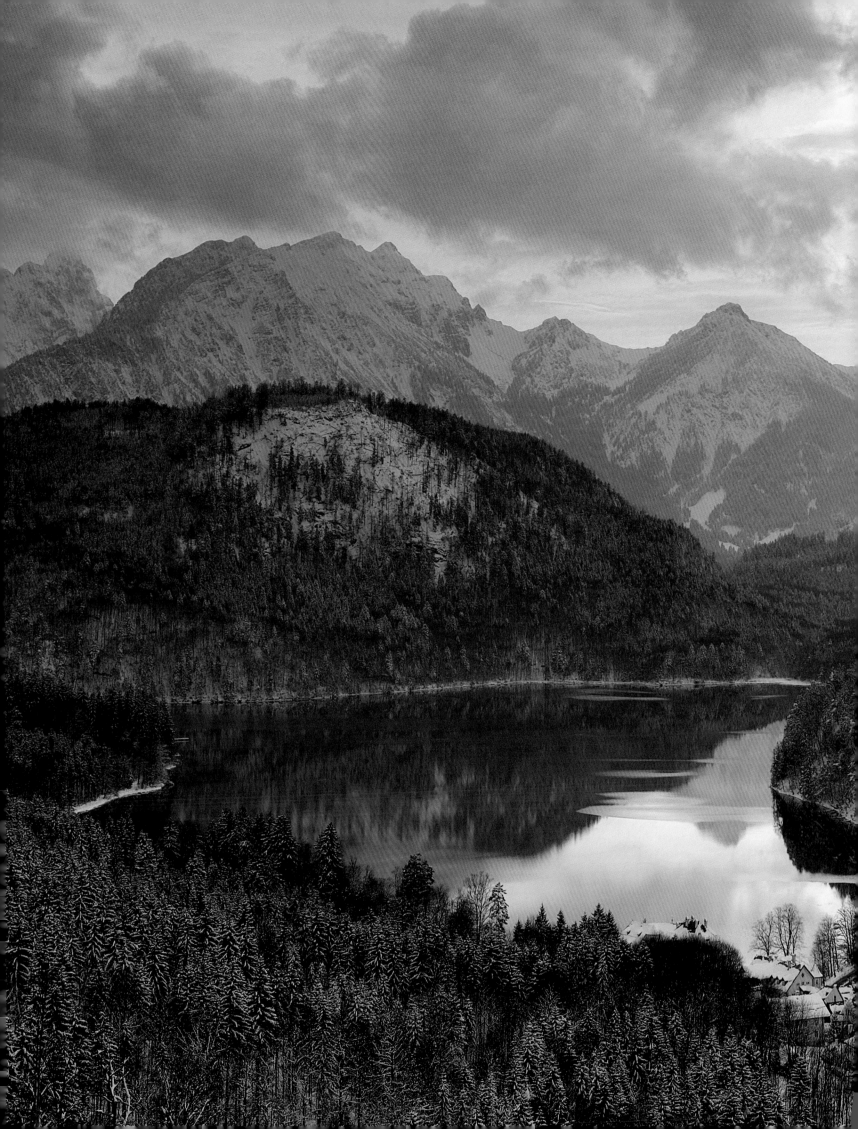

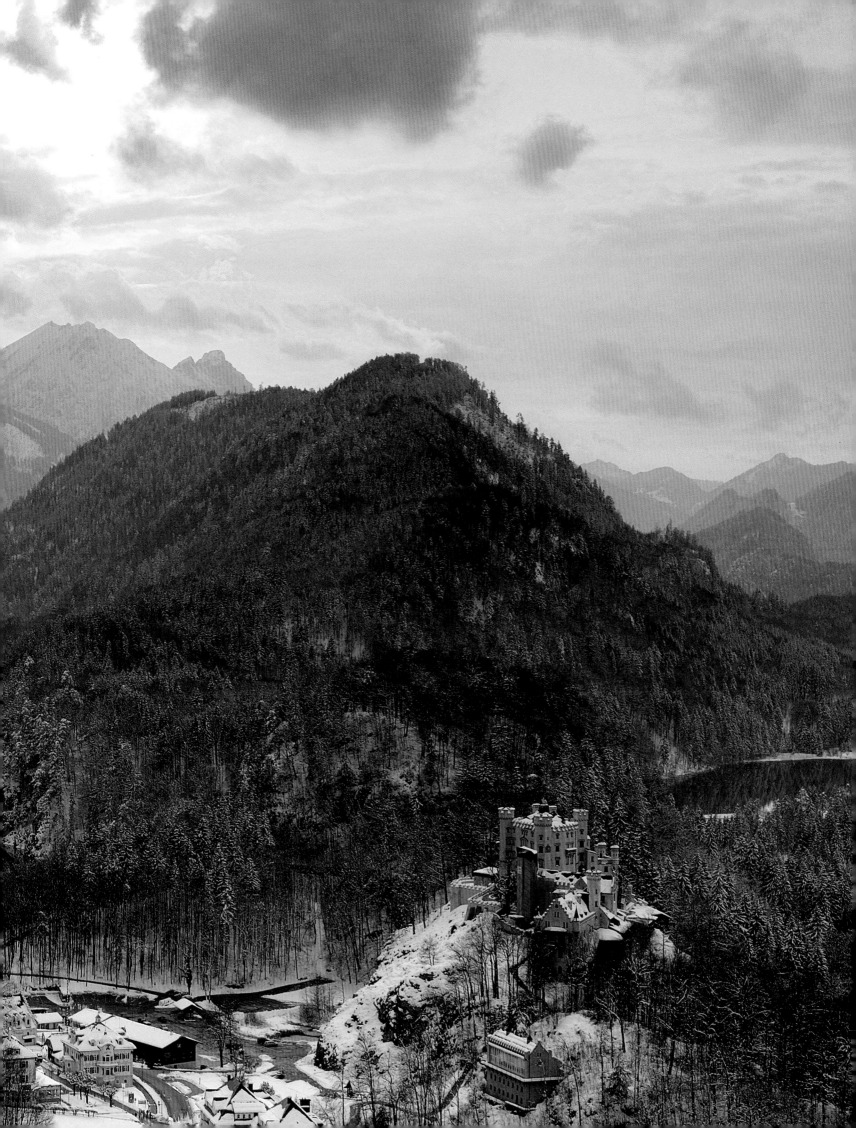

"FOREVER A MYSTERY TO MYSELF AND OTHERS" – KING LUDWIG II OF BAVARIA

A puzzle never solved, an eternal myth, forever a mystery: this is what King Ludwig II of Bavaria wanted and what he has indeed achieved – in death and beyond. And it is precisely his final hours on this earth which have left us the most flummoxed. Did the king consciously seek a watery grave in the depths of the Starnberger See, as official sources would have us believe? As Ludwig was a good swimmer, this explanation is thrown into considerable doubt. Was he shot in the back, as one popular Bavarian folk song – among others – scandalously claims? There's no evidence to prove it – although allegedly there were once bullet holes somewhere. But where? In his light summer jacket or one of his dark winter coats? A winter coat, in the middle of summer?!

June 13, 1886, Whit Sunday, was grey and wet. This is fact. According to his doctors, the mood of the certified monarch wasn't as bleak on that day as one would expect of a potential suicide. Was this the statement coerced out of the psychiatrists to make his self-inflicted end seem more plausible? Or was the king really in cheerful spirits because he was going to be aided in his escape? By Sissi, perhaps, the equally tragic and mythical empress of Austria?! Was Ludwig shot trying to flee – or by accident? Maybe if we opened his coffin, things might become clearer. But on the other hand, why trouble a man in death who was so troubled in life?

FOAM ON THE WAVES

One of the most moving literary descriptions of Ludwig's demise in the Starnberger See is not that well known in his native Bavaria. It was published in 1890 in Japan. Japanese military doctor and writer Mori Ogai had studied in Munich in 1886 and noted his tale on his return home. A Japanese man takes a young lady from Munich out on a boat on the lake on June 13, 1886. They pass the spot where Ludwig II is taking a stroll with his physician, Dr Gudden. The king sees the girl and tries to get closer as he mistakes her for her mother whom he once adored. The maiden is so shocked she falls into the water, recognising the former admirer of her dear mama. Dr Gudden follows the king into the water in an attempt to hold him back. The Japanese student pulls the girl back into the boat, trying to save her. To no avail; the young woman is already dead.

The view of the Venus Grotto from Schloss Linderhof is blocked by the huge linden tree, centuries old, which gave the palace its name. It bears witness to Ludwig's love of nature; despite requests from builders and garden designers to have it removed he insisted that the tree be left standing. Although it may somewhat 'mar' the otherwise perfect symmetry, it certainly adds to the flair of Ludwig's Graswangtal abode.

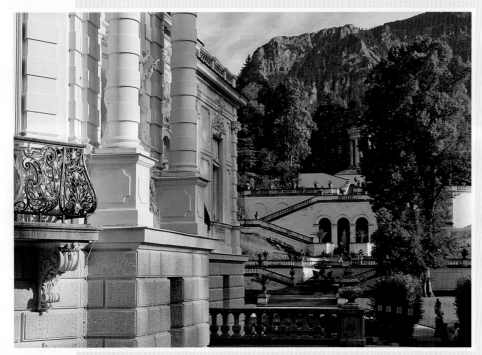

This narrative, entitled *Foam on the Waves*, is to Japanese literature what Goethe's *Die Leiden des jungen Werthers* or The Sorrows of Young Werther is to German. It's the first narrative in the first person in modern Japanese literature; for the first time a Japanese author pours his own personal experience into a narrative text. The original is penned in an overtly artificial language, in a combination of classic Japanese and carefully constructed Germanic sentences with German names and words dotted about the text. The exotic appeal of this mixture of languages still enthrals the Japanese today.

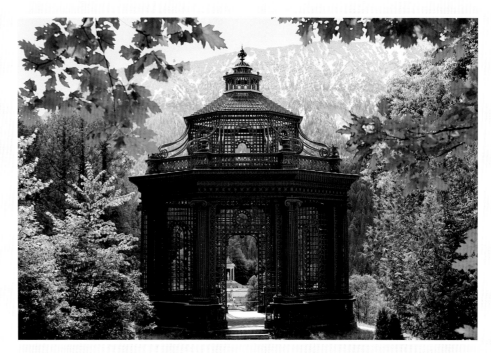

The green wooden Music Pavilion in the palace park at Linderhof – a structure which would have done the French Sun King proud – seems to blend in with its natural surroundings. This and the other park buildings are what make a stroll through the palace grounds so unforgettably delightful.

THE FAIRYTALE KING

And so they undertake an extremely long journey to get closer to the man whom they have admired for so long: King Ludwig II of Bavaria. His life was no less spectacular than that of Marilyn Monroe or Jim Morrison. But maybe it's less the dramatic aspects which appeal: his nimbus of fairytale king is far more brilliant when we visit his castles. His dreamlike being is epitomised herein, in the midst of the fairytales he himself created and which he loved with great passion.

Ludwig's nocturnal sleigh rides are legendary. Contemporary technology helped a bit; the king may not have been particularly interested in how it all worked but he knew how to use the latest inventions to his advantage. His famous sledge had a battery installed under the royal seat which lit up the crown on his head when His Royal Highness set forth. The first electronically illuminated vehicle in the world must have caused amazement and wonder at a time when many peasants' hovels were still dimly lit by spills or at best by petroleum lamps.

FAIRYTALES OF THE KING

Not only the king himself is like something out of a fairytale; there are also many fairytales told about him. Many of these may have been fuelled by the accounts delivered by one Luise von Kobell in c. 1900 which posthumously placed her husband, cabinet secretary Johann August von Eisenhart, in a favourable light. At the time the first excerpts of Ludwig's diary had been published under a pseudonym by one of Minister Lutz's stepsons, the minister who was largely instrumental in getting Ludwig sectioned.

These were later followed by an extended new edition and even some of Ludwig's very private letters were published, procured for vast sums of money. It seemed the sources were inexhaustible, sources which cast the fairytale

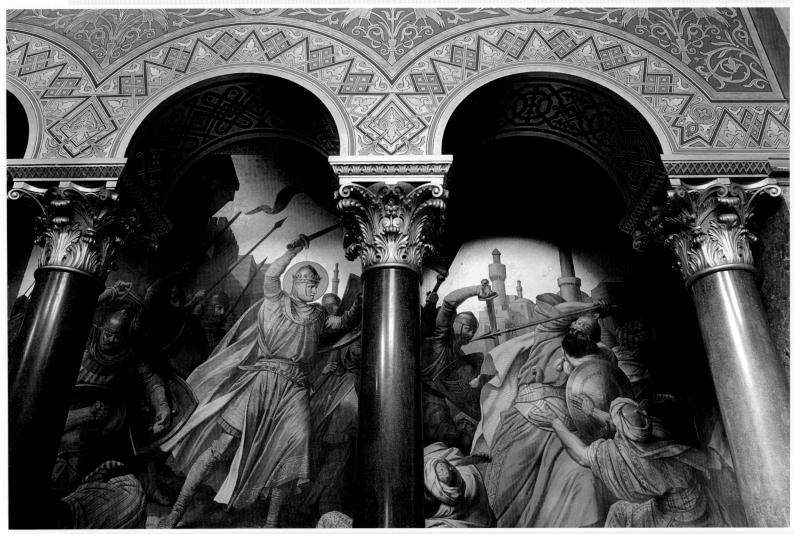

Behind the lower row of pillars in the Throne Room at Schloss Neuschwanstein a mural depicts the battle of King Ferdinand of Spain against the Moors. Ferdinand is one of the canonised kings shown in the apse, indicated by his golden halo. The wall paintings are meant to depict the services kingship has done to the dissemination and consolidation of the Christian faith.

king in an array of very different roles. As if by magic photos suddenly appeared, supposedly sent to Ludwig on request by pretty young men from all over Europe. Rumour had it that he didn't see the likenesses as casting for non-public performances of his Wagnerian legends but that he himself wished to revel in the classic Greek beauty of these boys in the privacy his own royal chambers.

THE MOON KING

Ludwig II found the world most beautiful at night, bathed in the light of the moon. In the year of his ascension to the throne, 1864, he had a luminous moon set into the ceiling of his

bedroom in Hohenschwangau which was later joined by an orgy of stars and a rainbow machine. French poet Guillaume Apollinaire thus called Ludwig II the Roi-Lune, the moon king, as opposed to Roi-Soleil or sun king Louis XIV. In his *Doktor Faustus* Thomas Mann has Freising teacher Serenus Zeitblom muse on Ludwig's showpiece bed at Linderhof, likening it to a bier flanked by candelabras.

Bedrooms were very important to Ludwig II. He never intended to actually sleep in many of them – like the one at Herrenchiemsee. He had an entire palace built around this room, with everything designed to suit. If he slept at all in any of his various other beds, then only during

the daytime. Ludwig was a man who turned the night into day.

In his own Blue Bedroom in the apartment of Herrenchiemsee there is an embroidery on Ludwig's headboard entitled *The Triumph of Ludwig XIV over Vice* in reference to a very personal problem which plagued Ludwig II. Symbols of atonement can be found all over Ludwig's buildings. Most of the sagas depicted in Schloss Neuschwanstein, for example, contain this motif.

LOLUS

The world of legend fascinated Ludwig II. He grew up with pictures of sagas dotted about his home of Hohenschwangau and had the legendary Nibelung Frieze painted at the resi-dential palace in Munich. Ludwig's obsession reached its peak in Schloss Neuschwanstein where his love of Wagner's operas – themselves focussed on medieval tales of epic heroism – was also greatly indulged. The king supported the then little known composer as well as he could – or, according to many, more than he should have done. This patronage caused as much unrest amongst the ministers in Munich as had the case of Ludwig I's mistress, Lola Montez, in the turbulent year of 1848. Ludwig II's grandfather foresaw that the people would put an end to the reign of the new king as they had done to his 20 years previously.

It was indeed the voice of the people who nicknamed the man who was to become a world-famous composer Lolus in reference to

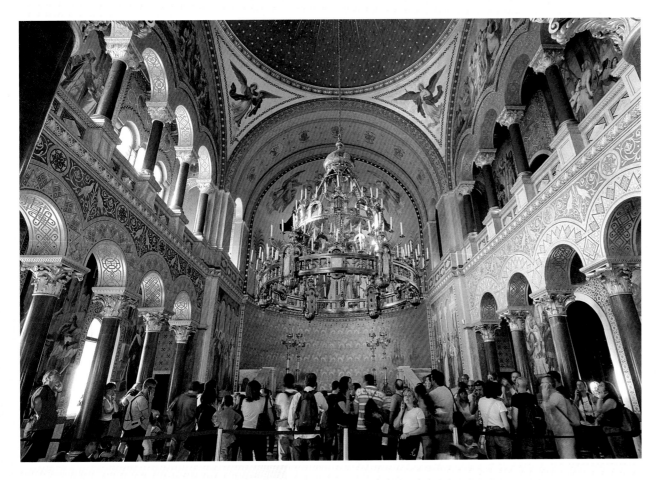

The Throne Room in Schloss Neuschwanstein may be missing a throne but is no less popular for it, as this large group of visitors shows. The many admirers are fascinated by the basilica-like proportions of this particular room, married with Ludwig's great and careful attention to detail.

Ludwig I's "Spanish dancer" from Ireland. The grand master was sadly not as agile as the former monarch's exotic love and his influence over the king, at least in political terms, paled on his forced exile to Switzerland. Despite the intrigue the king remained true to his friend long after his death. For Wagner, the same applied as to singers giving a forced rendition: the king was more interested in art than grace and it is to this he played.

THE THEATRICAL KING

Art, the theatre, opera and musical drama were all important to the king. He loved them, patronised them, he lived in them and for them; his life was a stage, a synthesis of the arts. The word *Gesamtkunstwerk*, attributed to Richard Wagner, has since become a fixed term in art, architecture and music. What composer and patron had in common was their notion of the perfect illusion in theatre, at its time a totally new concept. Wagner had his orchestra disappear into a pit; with the first electrically lit theatre in the world Ludwig was able to plunge his auditorium into total darkness. But this wasn't enough for the king.

In his legendary private performances he even got rid of the audience. And this was just the first stage in what the king was later to create with Schloss Herrenchiemsee, where he was both actor and spectator rolled into one. It's easy to see how this wonderful but slightly warped dream world inadvertently casts a spell over the modern visitor. We can't even begin to imagine which grand ideas the king would have gone on to realise had he not been

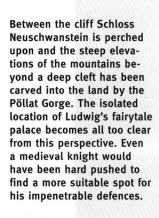

Between the cliff Schloss Neuschwanstein is perched upon and the steep elevations of the mountains beyond a deep cleft has been carved into the land by the Pöllat Gorge. The isolated location of Ludwig's fairytale palace becomes all too clear from this perspective. Even a medieval knight would have been hard pushed to find a more suitable spot for his impenetrable defences.

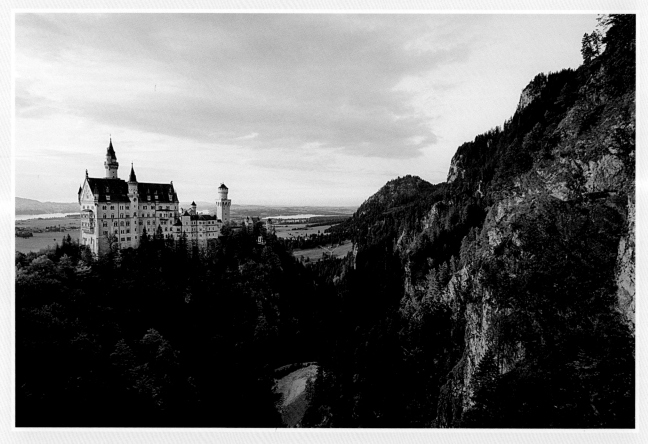

rudely stopped in his tracks by pernickety bureaucrats.

THE TOURIST MECCA OF LUDWIGSLAND

With the laboriously planned certification of the king and his sudden and mysterious death Ludwig's *Gesamtkunstwerk* came to an abrupt halt. Today it hovers somewhere between dream and reality, an unwitting precedent to the cinema and theme parks such as Disneyland, mirrored in the weird and wonderful mock guest houses springing up left, right and centre all over Ludwigsland: in Upper Bavaria in general and close to Neuschwanstein in particular. This has helped to permanently mould our image of Bavaria – and to channel mass tourism to these few specific spots.

It's good that this is the case. If keen visitors were to apply their clichés and interests in vast numbers to Bavarian culture across the state as a whole, there would be none of those peaceful and unadulterated places of refuge left which were so important to Ludwig II. With his castles 'Mad' King Ludwig created the proverbial eye of the needle all those wanting to "do" the world in eight days now have to pass through. Everyone else can take a look at his castles and then, like Ludwig, rapidly flee – to the solitude and serenity of the surrounding mountains, for example. Yet it's not only the lofty peaks and impressive backdrops which make Bavaria famous the world over; there are also the state's other many royal and imperial institutions, such as the splendid boulevards of Munich and

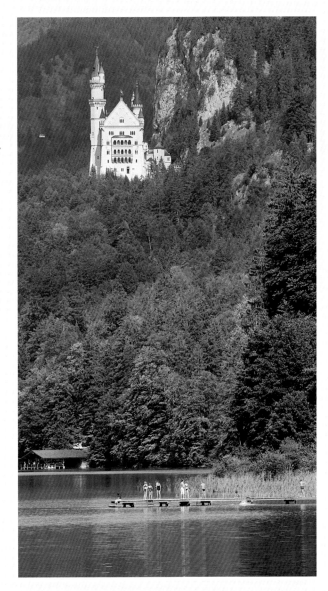

Neuschwanstein keeps a watchful if distant eye on the serene waters of the Alpsee. The lake borders on the district of Hohenschwangau; despite its close proximity to two of Germany's most famous castles there are still peaceful spots to be found here.

of course the city's Oktoberfest, and the church of St Bartholomä on the Königssee which Ludwig was responsible for saving. And if it all gets too much, you can always escape to Majorca – which is what Ludwig once planned to do.

IDEAL HOMES AND CASTLES IN THE AIR

Once Ludwig had abandoned his project to set up an empire in the Canaries – and the plans had been drawn up in full detail, albeit without a name – he turned his attentions back to his castles. These were not mere places of resi-

dence. There were no libraries and no theatres which seems extremely strange for someone like Ludwig, both keen theatregoer and avid bookworm. Comfortable and homely – or even the German *gemütlich* – are not words which can be used to describe these edifices, despite all the mod cons he had installed. His palaces were ideal homes, built for viewing but not necessarily practical living, the result of the knowledge, ability, dreams and desires of a king totally misunderstood in his day and age. His dream world is still there for us all to enjoy; we just have to have the courage to abandon ourselves to it.

Some of his castles were summer residences to be enjoyed on a seasonal basis. Perhaps the best example is Linderhof, stuck somewhere between royal villa and *maison de plaisance*, a giant summer house modelled on the French baroque. The gardens are practically more important than the big house itself. Even in winter, when much of the park and house are inaccessible, in the solitude of the Graswangtal Linderhof is overpowering. Ludwig couldn't have planned the perfect melding of his architectural ensemble and the abundant beauty of its natural surroundings any better – even if he did briefly toy with the idea of blowing up a few mountains to enhance the setting even more. And then there are his castles in the air. In Landshut, the oldest seat of the house of Wittelsbach to survive, he had an apartment built which he not only never inhabited but never even saw. Falkenstein is equally infamous; it was to have been the ersatz should Neuschwanstein have turned out more Wagnerian castle of the Grail than 'genuine' medieval German *Burg*. Not to mention his Byzantine and Chinese palaces...

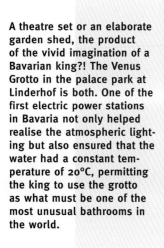

A theatre set or an elaborate garden shed, the product of the vivid imagination of a Bavarian king?! The Venus Grotto in the palace park at Linderhof is both. One of the first electric power stations in Bavaria not only helped realise the atmospheric lighting but also ensured that the water had a constant temperature of 20°C, permitting the king to use the grotto as what must be one of the most unusual bathrooms in the world.

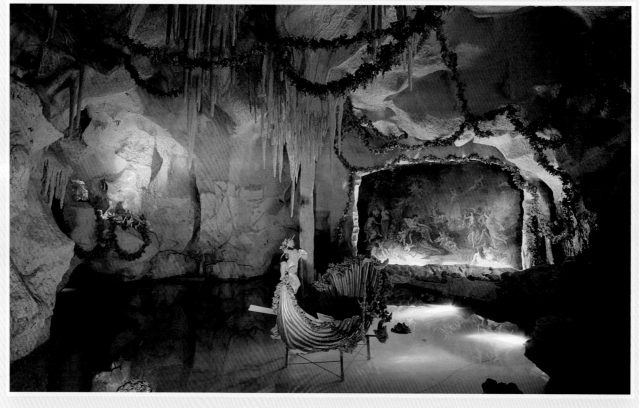

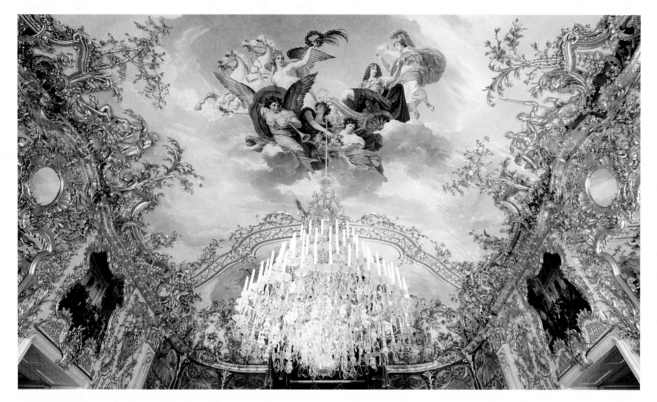

The bedroom at Linderhof was lit by an enormous glass chandelier holding 108 candles and made by the Lobmeyer company. The ceiling fresco by August Spieß junior (1841–1923) depicts the apotheosis of King Louis XIV of France: his deification or elevation to the rank of a god.

In Alpine solitude

Ignoring the major refurbishments to his residence in Munich, Ludwig built his castles as far away from anywhere and anyone of importance as possible – from his go-getting minsters, from those who thought they could bask in some of his limelight. Even in Munich itself he tried to escape by getting above it all, erecting a conservatory like his father's but much higher, bigger and more splendiferous. If he had to spend time in the little-loved – even hated – city of Munich, then at least he could be on his own. Only a select few were permitted to join him.

He had actresses come and sing to him – indulging a desire which in one case literally had a watery end. He graciously granted the children of Empress Elisabeth an audience. As he did one of his relatives, Queen Olga of Württemberg. He asked her to visit and she understood the invitation to be on the scale she was accustomed to from her family home in Petersburg and her own palace in Stuttgart; she came expecting a royal banquet. She was pretty surprised to find herself seated opposite the king in his garden of glass with no hint of ceremony whatsoever. The awkwardness of the situation may have been eased somewhat by the fact that both were able to speak in their favoured native language: French.

The ambience of his royal abode on Schachen Mountain (Königshaus) was less French than Turkish. Here, 2,000 metres (6,500 feet) up above the wrongs of the real world, the king was free to mingle with the gods in his own celestial sphere. It is said that he, in Turkish dress, sipping a cup of mocha and puffing a hookah, ordered his servants to create a staffage for his dreams. Like so much else which surrounds King Ludwig II, this may just be pie in the sky...

King Ludwig II's gallery of beauties

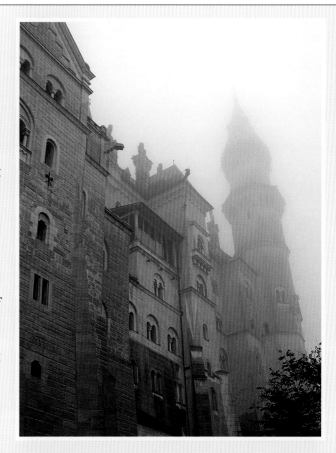

Königshaus is still there and thus the fourth of Ludwig II's fairytales open to the public. His other three, better known edifices may involve a trek up a steep hill; this royal Alpine hut really is out in the sticks. 'Civilisation' is three hours away – provided you've got the stamina and skill of a mountaineer. King Ludwig took on several mountain chalets from his father which he gladly visited on a regular basis. Some of them have fallen into rack and ruin; you can be sure, however, to find them where you'd least expect to.

Another royal bequest was more concerned with human beauty than the delights of the Alps. Grandfather Ludwig I liked to have pretty women portrayed – from aristocrat to actress to peasant – among them his lover Lola Montez. Ludwig II was more interested in horses. He had his trusty steeds painted on canvas by Friedrich Wilhelm Pfeiffer, often with a hunting lodge in the background, capturing both the king's favourite animals and his solitary haunts. These paintings can now be admired at Schloss Nymphenburg where Ludwig was born. The most famous depicts his mare Cosa Rara in Linderhof. The dapple grey stands in front of a table laden with roast meat, trout and red wine, snuffling among the delicacies for hay and oats.

Wittelsbachs and other relatives

His place of birth was never of the remotest importance to Ludwig – as opposed to his ancestral line of Bavarian (and foreign) Ludwigs. From Duke Ludwig of Kelheim, who introduced the world-famous blue-and-white diamonds to the Bavarian coat of arms, to Ludwig of Bavaria, the first emperor of the house of Wittelsbach, to Duke Ludwig the Rich of Bavaria-Landshut, who founded the first Bavarian university, the line can be continued through to Ludwig II's grandfather, Ludwig I. He was Ludwig II's godfather and his godfather was none other than Louis XVI (or Ludwig in German) of France. Through Ludwig I a long line of Ludwigs could be traced back from Louis XVI to Saint Ludwig himself.

This obsessive Ludwigism climaxes in Ludwig II of Bavaria. On his 22nd birthday the foundations were laid for the Neues Rathaus in Munich. The facade depicted the four kings of Bavaria to date, i.e. Maximilian Joseph I, Ludwig I, Maxi-

milian II and Ludwig II. There wasn't really a fifth king; Ludwig's brother Otto was only nominally king due to his mental illness, the prince regent was no more than this (i.e. not a king) and his son, Ludwig III, may have put the crown on his head during his father's lifetime but was only allowed to wear it for a very short period.

LUDWIG II – A PUPPET KING?

Whether King Ludwig II justified his claim to the throne with the "Ludwig line" or with the Wittelsbach dynasty – which became less lucid through its dealings with the Palatinate – or, as is assumed, with his baptismal link to the Sun King will never be clear. What is known, however, is that he never wanted to be a puppet king with no real power. And he also didn't want to be a "signing machine", as his grandfather had once put it. The hated subordination under the Prussian eagle, whose wings seem to beat from Berlin to the Bavarian Alps, practically robbed him of his senses. In times of resignation he thought of abdicating in favour of his brother Otto – in vain, as Otto had already been 'eliminated'.

Right up until the last days of his life Ludwig carried out his governmental duties on time and wherever necessary – avoiding Munich if at all possible. Whether at Schloss Berg, in his mountain chalets or – dressed in his travelling clothes – outdoors in the fresh air, he signed what was put in front of him – but not without carefully reading the small print. Because of his extensive knowledge the king was probably not an easy regent. He opposed the Pope's doctrine of infallibility, wrote his *Kaiserbrief* in support of Wilhelm I with great revulsion and made decisions on important matters of state, such as the levying of local duties for beer, malt and flour and the naming, marriage, holiday periods and retirement of individual civil servants.

ART OR KITSCH?

The rather irritating business of ruling the country was definitely not what Ludwig dreamt about during his many sleepless nights. Instead he focussed his energies on the arts. The architectural style of Ludwig II's castles can be clearly placed in the Historicist bracket of the 19th century, although some art historians believe his creations to be an early form of pop art. Andy Warhol's picture *Neuschwanstein* was executed in this vein in 1987. The park buildings at Schloss Linderhof are reminiscent of land art; we only have to think of the famous exponents thereof Christo and Jeanne-Claude. With his countless commissions Ludwig greatly supported the arts and crafts in Bavaria, helping them

His dream of flying was never fulfilled; this was how Ludwig II intended to cover the distance between his father's castle of Hohenschwangau and his own more elevated Schloss Neuschwanstein. His then novel idea shows that the Bavarian king was ahead of his time – in so many areas. This view of the Alpsee illustrates just how remote the two castles were, hidden away in the Bavarian mountains.

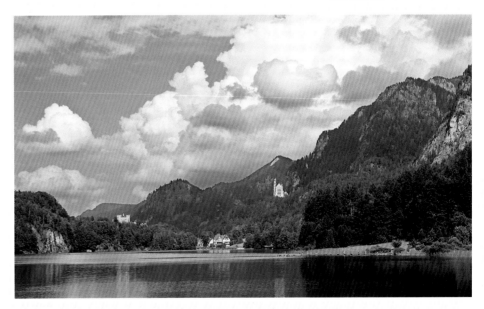

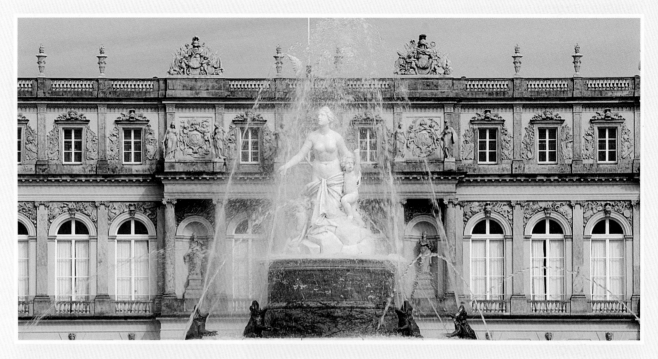

Outside Schloss Herrenchiemsee gentle jets of water splash the figure of Roman goddess Latona, Zeus's lover who bore him the twins Artemis and Apollo. Ludwig was not able to enjoy the fountains; they weren't finished until the year of his death.

to flourish on an unprecedented scale. By the time the royal demand had waned many artists in Schwabing were able to sell 'mass-produced' goods, paintings quickly dashed off for the increasing number of travellers and summer guests and frequently derided as kitsch.

The word "kitsch" could also be used to describe the plaster chandeliers at Schloss Herrenchiemsee. Appearances here are deceptive. The lights were temporary fittings for the king, too impatient to wait for the far more expensive objects which were to adorn the ceilings. The king set great store by genuine materials. Unlike other hangers-on of the wayward Historicist movement, King Ludwig II was not bent on prestige and representation; the "common people" weren't even allowed to see his castles. He believed in art for art's sake – and this is how he planned, designed and built right up until his untimely death.

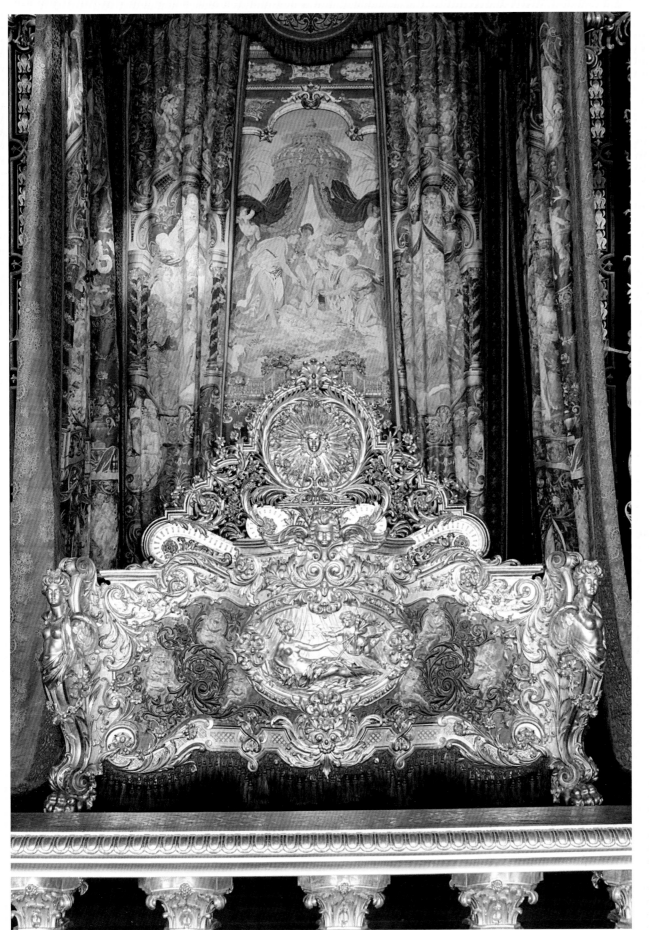

The State Bedroom is the core around which Schloss Herrenchiemsee was built – literally. Embroidery was begun on the tapestries before the basic framework of the building had even been erected. The golden State Bed is particularly splendidly decorated and fenced off by a balustrade which – unlike Ludwig's French model – no mere mortal was ever to cross.

Page 22/23:
The Hall of Mirrors at Schloss Linderhof is nowhere near as enormous as its Herrenchiemsee counterpart but is no less (or perhaps more) splendiferous and abundant in its neo-Rococo decor. Both the impressive chandelier and the candelabras on the walls bathed the room in a soft light which was reflected a thousand times over.

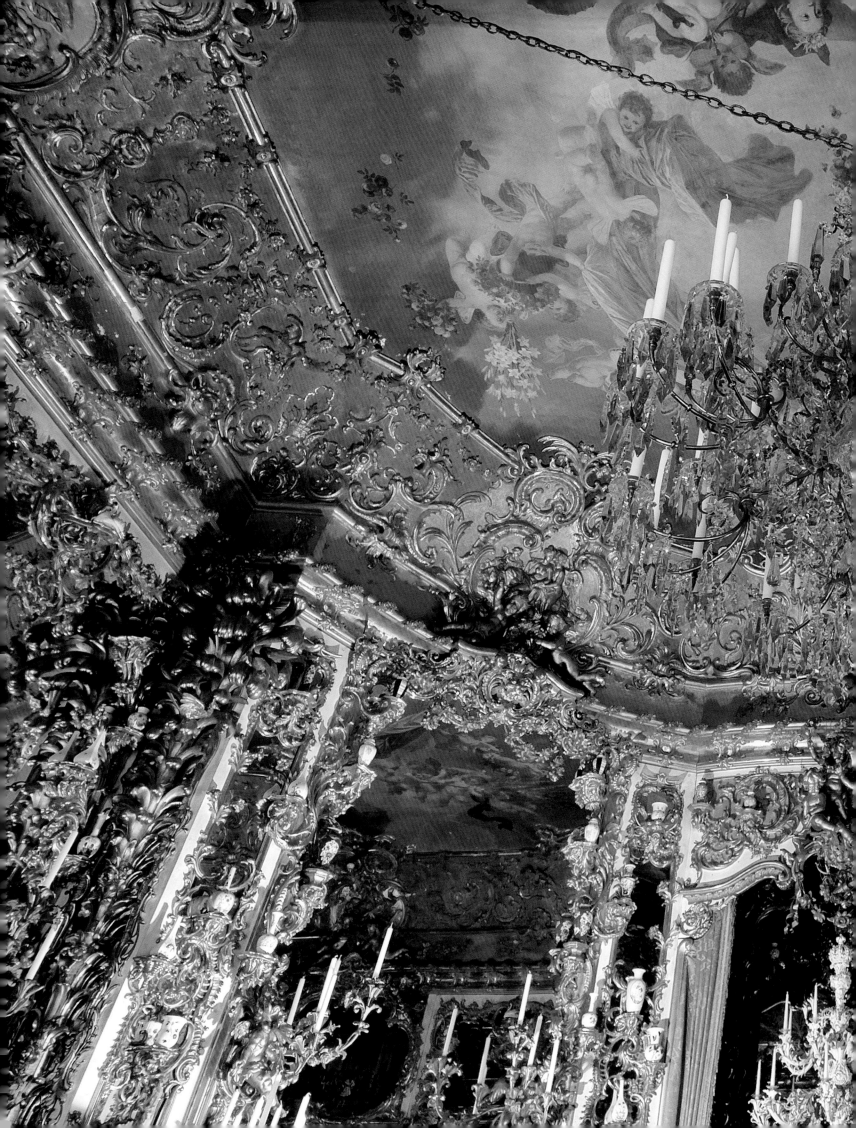

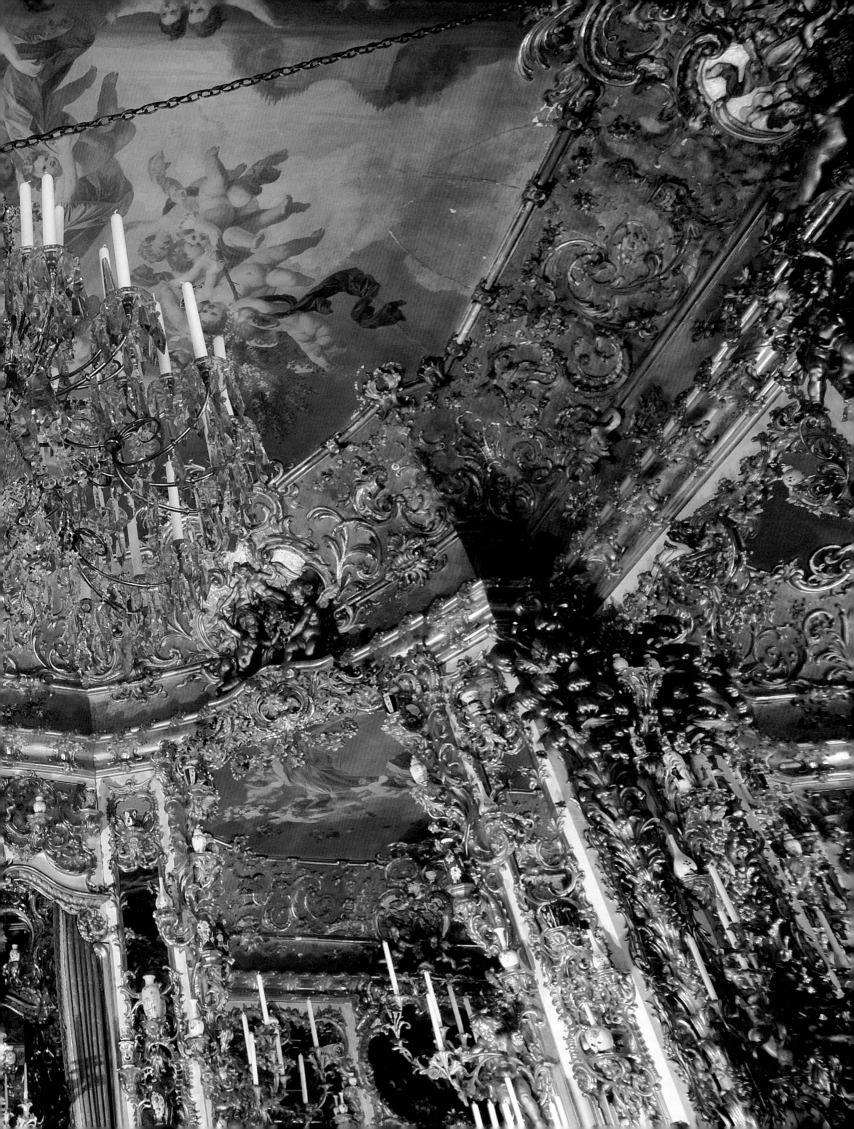

SCHLOSS NEUSCHWANSTEIN –
A 'MEDIEVAL' CASTLE
ON A ROCKY CRAG

Lit up at night Neuschwanstein really does hold all the magic of Cinderella or Sleeping Beauty. Ludwig II was mad on fancy illumination and fireworks, a tradition which is reverently continued today; visitors who stay the night near the castle, with this magical vision imprinted on their retina, may fall asleep dreaming of Walt Disney and fairy godmothers...

Not only Parsifal, Lohengrin, Tannhäuser and Tristan and Isolde live in the legendary Schloss Neuschwanstein; they share these hallowed halls with hoards of visitors, as many as 5,000 a day. It was the job of architect Eduard Riedel to realise what theatrical set designer Christian Jank had developed. At the time of Ludwig's death in 1886 17 years had been spent on construction and the castle still wasn't finished. The Kemenate or heated apartments were only completed in 1892 and the mighty keep still hasn't been erected.

Despite this Neuschwanstein is one of Germany's top tourist attractions and on the way to being included on the list of UNESCO World Heritage Sites. It didn't quite make it as one of the new seven wonders of the world; maybe we could be allowed to term Ludwig II's 'medieval' castle on its rocky crag number eight?!

200 to 300 workers a day worked on the building of the castle, all of them covered by health and social 'insurance' which was exemplary for the day and age. Even today King Ludwig II's most famous edifice feeds and clothes many in the catering and tourist industry. What would Bavaria be without Neuschwanstein – and what Neuschwanstein without the fantastic backdrop of the Alps? The pair form a perfect union which will hopefully never be broken.

Page 26/27:
From here Schloss Neuschwanstein looks as if a famous Romantic artist has painted it on canvas. What was executed first, Ludwig's mock fortress or the magnificent Alps? Is the castle a staffage for the expanses of the Alpine foothills? Or has the scenery been adapted to blend in with the castle?!

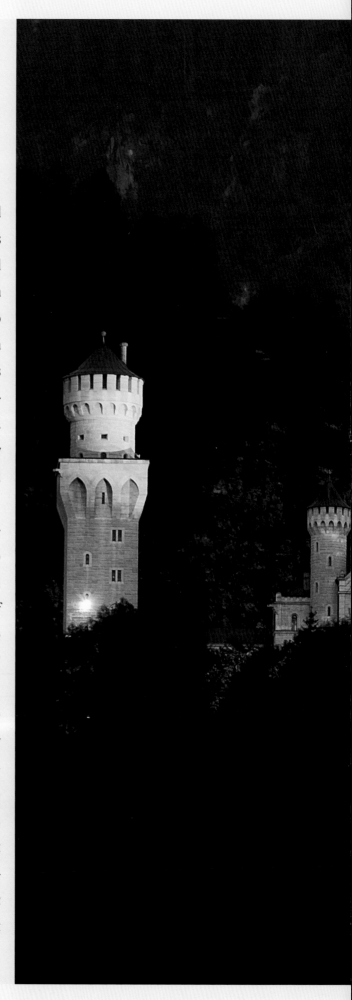

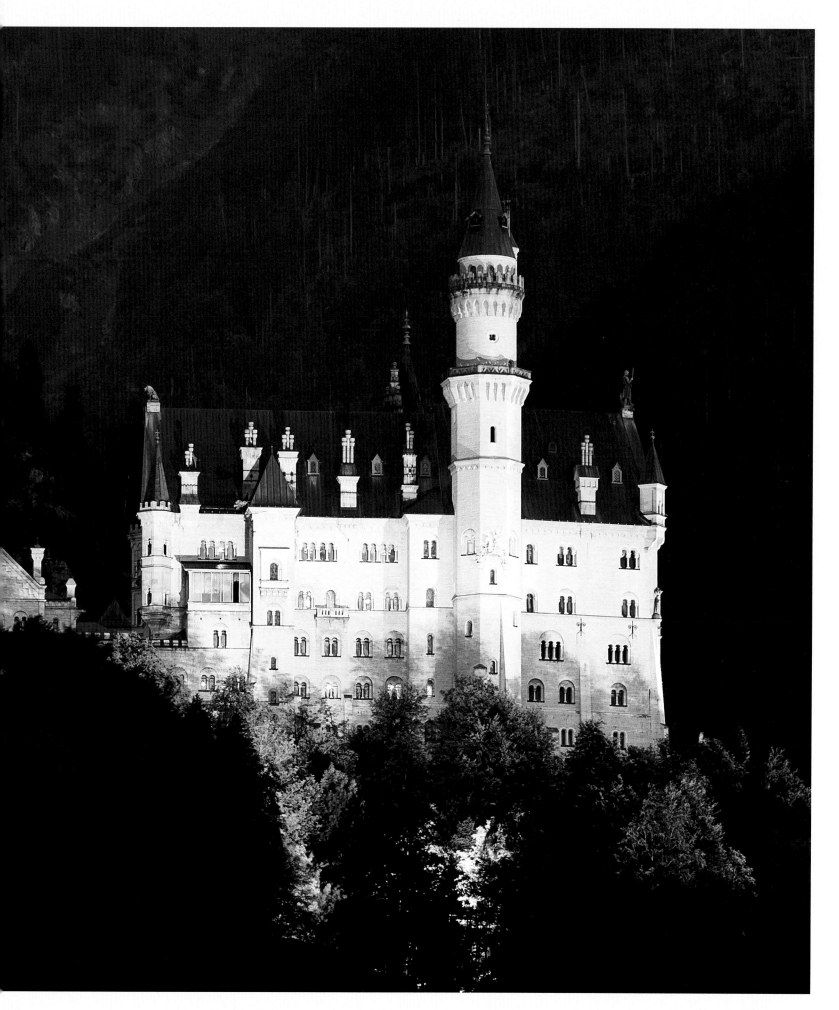

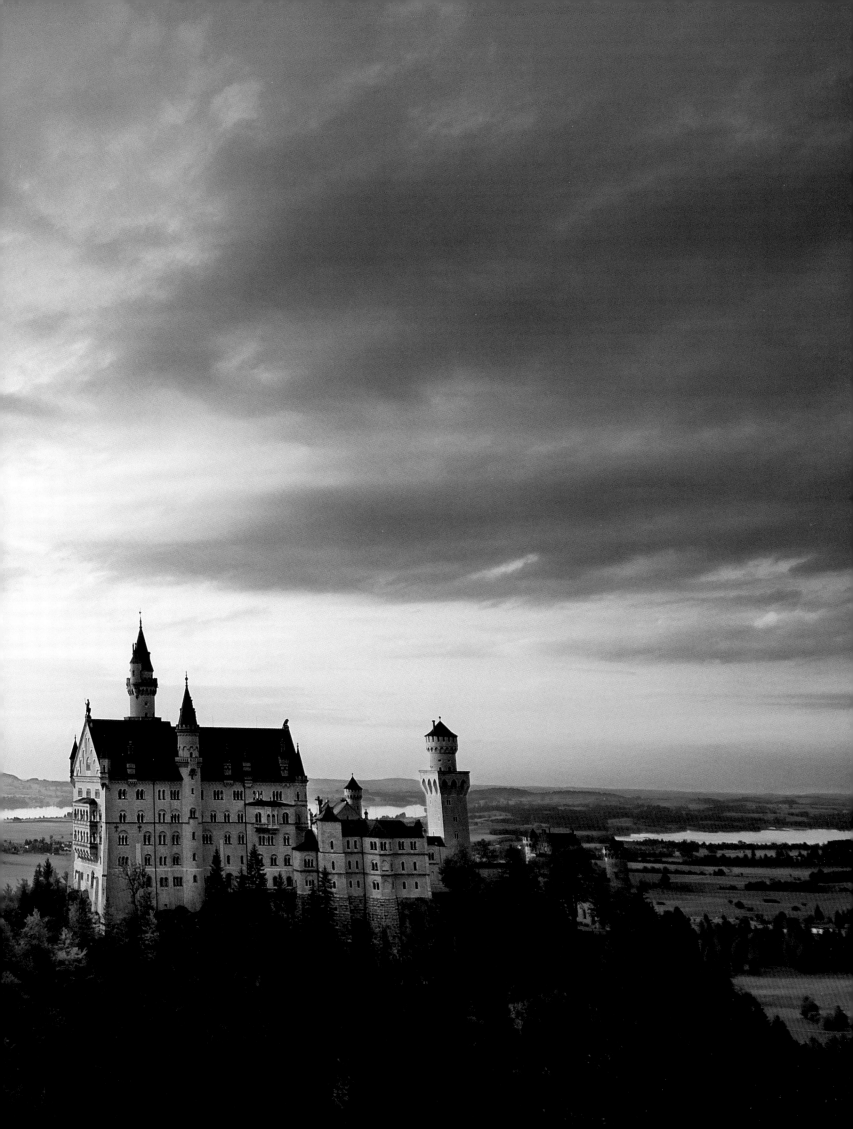

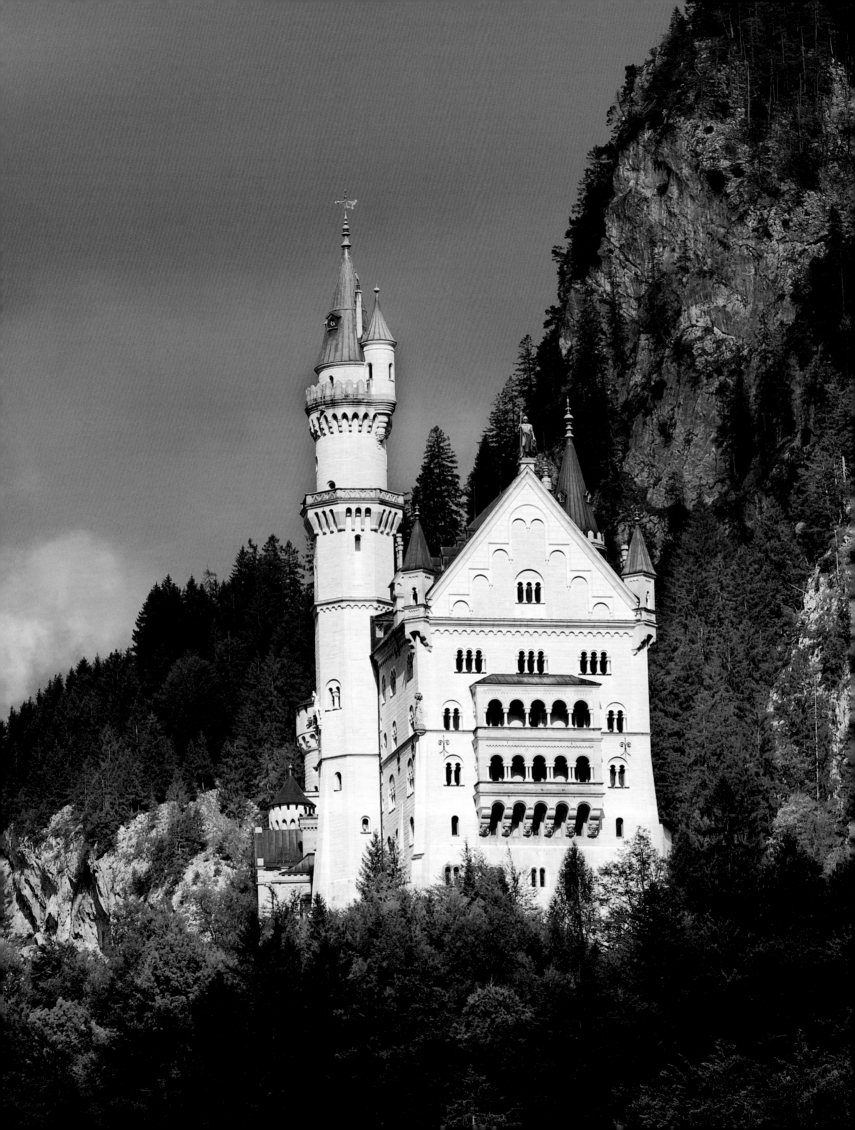

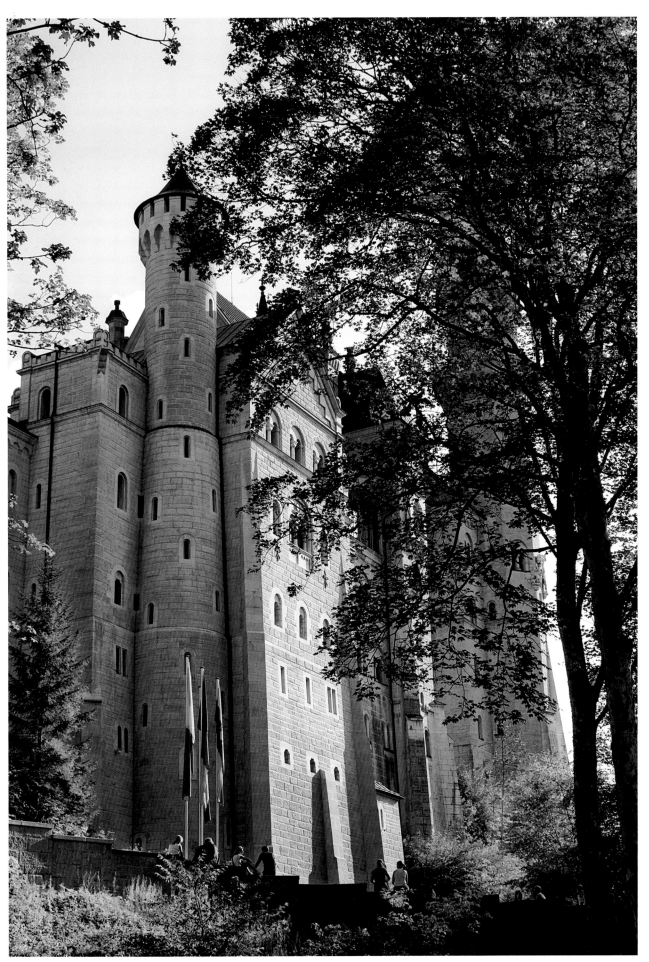

Left page:
A spacious two-storey balcony punctuates the west front of Neuschwanstein. From here the king could bask in the beauty and drama of the sunset – shortly after he had got out of bed. Ludwig II turned night into day, his eclectic life enacted in a number of fantastic settings he himself created.

Half hidden behind the trees Neuschwanstein looks like something out of a fairytale. It's easy to see how the most famous castle in the Bavarian Alps has influenced the designers of the Walt Disney theme parks.

Page 30/31:
From this angle Neuschwanstein is nothing less than monumental. During Ludwig's lifetime one of the floors had yet to be finished – and so it remains today. After revelling in all the pomp and splendour a coffee in the less hallowed halls of the castle café or a browse around the shop may ease the transition back into everyday life...

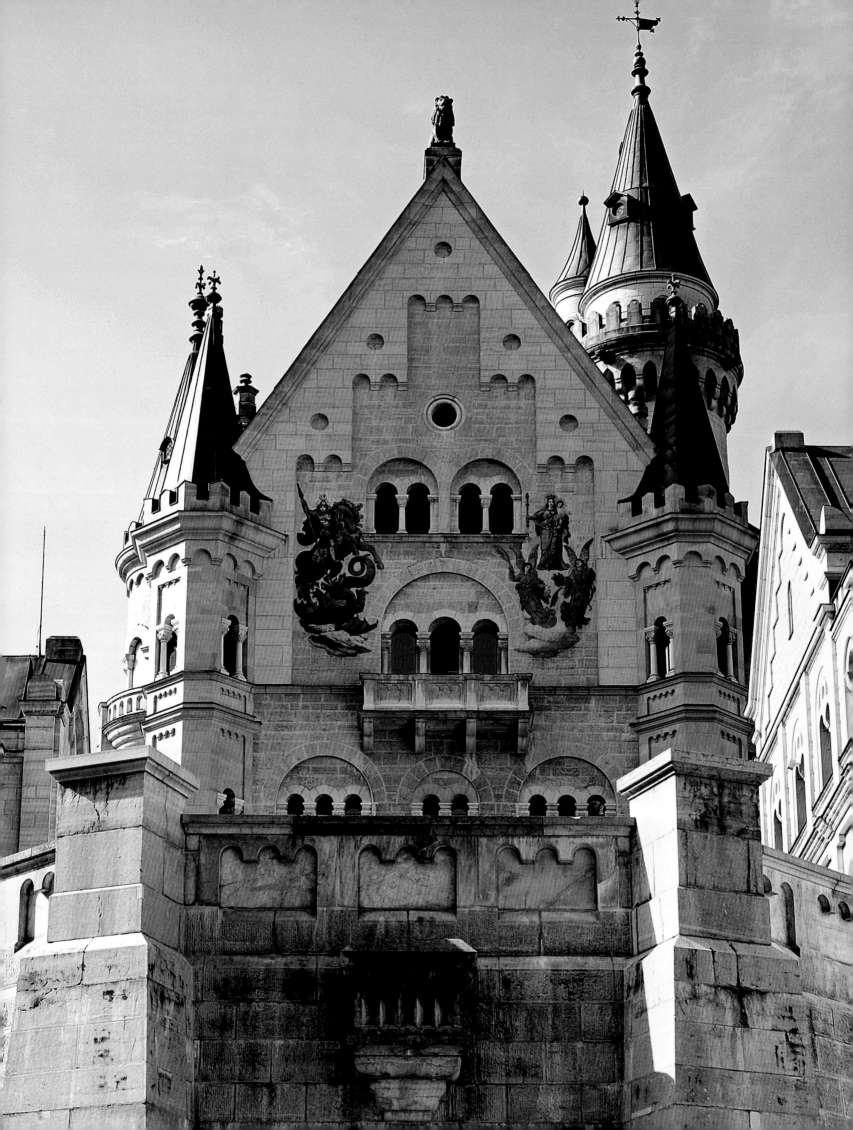

Left page:
Looking up at the gable
of the Palas or great hall
from the Lower Courtyard
of Schloss Neuschwanstein.
Against this spectacular
backdrop visitors queue to
be admitted to the interior
of this awe-inspiring edifice
– with plenty of time to
admire their surroundings
during long waits at the
height of the season.

Below:
Grotesque heads with wild
eyes and fierce grimaces
ward off evil at Neuschwan-
stein. The round arches of
the loggia give the facade
a Romanesque or Norman
tinge, with the friezes almost
Oriental. These details on
the west facade are only
visible from a distance
through a telescope or
powerful telephoto lens.

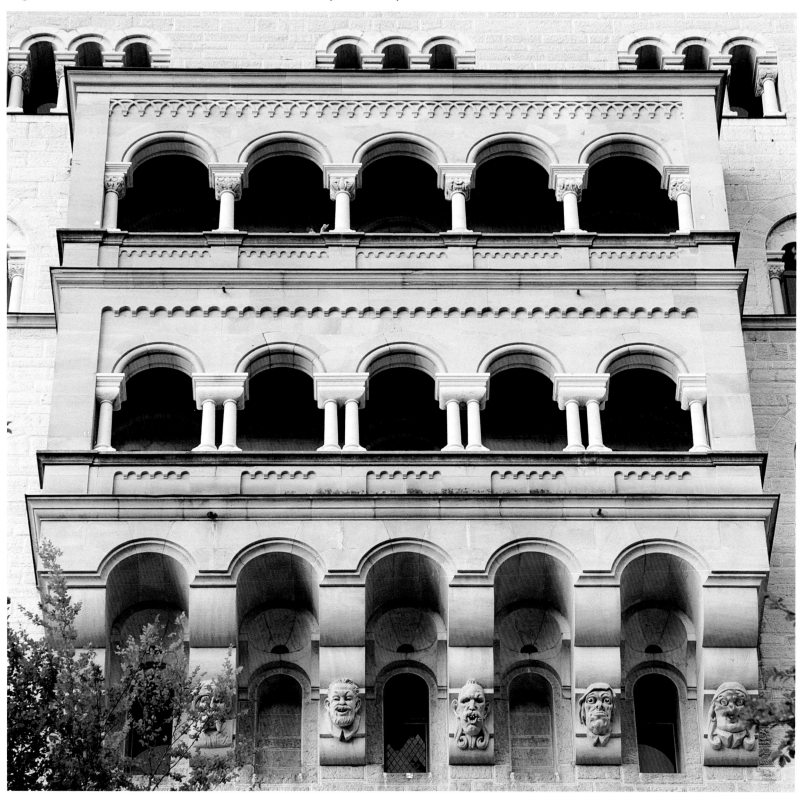

SCHLOSS NEUSCHWANSTEIN – FROM MEDIEVAL CASTLE TO STUFF OF LEGEND

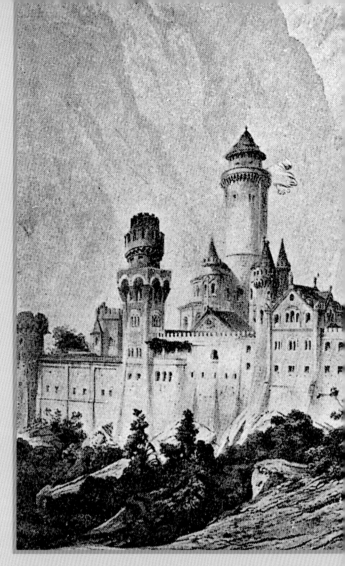

Architect Julius Hofmann (1840–1896) provided all the plans for the interior of Schloss Neuschwanstein. In 1884 he took over from Dollmann and was to design both Burg Falkenstein and the Byzantine and Chinese palaces. Ludwig's successor, Prince Regent Luitpold, later made him his senior architectural advisor.

In keeping with the fads and fashions of the day King Ludwig II's father, Maximilian II, had a new castle built on top of the ruins of Hohenschwangau in neo-Gothic. Over the years the castle was constantly extended to provide a suitable abode for the royal family and their huge entourage in the summer months. This "old German knight's castle" was adorned with depictions of medieval sagas and greatly impressed young Ludwig in his formative years. On the death of her husband his mother retired to Hohenschwangau; huddled together under one roof the dowager queen and the young, ambitious king didn't always see eye to eye. Ludwig thus decided to build a new fortress higher up on top of ruins on the opposite moun-

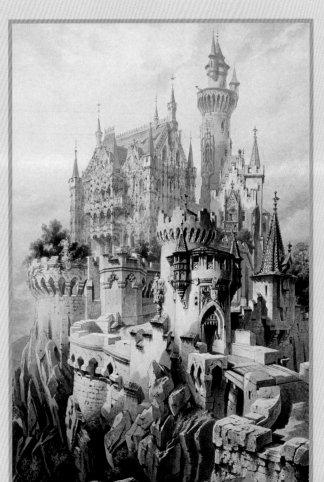

This picture looks like a stage set – which is hardly surprising as it was penned by theatrical designer Christian Jank (1833–1888) in 1883, the man who drew up most of the plans for Ludwig's castles and palaces. It shows the first design for Burg Falkenstein, the castle planned for near Pfronten. Only a road and water pipe were actually built; today a hotel beneath the medieval ruins affords marvellous views of Schloss Neuschwanstein.

tain ridge. Originally Neuschwanstein, as the castle was finally called, was to be constructed in the "genuine style of the old German medieval castles" – neo-Gothic; in the second stage of planning, however, it transmuted from mock Gothic to neo-Romanesque in keeping with the Wartburg near Eisenach. True to baroque building traditions the new edifice was not made to fit the lie of the land as medieval castles were; the land itself was 'adjusted' (in other words, dynamited) to suit the topography of the mountain king's new dream home.

A MODEL OF HISTORICISM

Whereas many a mock building simply emulates one famous architectural style – from Romanesque to Gothic and Renaissance, from baroque to Rococo and neoclassicism – Neuschwanstein begged to differ. It isn't just a kitsch copy of something which has gone before it; it is based on a completely novel concept which exploits what

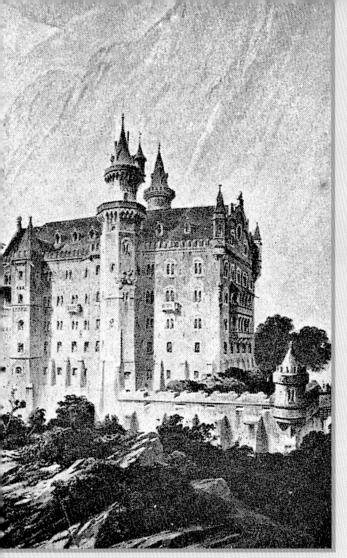

THE KING WITHOUT A CROWN OR A THRONE

In the apse of the Throne Room Jesus is depicted as the king of heaven with the Virgin Mary and John the Baptist, with the six canonised kings turned to face the enthroned monarch beneath them. The throne is, however, missing; it wasn't finished in time. The king is also missing his crown. The kings of Bavaria by Napoleon's grace were never actually crowned; in other words, the crown was never actually placed on their heads. The royal insignia, arranged on a velvet cushion, were merely paraded in front of their noses. As the constitutional monarchy had no absolutist power, at his castle at least Ludwig attempted to symbolically to erect a shrine to a kingship which was delivered of all evil and free of sin.

Ludwig's brief spell on this earth did not permit him to fully indulge his ethereal ideas under the divine protection and in the face of St Ludwig, King Louis IX of France. He did, however, live to see his bedroom finished, the only neo-Gothic room in the entire palace. It has all the mod cons of the late 19th century, including hot and cold running water. And what other shape could the wash stand in Neuschwanstein have but that of a swan?!

Franz von Brandl was not only rich in experience; he had also managed to amass a considerable fortune. Both were used in equal measure to help hurry the king's building endeavours along. He was rewarded with several royal medals and honours for his pains, including the coveted and aristocratic Order of the Bavarian Crown.

has been learned from and is treasured in older buildings to create something totally new. The pinnacle – both literally and figuratively – of Neuschwanstein is the Sängersaal or Singers' Hall which Ludwig had set designer Christian Jank compile from the Festsaal at the Wartburg and the minstrel's gallery in the Sängersaal of the same castle. This creation itself later acted as a model for stage sets of Tannhäuser.

It may not be quite right to describe Neuschwanstein as a model of Historicism because this would imply that bigger, better, more beautiful buildings followed. Ludwig's castle was instead the climax of this architectural trend; it has never been trumped. Under his Sängersaal is the Thronsaal or Throne Room which had no specific model and has seen nothing quite like it since. It's vaguely reminiscent of a scared Byzantine setting, such as the Hagia Sophia in Constantinople, and was conceived with the All Saint's palace chapel in Munich in mind.

This plan for the gatehouse at Neuschwanstein was also made by Christian Jank. The artist furnished Ludwig's infamous "private performances" and also worked on the design of the conservatory at the Residenz in Munich. For his services the king awarded him the Ludwig Medal and the First Order of St Michael.

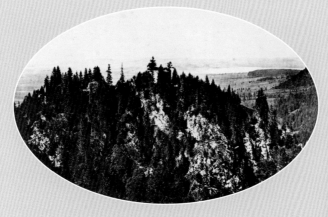

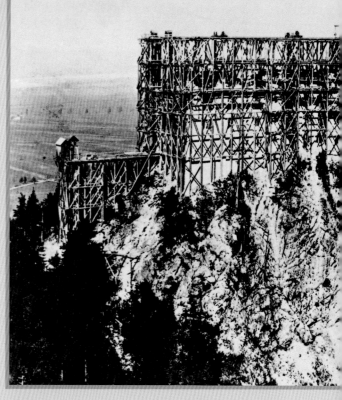

VORSPRUNG DURCH TECHNIK

Originally the construction of Neuschwanstein was to take three years, as Ludwig reported to Richard Wagner in 1868. This came to nothing – or rather, to much more than Ludwig had reckoned with. And it still wasn't finished. This probably had a lot to do with the fact that instead of his "old German knight's castle" Ludwig II now required a castle of the Holy Grail in honour of the composer, one which was to literally become the unsurpassable stuff of legend. The king wanted to chivvy his artists along, to snap them out of their creative "boringness". He also wished to speed up the building process, making use of the state-of the-art technology then at his disposal.

A steam-powered crane and road locomotive or steam tractor greatly eased the transportation of building materials up the steep mountainside. The newly established Dampfkessel-Revisions-Verein (Bavarian Boiler Inspection Association) regularly checked the steam boilers so that they operated safely. This association was later to become the famous German Technische Überwachungs-Verein (TÜV or Technical Inspectorate). Health and safety aside, aesthete Ludwig was naturally also concerned with what his new home looked like. In 1845 his father had the Marienbrücke built across the Pöllat Gorge in wood. It later had to be renewed and made stable; the planned measures wouldn't have improved its appearance in the slightest. Ludwig II thus replaced the bridge with a secure yet ornate filigree iron construction in 1866.

FROM HOLY GRAIL TO TOURIST MAGNET

For Ludwig the world of the Holy Grail was the most chivalrous and highest of Christian endeavours. The chosen sagas thus centre on the difficult conflict which was to burden him throughout his entire life: that of eroticism, which he found sinful. He thus strove to create a pure and holy environment for himself at all times. In his study we find Tannhäuser taking his pleasure at the ducal court of Burg Trausnitz and opposite the knight being condemned for his sins by the pope of Rome.

At the end of the 19th century Neuschwanstein was seen as a 'proper' German castle in the wave of German nationalism which engulfed the country at the time, something the 'French' palaces of Linderhof and Herrenchiemsee were clearly not. Right from its very beginnings the castle near Füssen was received with great enthusiasm and therefore remains to this very day the most famous of King Ludwig II's fairytale castles.

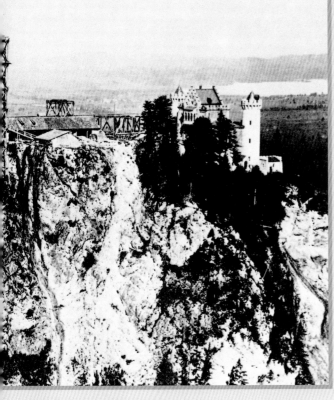

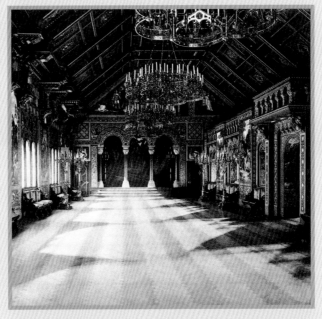

The Singers' Hall at Schloss Neuschwanstein had by 1886 taken on its present appearance. As opposed to the Throne Room (where the throne is still missing) King Ludwig II was allowed to enjoy it in full – albeit only briefly.

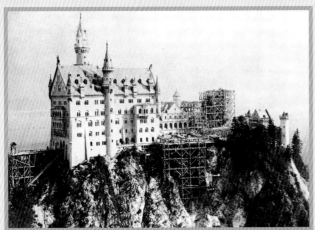

The king also had a conservatory built at Schloss Neuschwanstein as this picture from 1886 illustrates. It may be much smaller than the one at the residential palace in Munich but – unlike the latter – it has been preserved to this very day.

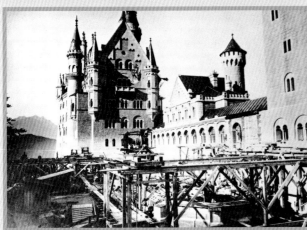

This photograph shows the dripstone grotto at Schloss Neuschwanstein in c. 1886. It's quite a contrast to emerge from the glittering and overtly ornate grandeur of the royal bedroom to find this rather coarse and primitive – yet impressive – room next door.

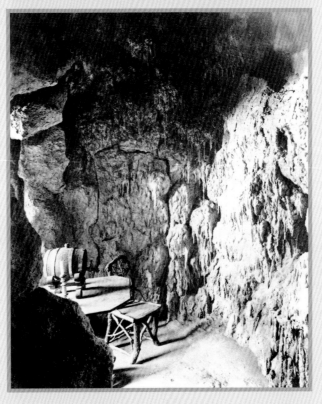

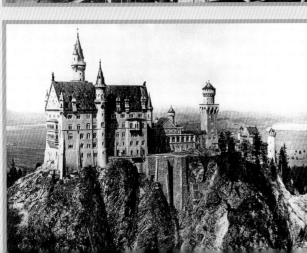

37

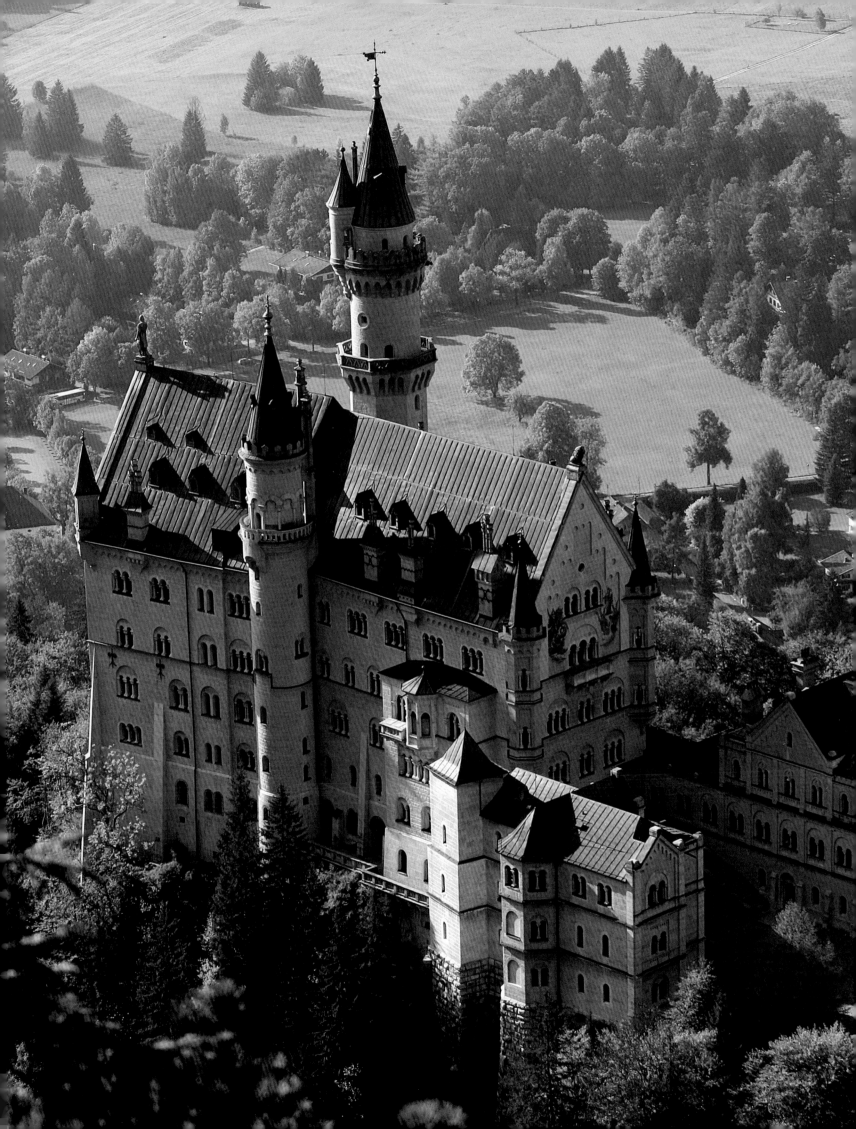

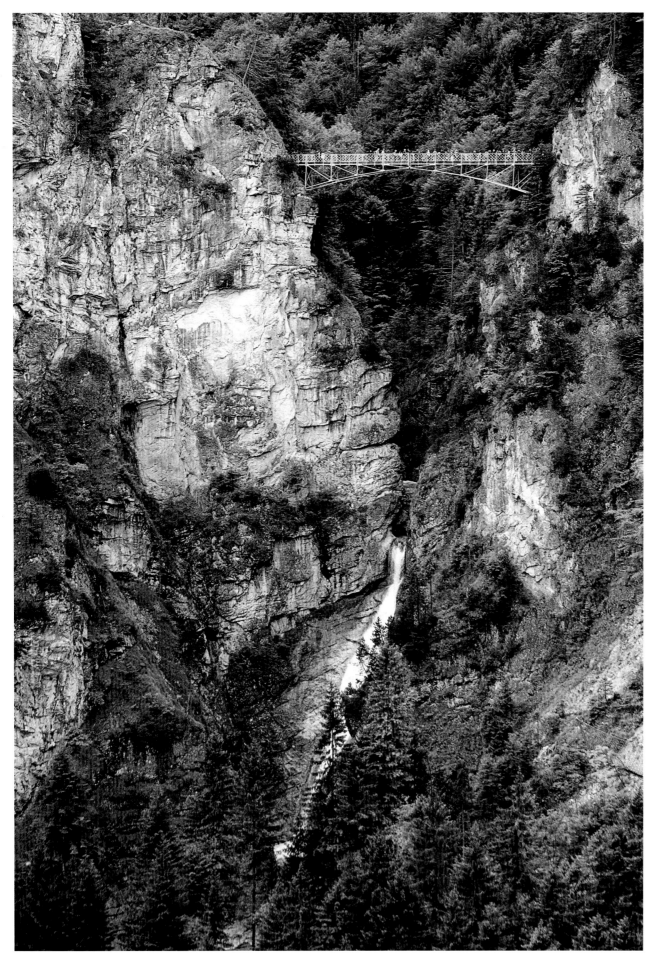

Left page:
This bird's eye view from the southeast shows the main castle building and upper courtyard of Schloss Neuschwanstein. The autumn colours only serve to heighten the beauty of the spectacular setting.

In 1866 King Ludwig II had the Marienbrücke over the Pöllat Gorge replaced by a filigree iron construction. His father, King Maximilian II, had named the old wooden bridge after his wife; despite its family significance aesthete Ludwig found the clumsy structure ugly. His bridge, built using the latest technology, has stood the test of time and reliably copes with several thousand pairs of trampling feet a day.

Right:
The Connecting Building in Neuschwanstein links the Palas with the Gateway Building. The latter was the first to be finished and was used by the king as a temporary apartment during construction.

Far right:
Richly ornamental capitals frame the grand view of the Bavarian mountains from the west balcony. Here King Ludwig II could dream of his absolutist monarchy – and if he hadn't have been born when he was ("too late"), his dream may have come true.

Right page:
Even if Neuschwanstein was never to house bold knights or medieval maidens, the left building is still referred to as the Bower and the right as the Knights' House. In the middle is the Palas or great hall, as the main living quarters of a medieval castle are usually called.

Right:
At Neuschwanstein even the doors to less important rooms are elaborately decorative. Here visitors can muse on the ends of the hinges; are they more French lily or fearsome dragon?!

Page 42/43:
The centre dome of the Throne Room at Neuschwanstein is based on the Hagia Sophia in Constantinople, now Istanbul. The original had to be shored up with supports as it threatened to collapse; technology freak Ludwig II had his Hagia Sophia built around a supporting iron construction. This also probably made the securing of the enormous chandelier easier – and safer.

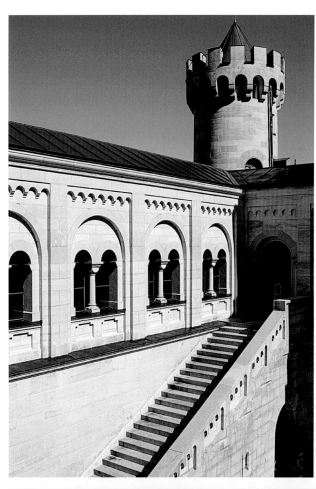
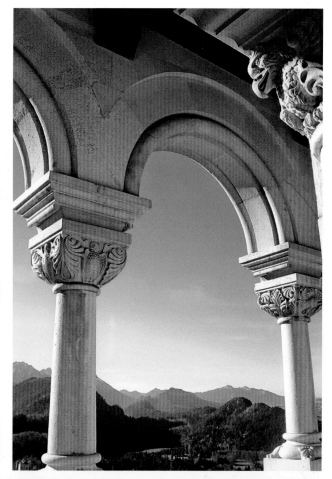

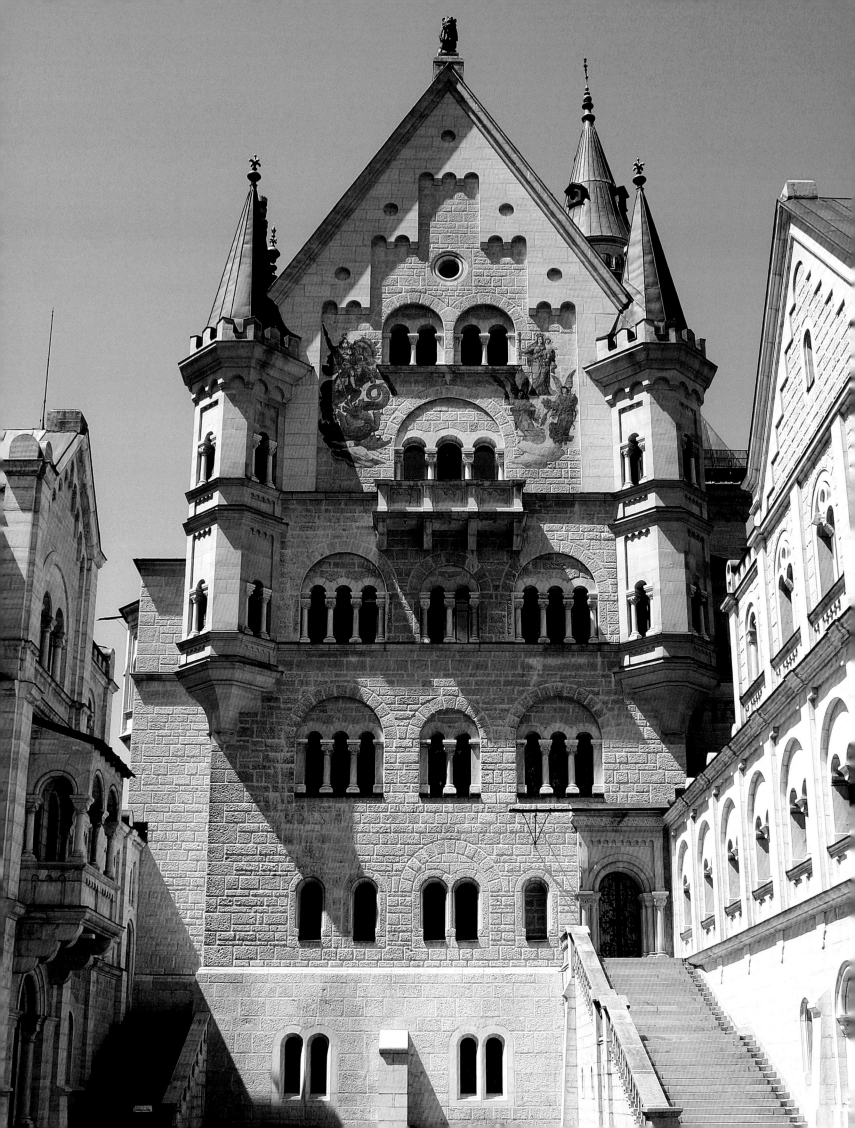

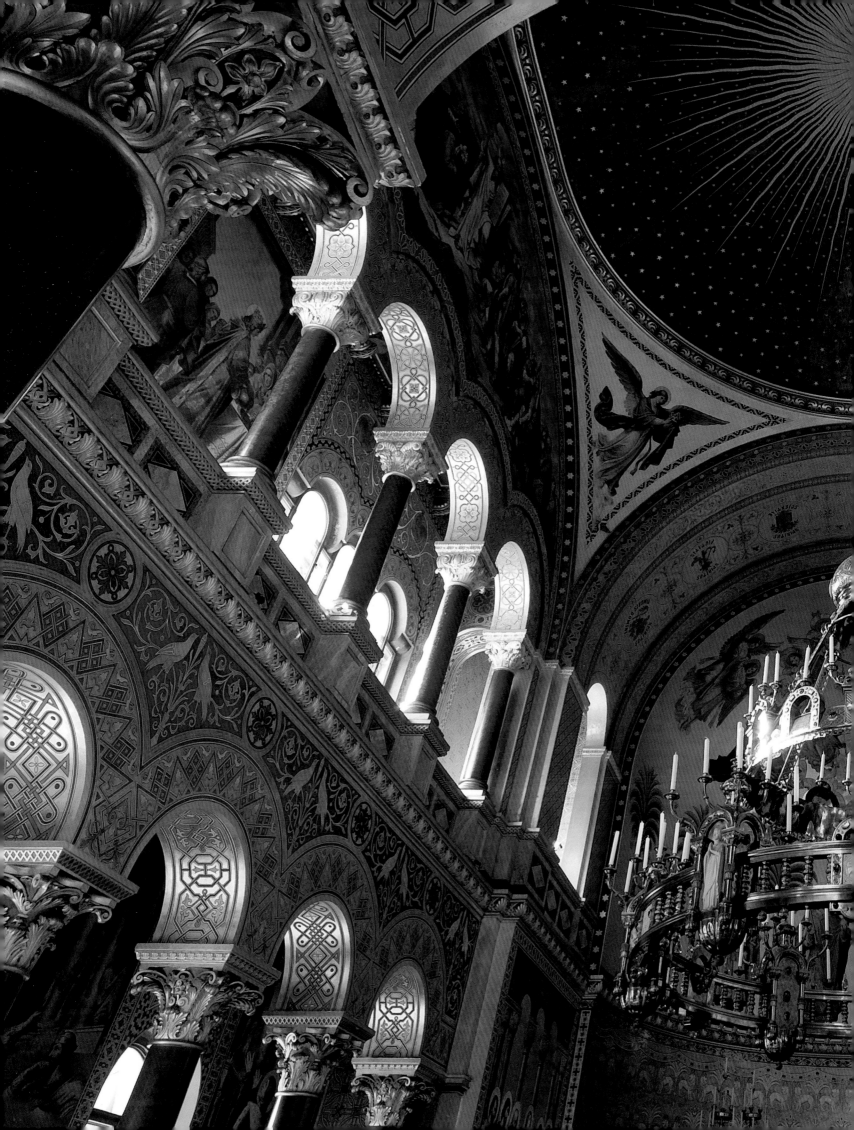

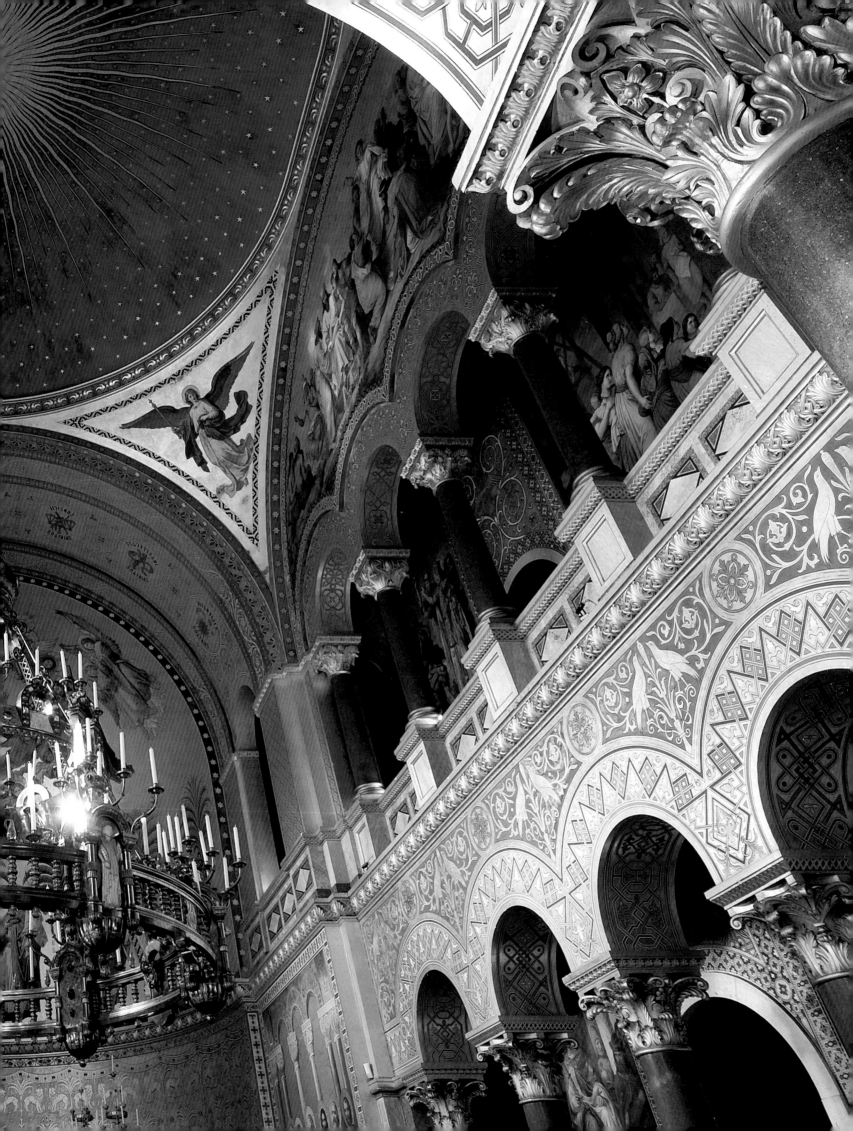

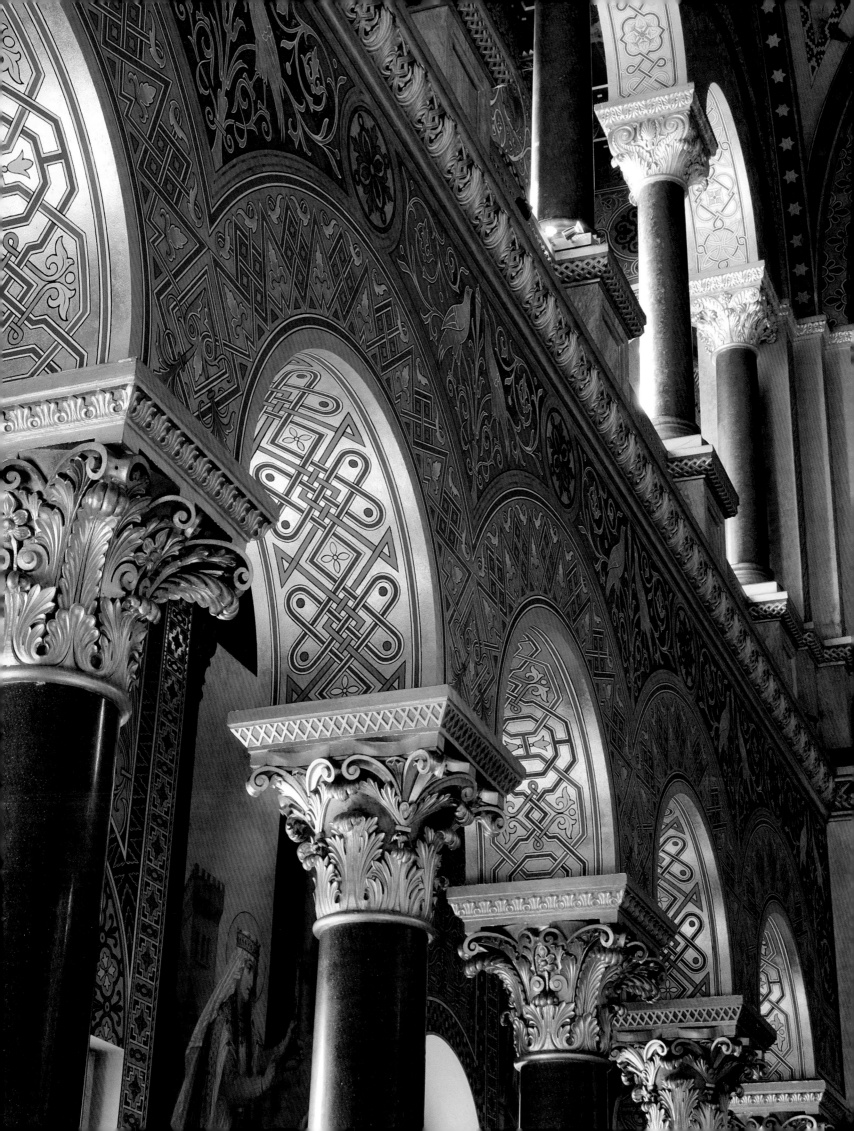

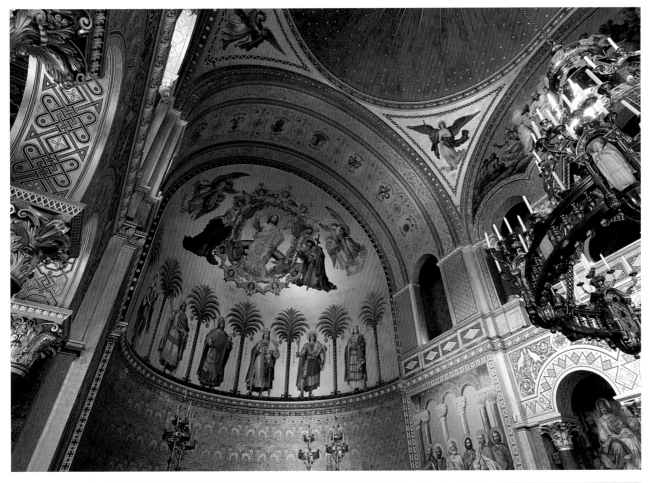

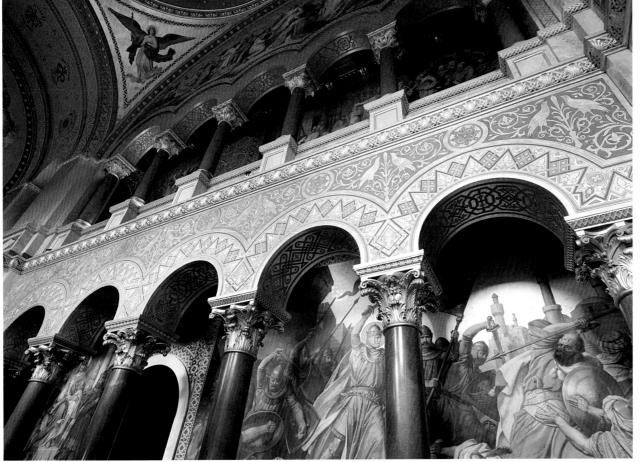

Left page:
The decorative capitals and ornamental frescos on the rounded arches give the Throne Room at Neuschwanstein a distinctively Byzantine appearance. Today's visitors may find the blue and gold decor a bit overdone but it was all the rage at the time of its making in the 19th century.

The apse of Neuschwanstein's Throne Room was inspired by the church of All Saints Court Church in Munich. The symbols of the Evangelists are depicted in the transverse arch, with the angels in the ceiling spandrels proffering the symbols of kingship. Among the six holy kings dotted amongst the palm trees is the French ruler St Louis, Ludwig's namesake, upon which the king of Bavaria based his notions of the monarchy.

Beneath the lower row of pillars in the Throne Room of Schloss Neuschwanstein murals depict the deeds of the holy kings. These are continued on the upper storey. We also come across King Louis IX of France here whose role of benefactor was emulated by King Ludwig II, the latter providing social security for his employees which was exemplary for his day and age.

Page 46/47:
The Singers' Hall on the upper storey of Schloss Neuschwanstein is the climax of a tour of Ludwig's fairytale castle. It is based on the Historicist room of the same name at the Wartburg near Eisenach. The room never fulfilled its intended purpose; no musical performances were given here during Ludwig's lifetime.

45

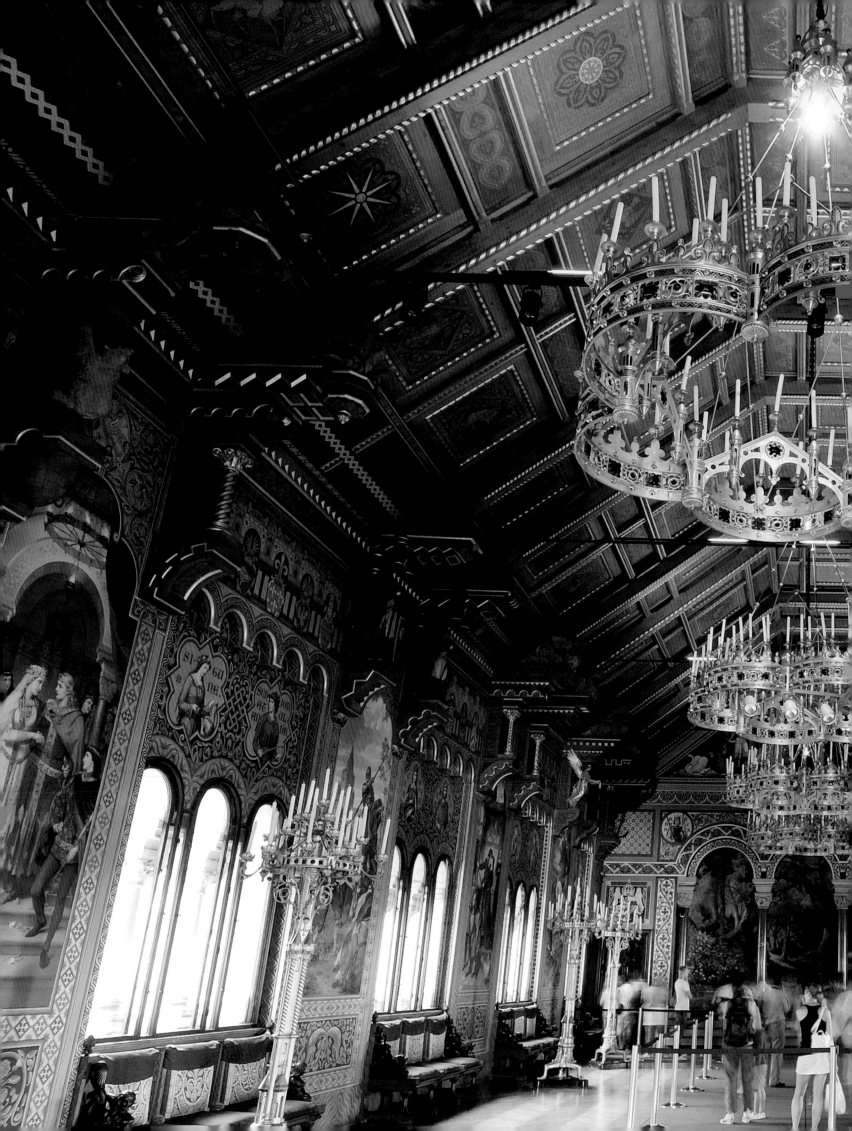

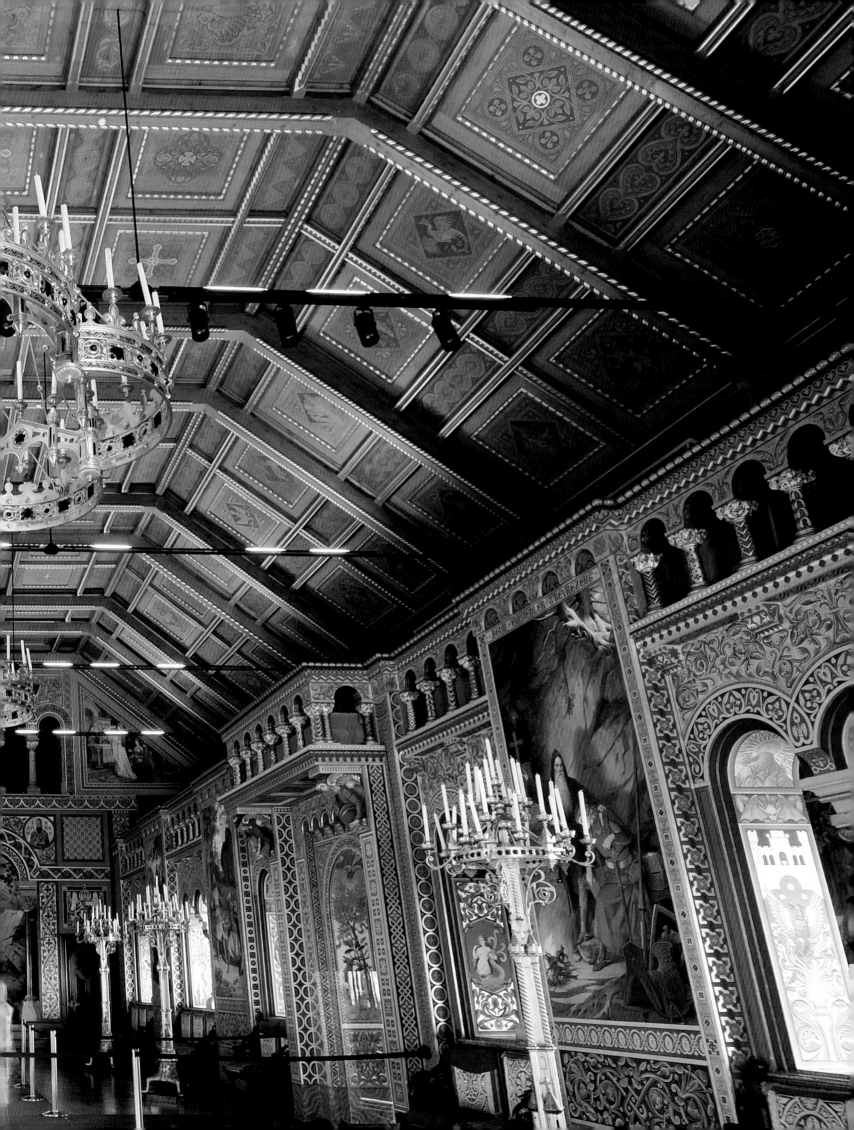

LUDWIG II'S FRIENDS – FROM RICHARD WAGNER TO LOYAL HAIRDRESSER

Right:
In 1864 Joseph Albert took this photograph of the internationally famous composer Richard Wagner. At the time he was little known and on the run from his creditors; King Ludwig II, one of his most fervent admirers, was only too happy to 'rescue' him, remaining loyal to both the man and his music up until his death and beyond. Ludwig's ministers and a good many of his subjects were not enamoured with Wagner, however, and he was soon forced to take his leave of Munich.

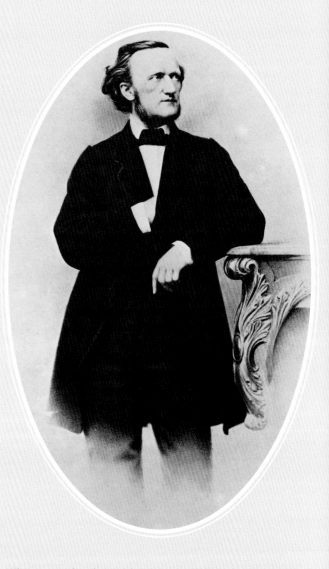

Even as a child Ludwig liked to give presents. His brother Otto was one of the first beneficiaries, one year eagerly receiving a modest gift of tin soldiers from his big brother. As king the billiard table at Schloss Hohenschwangau wasn't big enough to hold all the Christmas parcels Ludwig later dolled out amongst the family and their servants. In his opinion his loyal Bavarian subjects were to receive the greatest gift of all, however: the fabulous art and music of Richard Wagner. But first he had to help the financially crippled composer back onto his feet.

The extremely generous funds which found their way into the pocket of the "Saxon revolutionary" were frowned upon by both Ludwig's ministers and sections of the population, neither of which moved in the same spheres as the composer

These two photos are unusual in more than one respect. At the end of his journey to Switzerland King Ludwig II had his picture taken with actor Josef Kainz (1858–1910) at the Synnberg studio in Lucerne. With the exception of his engagement photograph, this was the only time the king had himself portrayed with another person. And another thing: the king is standing up and the young man sitting down, which was totally unheard of at the time! It was also unprecedented that the actor (now standing) has his hand on the king's shoulder; shortly after its publication the photo was retouched and the hand removed. Kainz must have made a big impression on the king, prompting Hugo von Hofmannsthal to call him the "unmagicked magician" in his tribute to Kainz ("Verse zum Gedächtnis des Schauspielers Josef Kainz").

 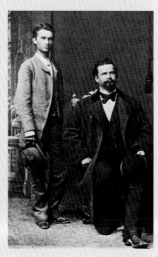

and his patron. Plans for the grand festival hall to be built in the Bavarian capital by star architect Semper also fell on deaf ears. Things became so fraught that Ludwig II's favourite, Richard Wagner, was hounded out of Munich as "Spanish" dancer Lola Montez had been before him, the woman who had captured the wayward heart of grandfather Ludwig I.

As highly as Ludwig praised the pompous works of Wagner he was bitterly disappointed in his royal musician as a man. It was almost a matter of state when Wagner failed to tell his patron that he had stolen his best friend's fiancé. There may have been many reasons for King Ludwig II courting his cousin Duchess Sophie of Bavaria. But to no avail: their engagement was broken off in the autumn of the year it had been announced, greatly shocking both the court and Ludwig's subjects.

The cause of Ludwig's abortive courtship may have been the queen mother. She had secretly confided in Ludwig's grandfather that her son wanted to live with Sophie "like a saint". Ludwig I must have been deeply scandalised by this; he himself was a famous philanderer. Ludwig II thereafter resisted any overtures made by the fairer sex. In some cases, such as in that of one hopeful actress, this proved blunt to the point of rudeness. At the end of her performance she let herself fall dramatically into the conservatory lake in the hope of a royal salvation. Ludwig had the soaking wet Valkyrie unceremoniously dragged out of the water by one of his lackeys. Ludwig's relationship to some of his servants, stable boys or riders was, on the other hand, often the subject of malicious gossip. His legendary journey to Switzerland with actor Josef Kainz, for example, was one cause of controversy. In the original photo of the two Kainz has his hand on the king's shoulders; later reproductions were retouched. By the time the photo was taken, however, Kainz was probably out of favour. He had dared to fall asleep on one of the boat journeys he had undertaken with his friend. On his awakening, Kainz feared the worst for showing disrespect. The king's only rather dry reply was: "You snored".

The one person who remained true to him even in death was Empress Elisabeth of Austria. He exchanged melancholy poems with her on the Roseninsel and in 1886 she was still swearing like a trooper at the prince regent whom she blamed for the tragedy. In his final years Ludwig had only his loyal hairdresser for company – and many friends and fans all over the world in whose hearts the fairytale king lives on even to this very day.

48

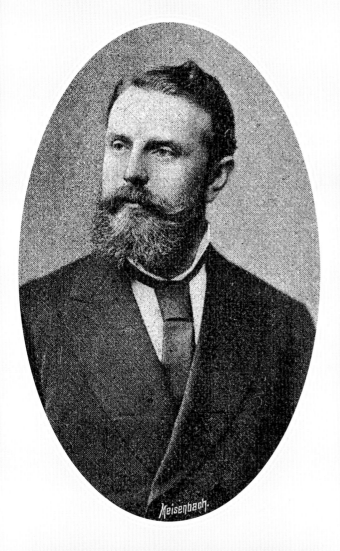

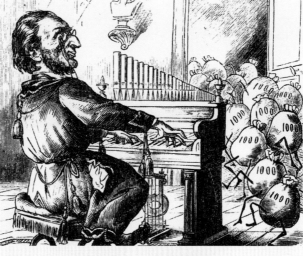

Far left:
The master of the king's horse, Richard Hornig, was for many years Ludwig's constant companion and private secretary. He was sent to Capri no less than twice to find the right shade of blue for the Venus Grotto at Linderhof.

Left:
On December 10 1865 this caricature entitled "A new Orpheus" was published in the "Münchener Punsch". It shows Richard Wagner playing for dancing sacks of money.

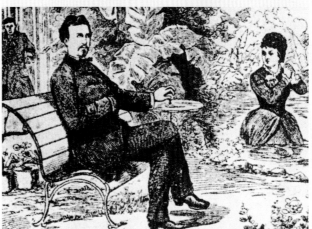

Left:
Soprano Josefine Scheffzky bewitched the king with her voice but not her figure. One of the lucky few to be invited to perform for the king at the residential palace in Munich, she tried to take advantage of the situation. Her clumsy overtures were ignored, however; on 'accidentally' falling into the conservatory's artificial lake the king merely summoned one of his servants to unceremoniously haul her out.

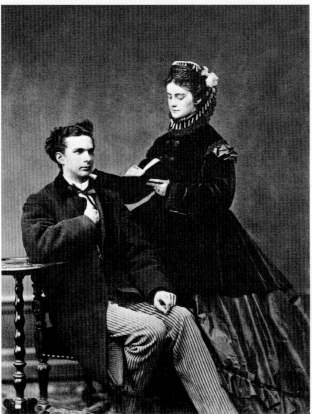

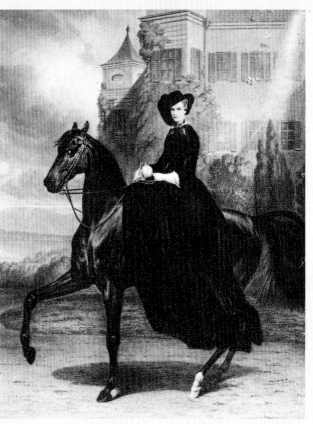

Far left:
This photo from 1867 was taken by royal photographer Joseph Albert, in which the king's fiancé, Duchess Sophie of Bavaria, is shown reading to her future husband. The only bond between them was the music of Wagner which they both loved – a bond which proved not strong enough as no wedding was to follow the engagement.

Left:
Sissi, later Empress Elisabeth of Austria, portrayed on her horse by August Fleischmann in Possenhofen in 1853. Elisabeth was Ludwig's cousin and confidante. Their friendship was marred when Ludwig broke off his engagement to her sister Sophie but Sissi forgave him and never came to terms with his death.

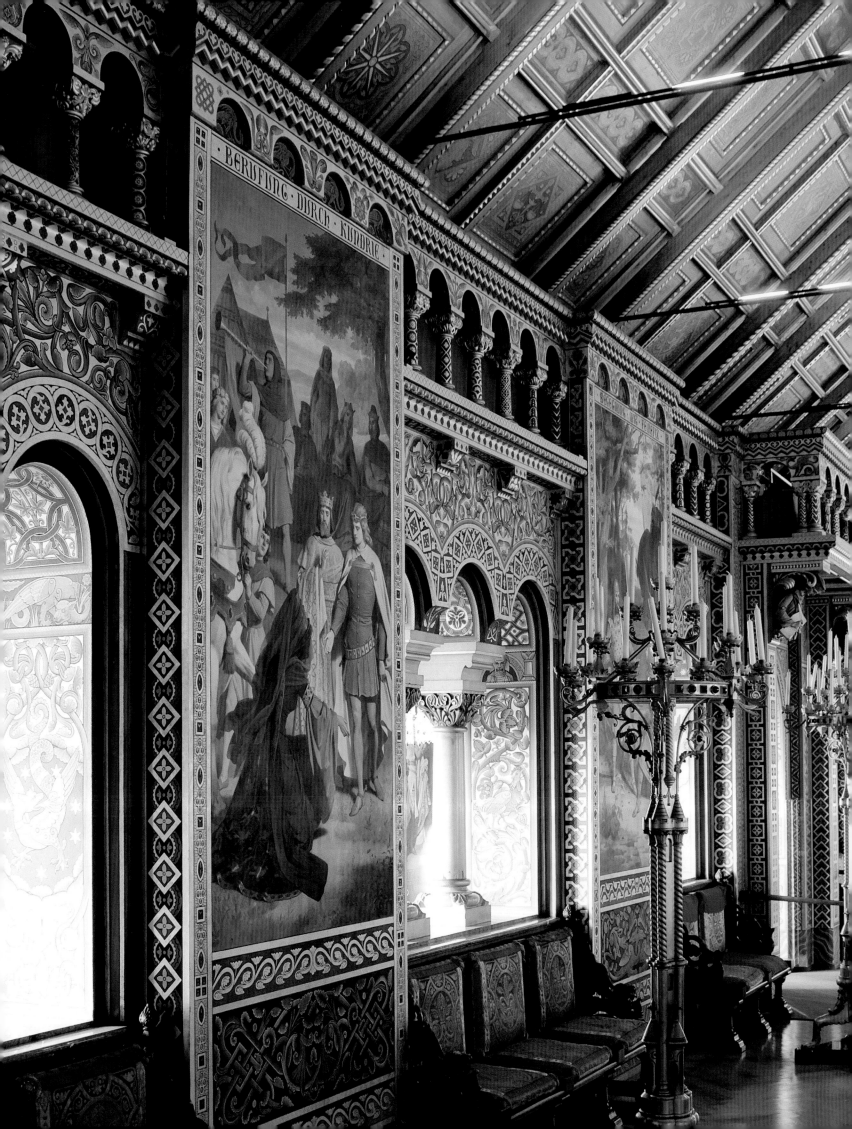

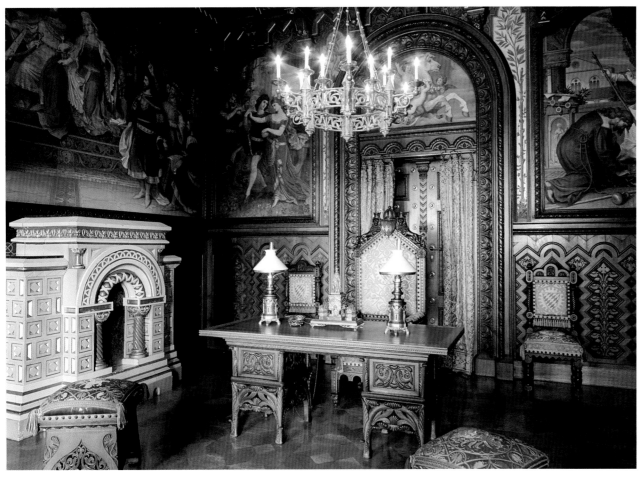

Left page:
Swirling patterns, miniature pillars with richly decorated capitals and huge murals between the windows adorn the long side of the Singers' Hall in Neuschwanstein. This painting shows Parsifal being made king of the Holy Grail by Kundry.

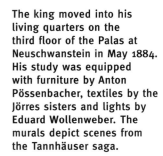

The king moved into his living quarters on the third floor of the Palas at Neuschwanstein in May 1884. His study was equipped with furniture by Anton Pössenbacher, textiles by the Jörres sisters and lights by Eduard Wollenweber. The murals depict scenes from the Tannhäuser saga.

Standard lamps lit with candles create an ethereal glow in the Singers' Hall of Neuschwanstein. The murals illustrate romantic and heroic scenes such as the wedding of Parsifal and Condwiramurs and Parsifal's battle with the Red Knight.

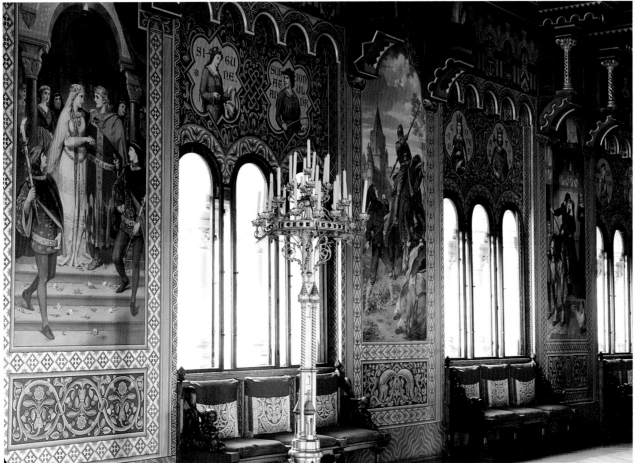

Page 52/53:
In the Salon or living room of Schloss Neuschwanstein is the Swan Alcove where King Ludwig II liked to read. The large mural by Wilhelm Hauschild shows the miracle of the Grail and Lohengrin's selection by the Holy Grail.

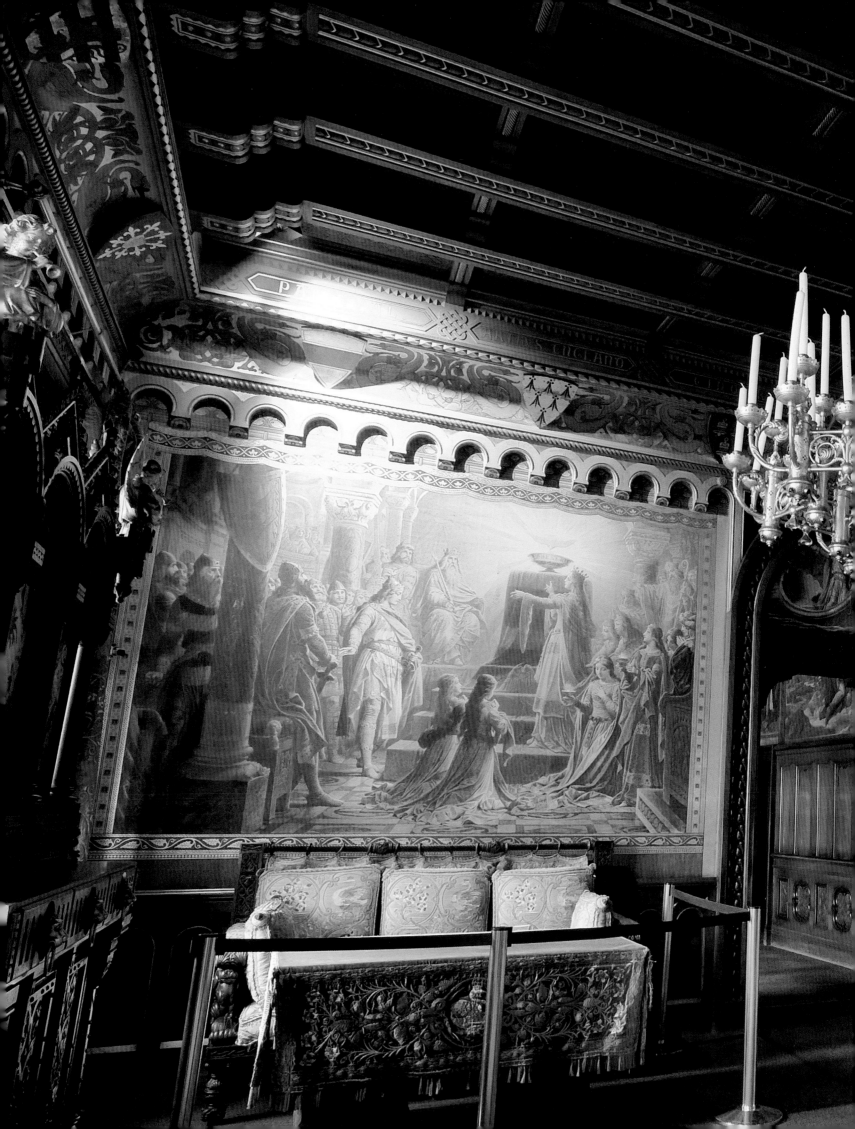

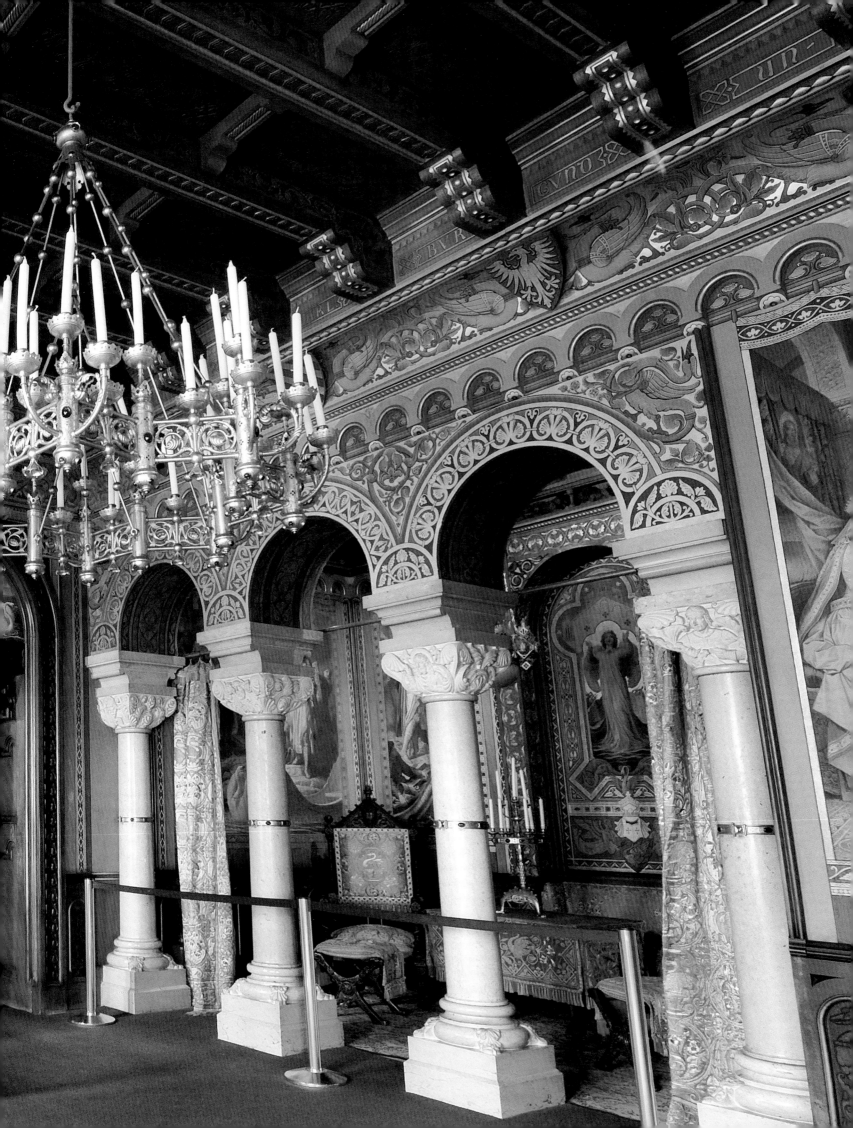

Right page:
The baldachin in the bedroom of Neuschwanstein is an orgy of mock Gothic carving, its design highly ornate and beautifully intricate. The king had a washbasin with hot and cold running water installed in his bed chamber – not surprisingly in the shape of a swan. Next to the bedroom is his small private chapel.

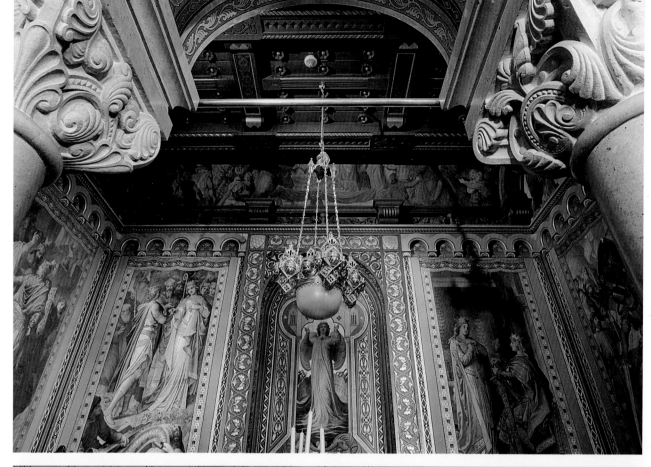

Decoratively sculpted capitals top the pillars which separate off the Swan Alcove from the rest of Ludwig's Salon. They portray the basic values of the German medieval world. The murals are also dedicated to the Lohengrin saga.

The bedroom is the only neo-Gothic room in Schloss Neuschwanstein, clearly manifested in the pinnacles of the furniture and wall panelling. In retrospect the expressive depiction of Tristan on his sick bed seems almost like a premonition; it was in this room that Ludwig II was handed his 'death warrant', the psychological report which heralded his deposition as king.

Page 56/57:
From the air there are grand views of the proud and mighty Schloss Neuschwanstein and of the glittering Alpsee and Schwansee, their setting both remote and spectacular. Between the two lakes Schloss Hohenschwangau clings to its mountain ridge. The River Lech running between the castles and the town of Füssen forms the 'linguistic boundary' between the ancient parts of Bavaria and Bavarian Swabia.

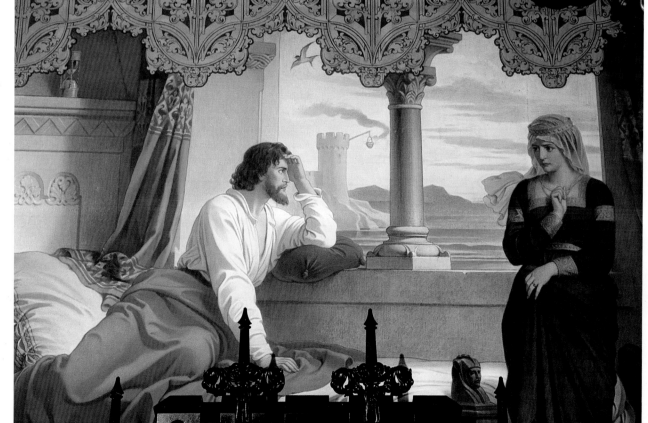

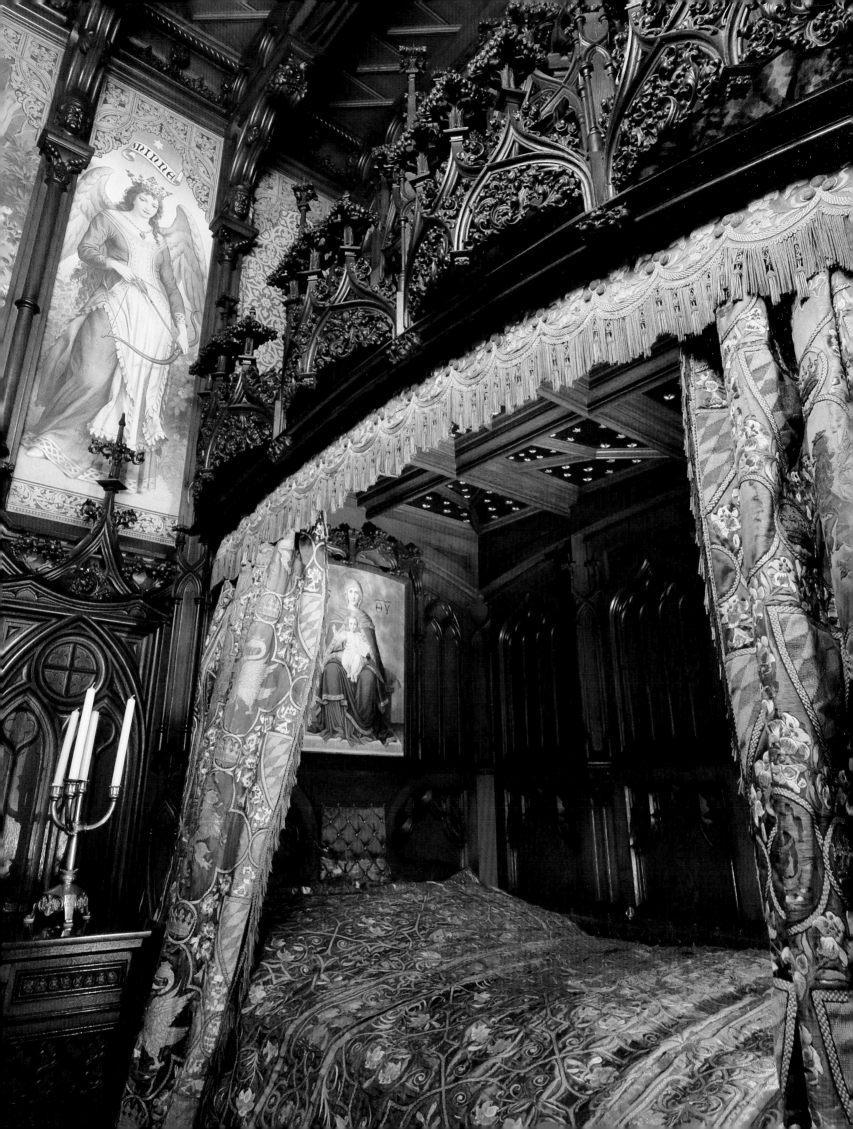

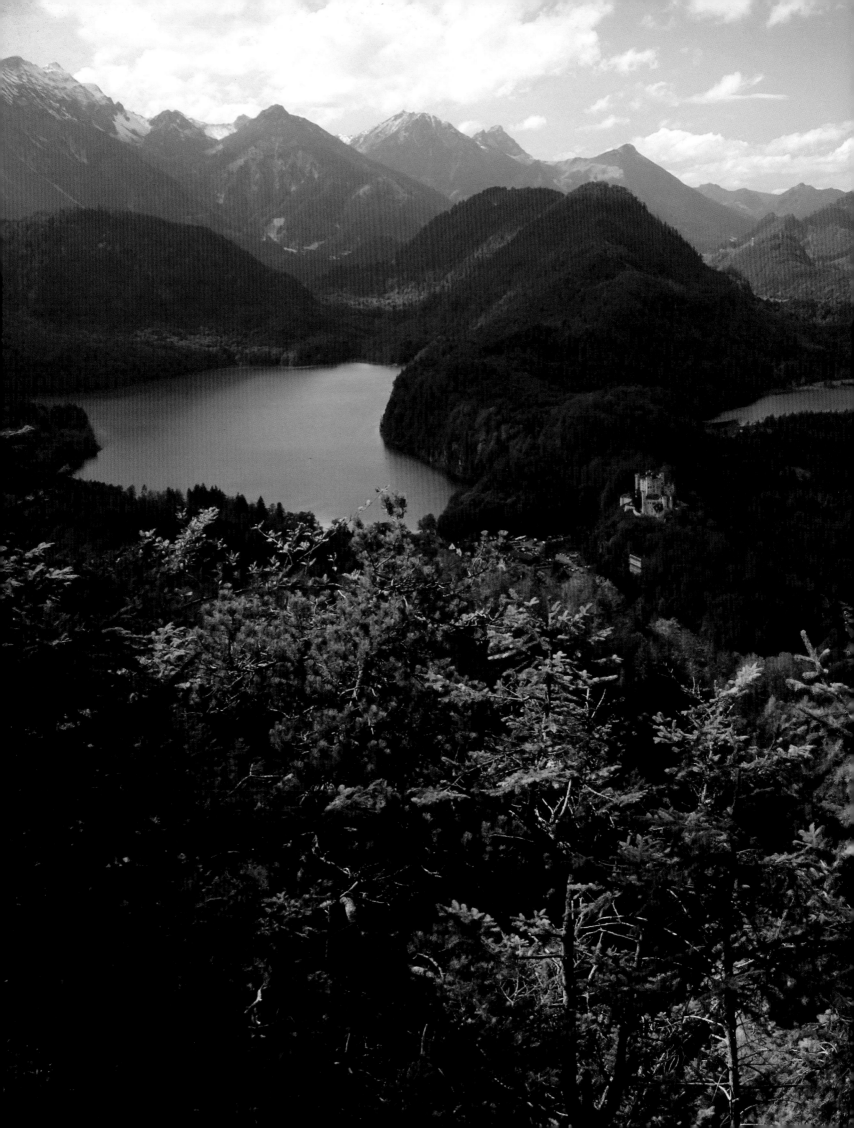

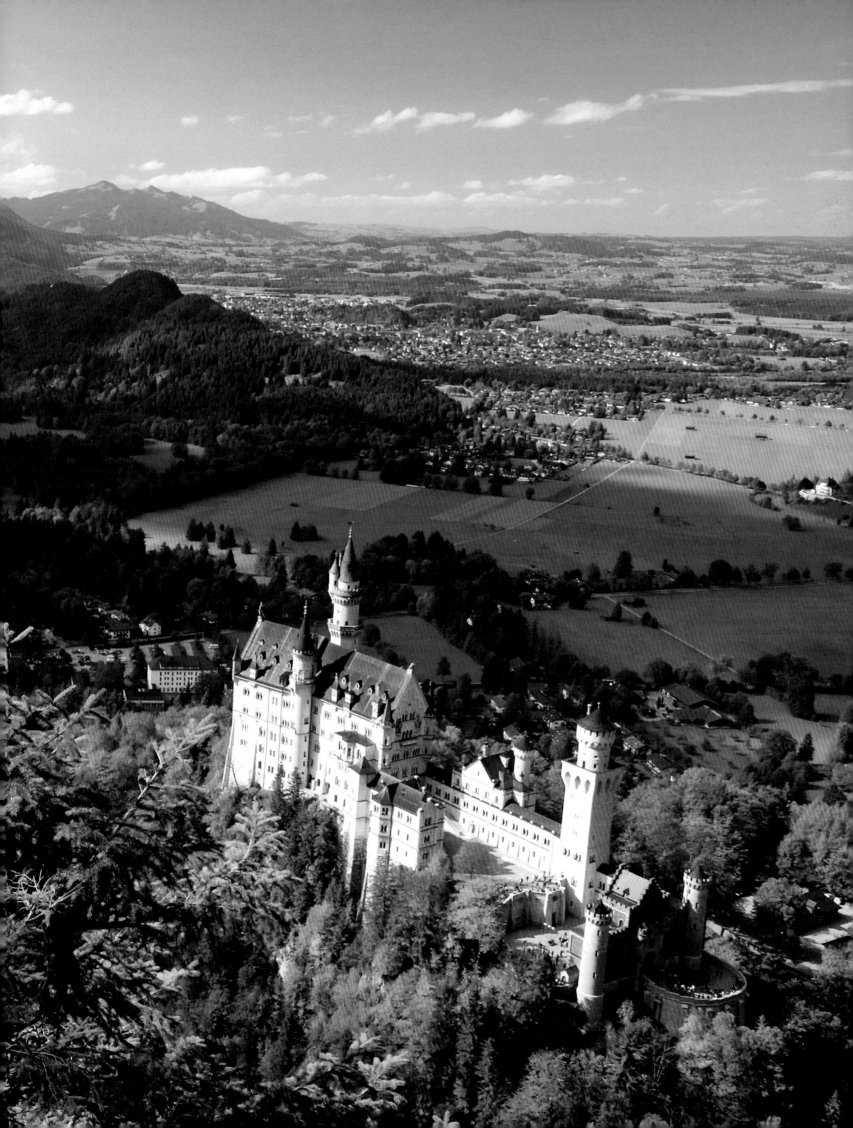

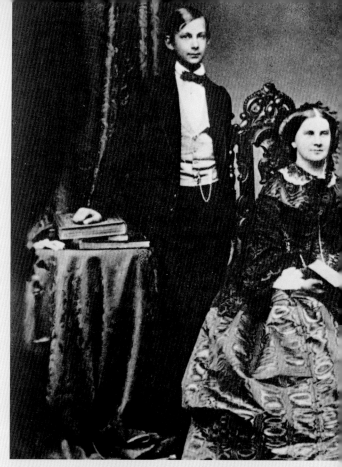

A BAVARIAN PRUSSIAN MADE KING – LUDWIG II'S YOUTH AND CHILDHOOD

Center:
In 1860 the royal family was photographed in 'civilian' clothes by court photographer Joseph Albert. At the age of fifteen Crown Prince Ludwig was almost as tall as his father, King Maximilian II. Queen Marie was the proud mother of Ludwig and Otto.

On August 25, 1845, 101 canon shots announced the good news: the crown prince had a son and heir! His parents Marie Friederike of Prussia and Maximilian were naturally happy and proud – but the most joyous of all was King Ludwig I. His grandson and possible successor had been born on his birthday and name day! He thus persuaded the boy's dewy-eyed parents that their brand-new offspring should be given his grandpa's name. Ludwig of Bavaria was born.

His father's successors can be traced back to a collateral line of the Wittelsbachs of Electoral Palatinate with the long title of Birkenfeld-Bischweiler-Rappoltstein-Zweibrücken. When the last in the male line of Bavarian Wittelsbachs died out in 1777 the Sulzbach branch of the family ruled for a good twenty years under Elector Karl Theodor. The Sulzbachs ceased to exist on Karl Theodor's death, enabling one Maximilian Joseph IV to make good his claim to the throne of the

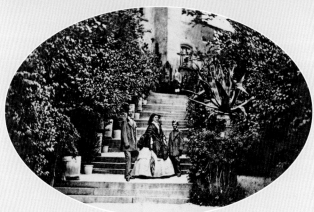

Right:
This photograph by Joseph Albert is also from 1860. As Ludwig is seated, the difference in age and size between himself and his brother Otto is not immediately apparent.

Right center:
This photo of the sixteen-year-old Ludwig seems to subtly capture his dreamy disposition. The picture was taken by Joseph Albert in 1861.

Far right:
Queen Marie with her sons Ludwig and Otto on the stairs of her favourite home, Hohenschwangau. Joseph Albert took this photo in 1860.

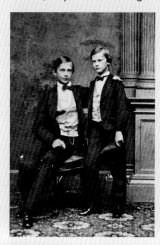

electorate of Bavaria in a line which had lands and estates strewn across the country. The otherwise little-known places show that this branch of the dynasty was akin to a micro-state. In 1806 Maximilian Joseph IV became Maximilian Joseph I, king of Bavaria by the grace of Napoleon – although strictly speaking the king of Bavaria was in fact from the Palatinate.

On his mother's side the Swan King was a Prussian through and through. Marie Friederike was Wilhelm I's niece; William I was later emperor by the grace of Bismarck. Ludwig didn't always share the opinion of his Prussian relatives and once referred to his mother in rather derogatory terms as a "Prussian princess". In his youth and childhood his parents often took him and his brother on hikes through the Bavarian Alps which greatly delighted his mother who was from the flat city of Berlin.

Ludwig's brother Otto was born in the turbulent year of 1848, the year in which King Ludwig I abdicated in favour of his son Maximilian II. Ludwig was made crown prince at the tender age of three. Even in his early years Ludwig had a clear grasp of his elevated position, engaging in serious play on the subject with his little brother. Otto happily joined in and the two became firm friends. In his first years in office young King Ludwig II thus always had his brother at his side when it came to representing the royal family.

Following an accident of the royal train in 1859 Ludwig's father is said to have ordered that a "modest speed" be kept to in future. Moderation is something the monarch believed in both on and off the rails, each royal decision being taken with great care and deliberation. Maximilian II had the castle ruin of Hohenschwangau rebuilt in keeping with the neo-Gothic trends of the 19th century; the sagas of days gone by which adorned the walls absolutely fascinated the young Ludwig. Even though the relationship between the royal parents and their sons is often described as distant, when Maximilian II died in 1864 he left a deep wound which Ludwig found hard to heal. At just 19 he was made king of Bavaria. This tall, handsome young man was suddenly thrust into a role many a stronger and older man would have had problems mastering.

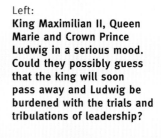

Left:
King Maximilian II, Queen Marie and Crown Prince Ludwig in a serious mood. Could they possibly guess that the king will soon pass away and Ludwig be burdened with the trials and tribulations of leadership?

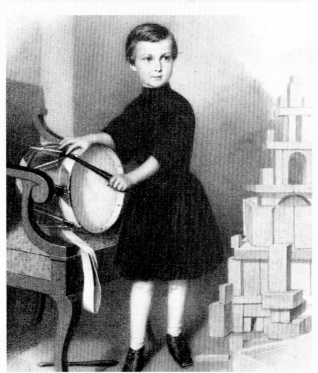

Left:
In 1850 Ernst Friedrich August Rietschel portrayed five-year-old Ludwig with a drum. As his grandfather, King Ludwig I, had abdicated just two years before, Ludwig was now crown prince – and his grandfather was delighted to note that his grandson had inherited not only his name but also his passion for building.

Far left:
Tours of the Alps were one of the royal family's favourite hobbies. Here, the royal princes Ludwig and Otto are shown in their hiking gear, photographed by Joseph Albert in 1858/1859.

Far left:
One of the famous works of portrait and genre painter Erich Correns (1821–1877) is this lithography from 1850: the royal family in Hohenschwangau. In keeping with the fashions of the day five-year-old Ludwig is wearing a dress.

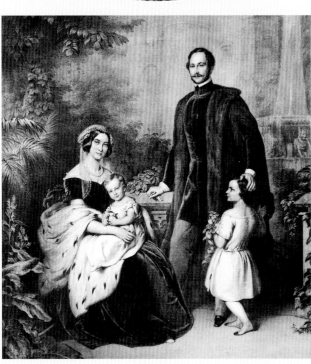

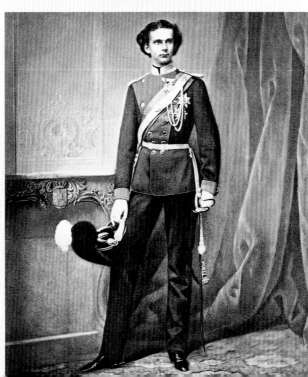

Left:
Ludwig was born on August 25, 1845, in Schloss Nymphenburg near Munich, the son of Crown Prince Maximilian and Prussian Princess Marie. On the abdication of his grandfather, King Ludwig I, his father succeeded to the throne in 1848 and Ludwig became crown prince. King Maximilian II died in 1864, making Ludwig king of Bavaria at just nineteen.

59

If it's unspoilt scenery and peace and quiet you're after, the area near the two royal castles of Hohenschwangau and Neuschwanstein is a good place to start. The Alpsee and Schwansee are great for swimming in and together with the Faulenbacher Tal form a nature reserve. During the 19th century the 'park' around the Schwansee belonged to Schloss Hohenschwangau. On the death of Carl August Sckell famous Prussian landscape gardener and designer Peter Joseph Lenné took on the park layout. The old castle grounds are now rather overgrown which makes them all the more idyllic.

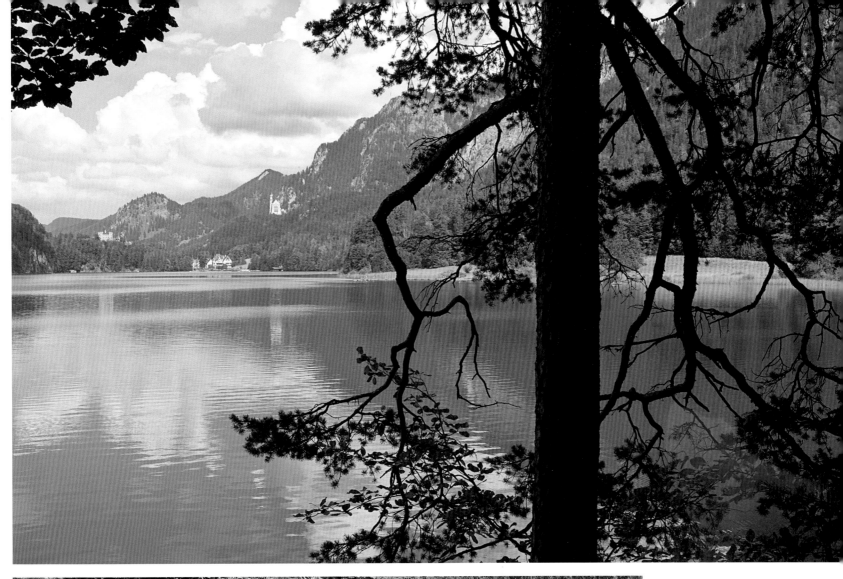

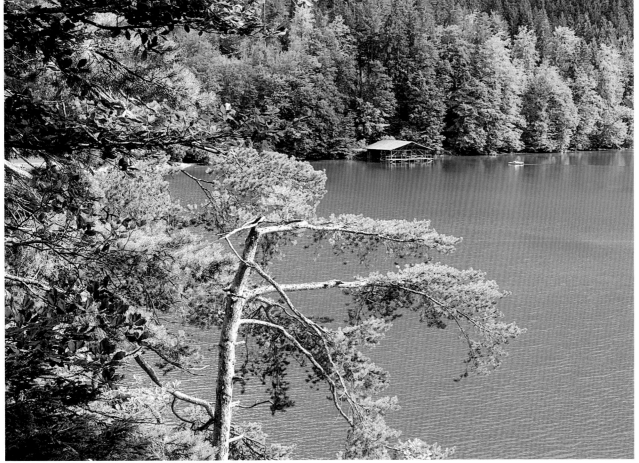

Page 62/63:
In winter Schloss Neuschwanstein seems to blend in with its snowy surround. This is also when the flood of tourists ebbs somewhat and the queues become shorter. A visit to the castle in winter is just as rewarding as at other times of the year.

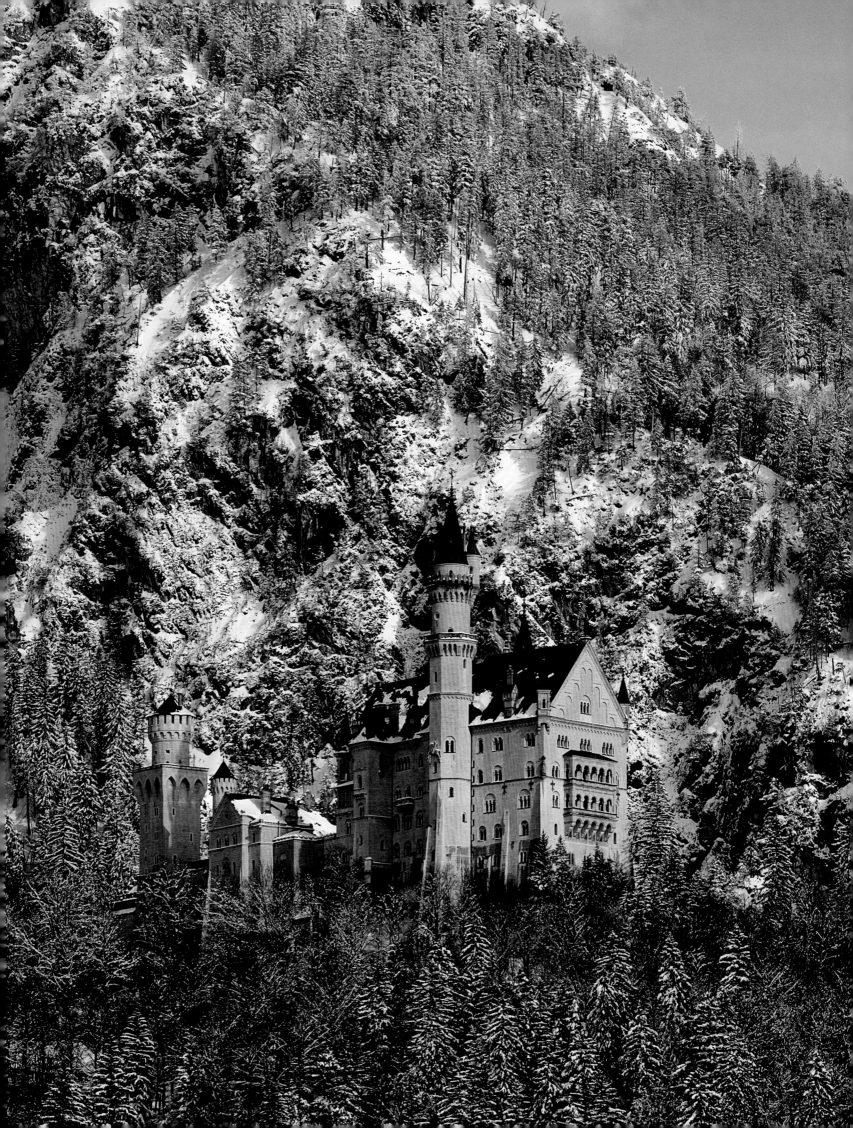

A ROYAL VILLA – SCHLOSS LINDERHOF

From the terraced gardens Schloss Linderhof looks a bit like a doll's house. From here you can marvel at how well the park has been meticulously planned so that it perfectly harmonises with the unspoilt scenery and surrounding forest.

The smallest of Ludwig's castles is also the only 'Bavarian' one and the only Ludwigian stately home to be finished. Versailles and its Trianon acted as models, as did the Kaiservilla in Bad Ischl, Queen Olga of Württemberg's Villa Berg and the "English village" in Hohenheim.

The palace was planned by architect Georg Dollmann from 1868 onwards; the suitably grand setting was provided not only by the surrounding mountains but also by Carl von Effner's magnificent gardens. Set designer Christian Jank also worked on Linderhof; it was, however, the king himself who created the most theatrical scenes when at night he ventured out into the Alps on his illuminated Rococo sleigh.

Whereas the Hundinghütte (Hunding's Hut) and Einsiedelei des Gurnemanz (Gurnemanz Hermitage) were initially a few kilometres away in the heart of the forest, the Venus Grotto has remained on its original site. It was lit by the first electric power station in Bavaria and the stable boy had to travel to Capri several times to find the right shade of blue for the grotto. Purchases made at the World Exposition in Paris added the Moroccan House and Moorish Kiosk to the ensemble where we find what was missing in the royal villa: the fairytale Peacock Throne.

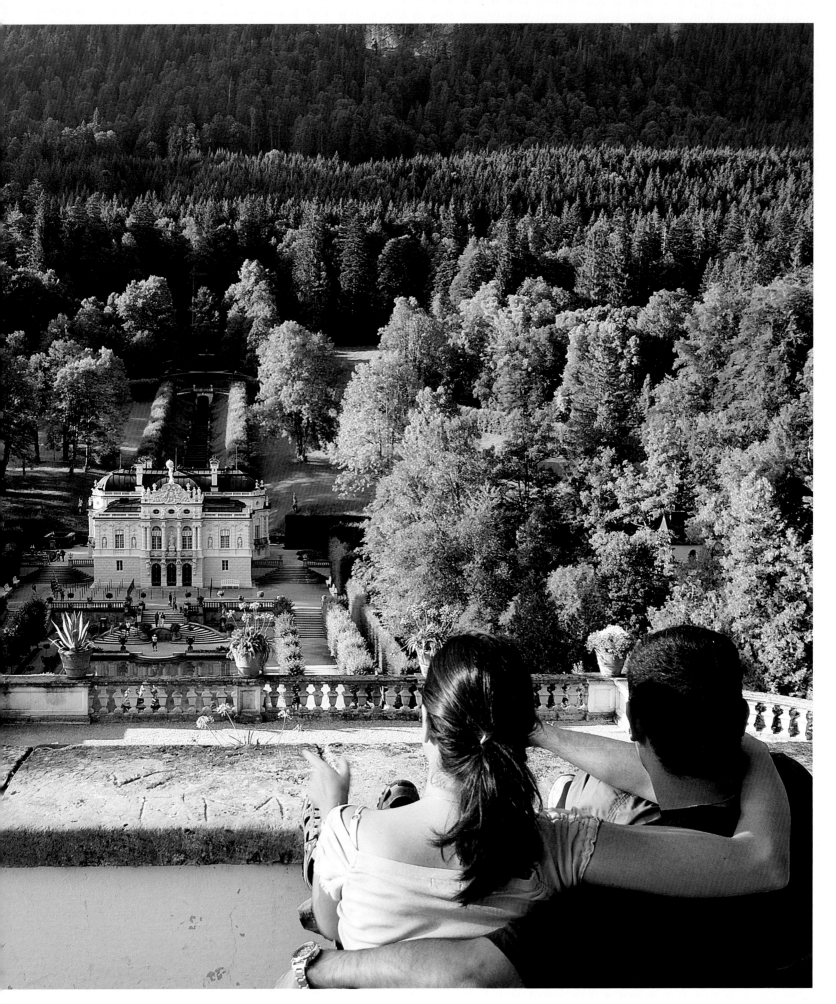

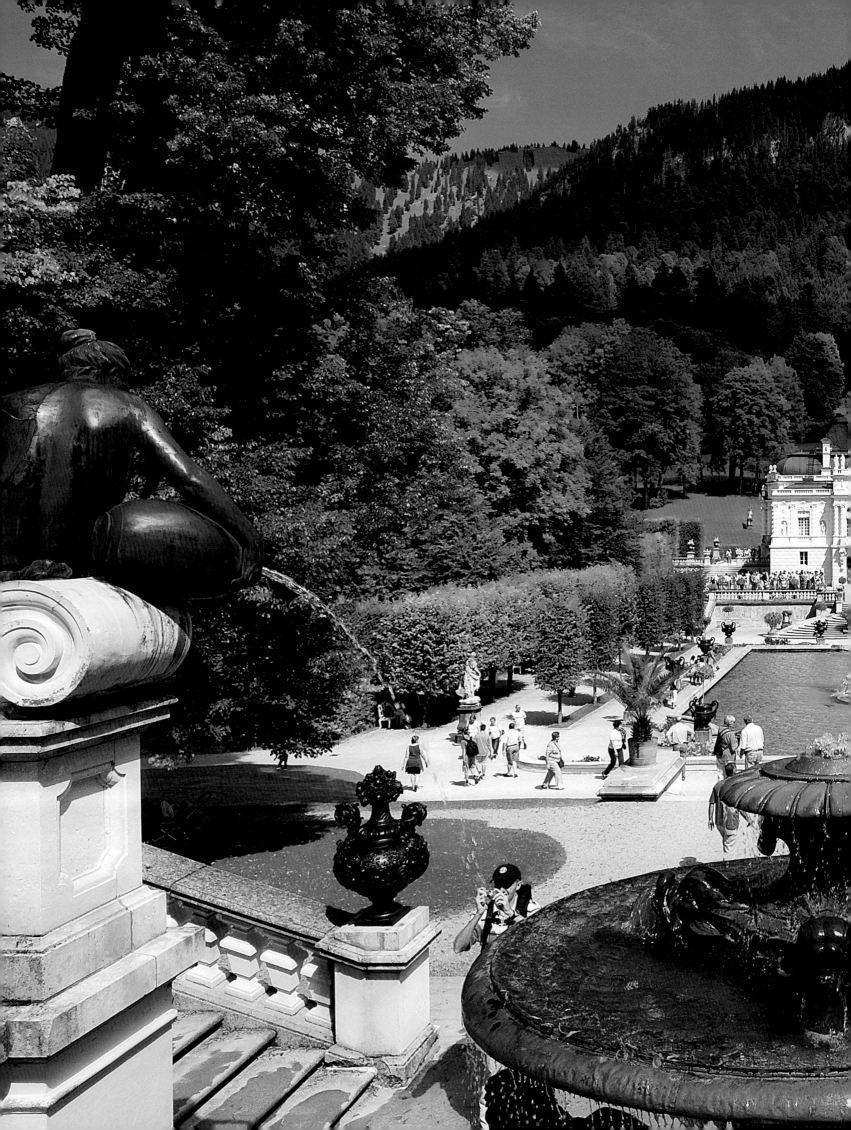

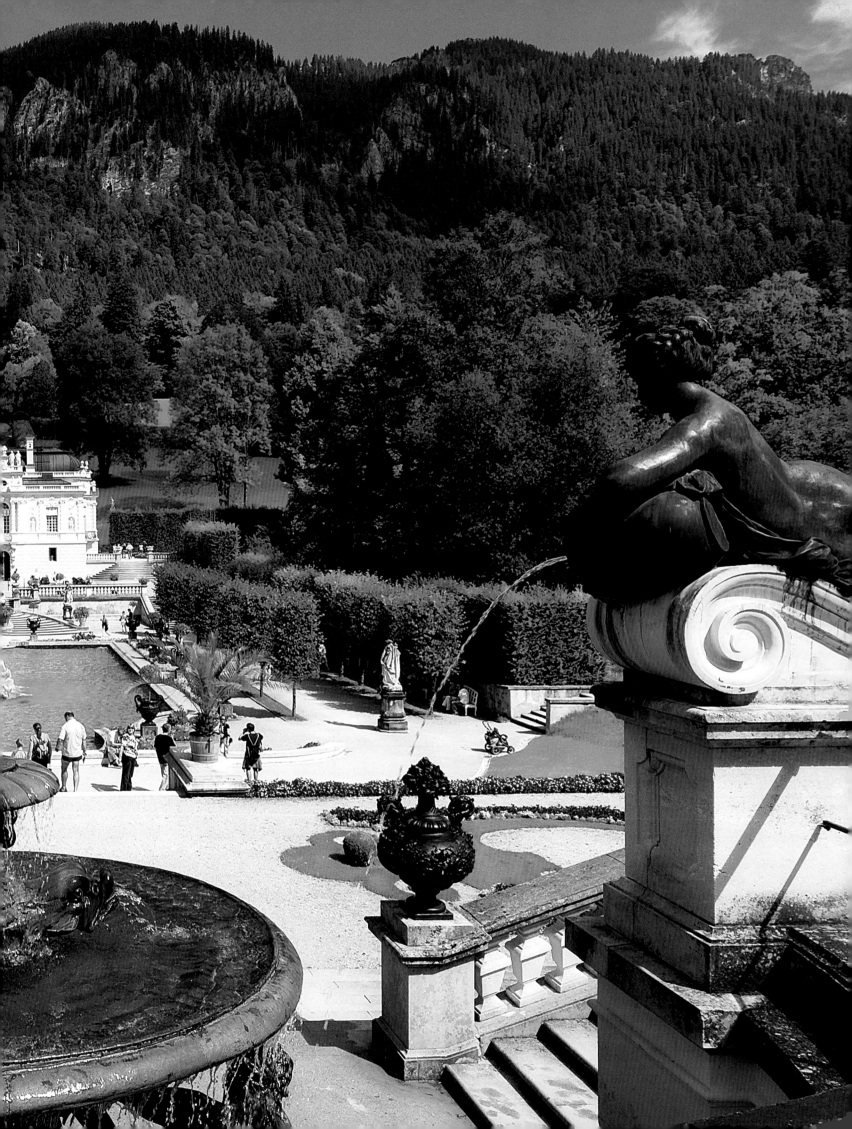

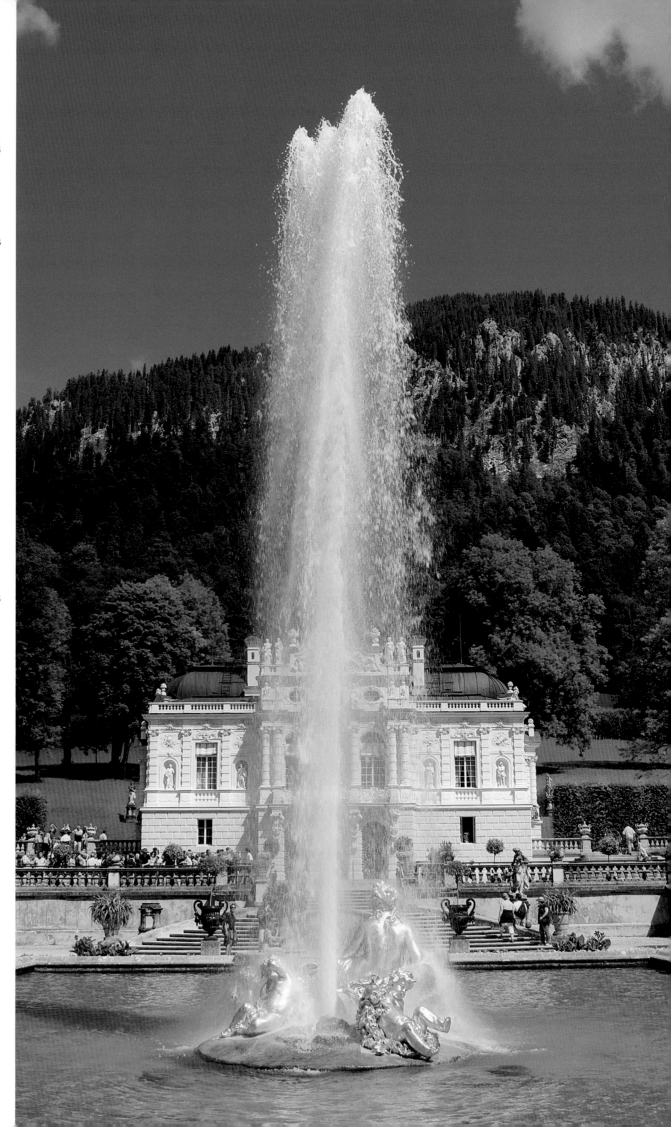

Page 66/67:
Schloss Linderhof can quite safely be called a royal villa, for compared to the generous proportions of the parterre it looks a bit like a summer house. The geometric arrangement of the steps, fountains and hedging sensitively complements the irregular curves and contours of the Bavarian Alps.

The fountains at Schloss Linderhof shoot 22 m (72 ft) up into the air. They operate on the pressure caused by the natural drop in the land. From this perspective the otherwise majestic mountains beyond seem small in comparison!

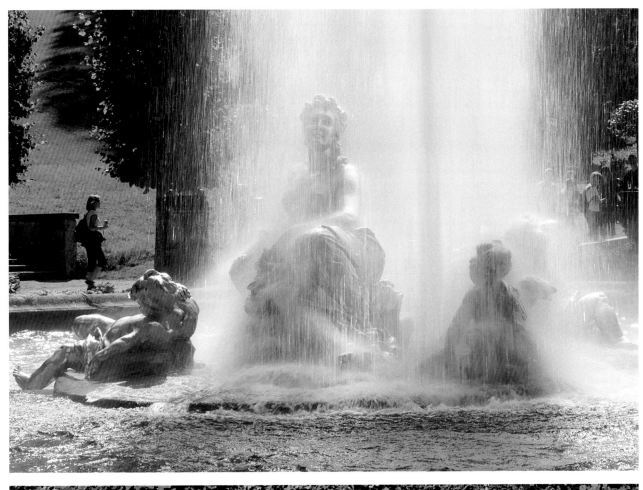

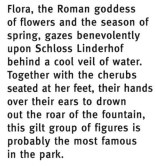

Flora, the Roman goddess of flowers and the season of spring, gazes benevolently upon Schloss Linderhof behind a cool veil of water. Together with the cherubs seated at her feet, their hands over their ears to drown out the roar of the fountain, this gilt group of figures is probably the most famous in the park.

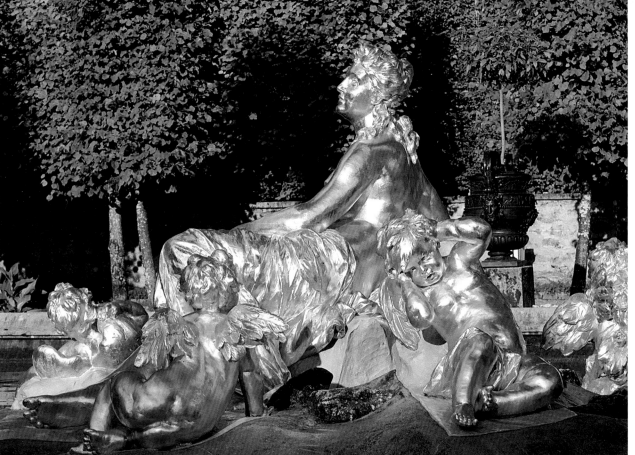

Page 70/71:
The colourful French baroque borders lined with hedges of box are paternally 'minded' by the enormous royal linden tree. Here the palace of Linderhof seems to play second fiddle to the horticultural display.

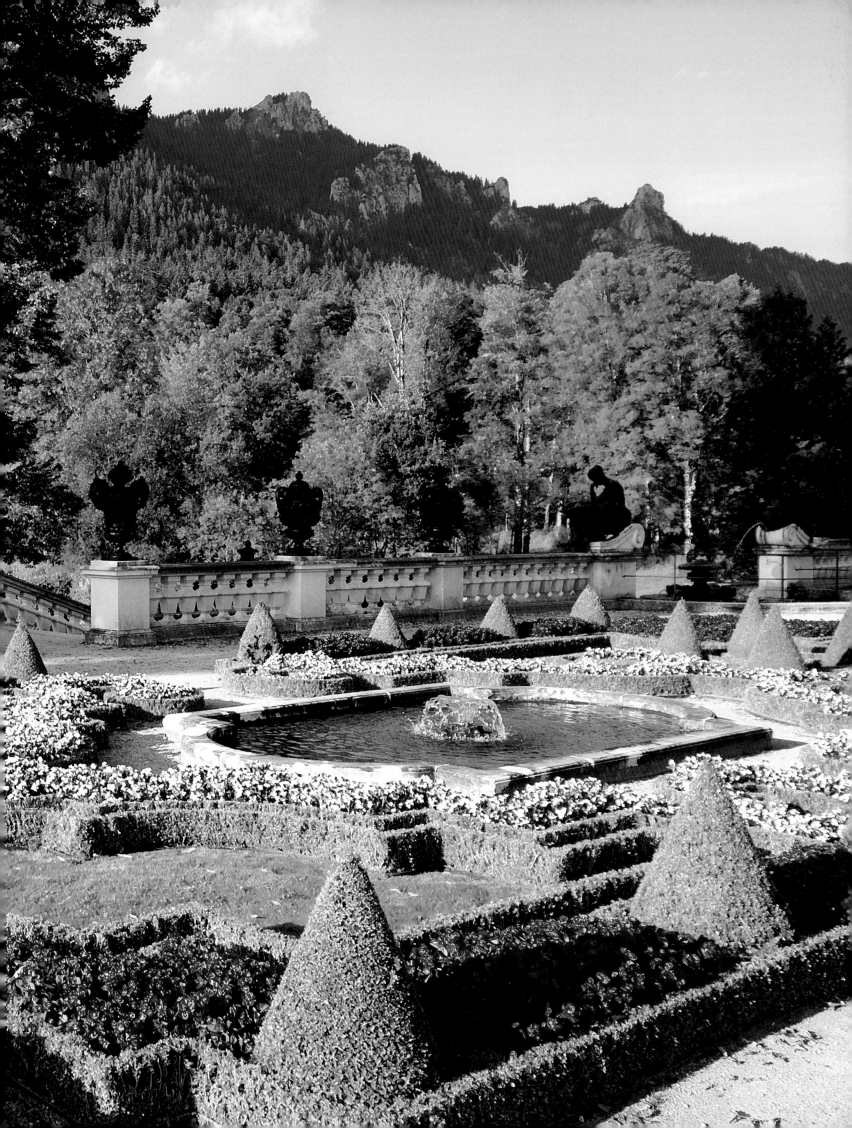

FROM ROYAL HUNTING LODGE TO MINIATURE VERSAILLES – SCHLOSS LINDERHOF

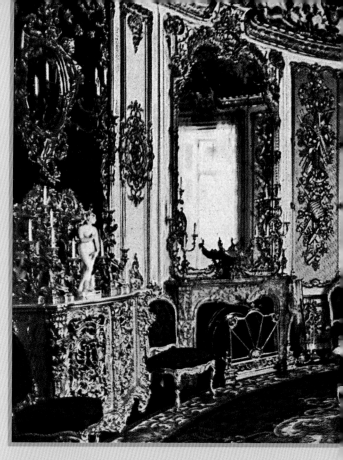

Center:
One of the most famous sights at Ludwig's castles is not immediately recognisable as such. The famous dining table or Tischlein-deck-dich has a recessed top where the royal feast could be placed out of sight and served when required, creating the illusion that the table was laid as if by magic...

The small palace in Linderhof King Ludwig II inherited from his father was perhaps the hunting lodge he loved the most. This may have something to do with the fact that the area had long belonged to Kloster Ettal, somewhere Ludwig had close ties with. The monastery was endowed by one of his most important Wittelsbach forefathers and the dynasty's first emperor: Ludwig of Bavaria. It wasn't only the history of the location but also its remoteness which provided Ludwig with a perfect place of retreat.

using the traditional post-and-beam method of building. This edifice was clad with boards and ornately decorated. The nearby hundred-year-old royal linden tree was carefully tended; Ludwig had himself a seat built under it where he once dined with one of his rare and extremely select visitors, actor Josef Kainz.

RETREAT AND ESCAPE

The king's retreat to the distant Graswangtal, a valley not far from the border to Tyrol, was seen as something of an affront, especially by Ludwig's bureaucratic ministers in Munich. Ludwig himself couldn't escape far enough. Linderhof was perfect; he could hold court in his royal apartment on the first floor above the servants' quarters. Just one thing was missing from his new headquarters: his throne. This was planned for a later date and to be installed where it was least expected to be found. Ludwig wished to have it placed in his very own Historicist setting, in his mixture of Versailles and Trianon. He created an edifice with flowing boundaries – not least those between the formal palace gardens and their magnificent mountainous surroundings.

This photo by Joseph Albert after a watercolour by Heinrich Breling (1849–1914) was reproduced as a collotype and published in a King Ludwig album by the Deutsche Verlagsanstalt. Ludwig had an outdoor seat set up under the ancient Linderhof linden tree where he once dined with one of his rare guests, actor Josef Kainz.

After much conversion and refurbishment the old wooden construction was turned into a splendid Rococo palace. The smallest and most intimate of Ludwig's castles is also the one he inhabited the longest. The extended Upper Bavarian farmhouse belonging to his father was later moved and the present royal palace erected, at first

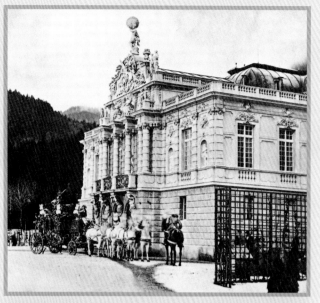

Left:
Here we can see one of the royal coaches in operation, the king having ordered it to be brought up to the palace at Linderhof. There obviously wasn't enough snow for a sleigh ride, although the king was the proud owner of a sledge which could be equipped with either wheels or runners depending on the weather. Royal photographer Joseph Albert took this shot in 1885.

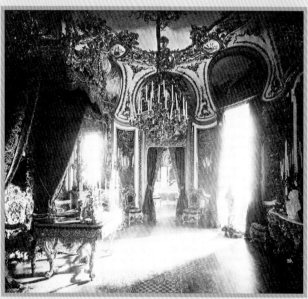

Left:
In 1886 this wide-angle photograph was taken by Joseph Albert in the Audience Room of Schloss Linderhof. As there were hardly any audiences held here, the room is also sometimes referred to as the king's study. Ludwig II probably felt safe here, busy at his papers protected by the baldachin above his desk...

Far left:
In 1874 work on the Linderbichl terracing at Schloss Linderhof was well under way, as this photo by Joseph Albert illustrates. The king was very receptive to the relatively modern technology of photography. He didn't only have the progress of his castles captured on candid camera; applications from actors also had to include a photograph, as Josef Kainz has demonstrated.

Left:
This photo by Joseph Albert dates back to 1886. It shows the East Tapestry Room at Schloss Linderhof. The royal villa in the Graswangtal was the only palace which was actually completed and which the king inhabited for any length of time.

Schloss Linderhof isn't a copy of Versailles; not only is the throne room lacking but the scale is too minute. Is it a new Trianon, like the one at Versailles? No; Ludwig's maisons de plaisances were erected elsewhere in the park and much further away in the depths of the forest. Unlike at Neuschwanstein, where the depiction of sagas is relegated to the flatness of the walls, the pleasure houses in the Linderhof gardens are three-dimensional stage sets which replicate Tannhäuser's Venus Grotto, the Valkyries' Hunding's Hut and the Gurnemanz Hermitage, taken from the third act of Wagner's opera Parsifal.

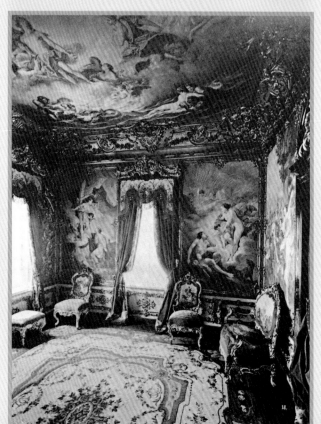

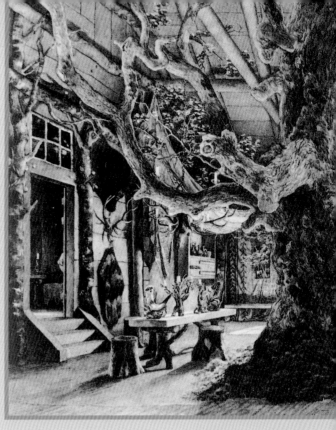

THE ORIENT MEETS THE BAVARIAN ALPS

This operatic setting which alienated the few contemporaries who were allowed to see it was where Ludwig thankfully sought respite from the duress of his official duties. It may have been here that he hatched his plans for more of his ambitious architectural projects. In 1876 he acquired the Moorish Kiosk and shortly afterwards, in 1878, the Moroccan House. He had both done out with the utmost flourish and it's here that we finally find what we've secretly been looking for all this time: his seat of power. The Peacock Throne is probably the most famous attraction in the whole of the Graswangtal and beyond. You don't have to have a particularly vivid imagination to envisage how here King Ludwig II dreamed his way to a new and better kingdom, far away from the pressures of everyday life in an illusionary theatrical scenario he himself created.

Ludwig had had a prototype built a few years previously which in its way is even more exotic. At first sight the Türkisches Zimmer or Turkish Room seems less spectacular yet its setting is remarkable. The Königshaus am Schachen is not in the Ammergau Alps but in the Wetterstein Range, that is, not in the foothills but right up in the high mountains, ca. 2,000 metres (6,500 feet) above sea level. Even further away from the machinations of civilisation it could be seen as a continuation of the buildings in the park at Linderhof – here taken to extremes.

FROM ANCIENT BYZANTIUM TO DISTANT CHINA

Ludwig's far-fetched ideas are more evident at Linderhof than at his other two castles. There were plans for an Arabic Pavilion, a baroque palace chapel, a theatre based on the Altes Residenztheater in Munich and a Hubertus Pavilion. Even in the year of his death Ludwig didn't give up, commissioning architect Julius Hofmann with two gigantic projects: a Byzantine Palace for the Graswangtal and a Chinese Palace on the lake of Plansee.

The question logically arises if the king wasn't more interested in the theory and design than the actual implementation. At Schloss Linderhof the many extensions, alterations, demolitions and refurbishments reached their peak – and also their end with the unexpected death of the king – in the rebuilding and decorating of the royal bed chamber. Ludwig was sadly unable to enjoy it; work was simplified and brought to a hurried conclusion in 1887, one year after his sudden demise.

A DREAM COME TRUE

In the Graswangtal King Ludwig II wanted to make his dream of a Versailles in the Bavarian Alps come true. No less than twelve consecutive planning stages had been implemented to this end. During the course of activities engineers discovered that there wasn't enough water, that the entire village would have had to have been bought and that it would have proved too expensive to re-route the road around the Alpine massif. Still the king refused to give up his dream.

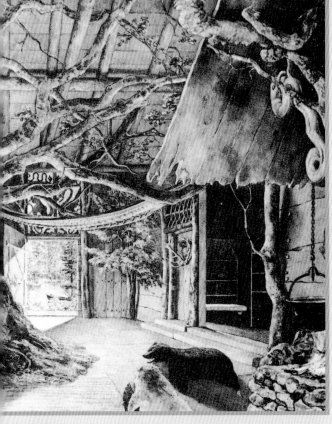

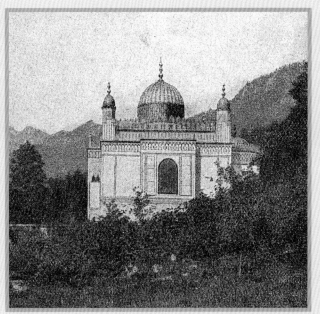

Left:
The Moorish Kiosk was built by Berlin architect Karl von Diebitsch for the Paris Exposition in 1867. King Ludwig II manage to procure the kiosk for his Linderhof park in 1876.

Bottom left:
The Gurnemanz Hermitage (historic photo) was originally not far from Hunding's Hut and was taken from the third act of Wagner's opera "Parsifal". Over the years it fell into disrepair and was reconstructed with the help of private sponsors in 2000. It now stands in the park at Linderhof.

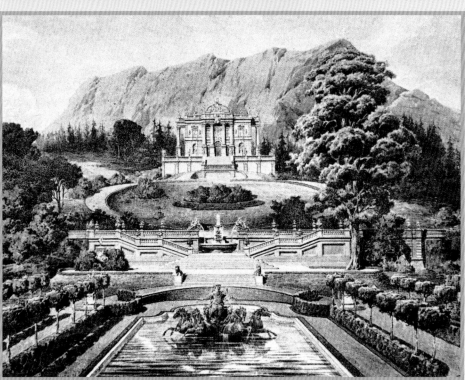

In a ceiling fresco executed by painter Eduar Schwoiser in the Spiegelsaal or Hall of Mirrors it appears for the first time: a palace on an island which depicts Herrenchiemsee in very simple terms. Ludwig's dream was thus to become reality, albeit at a very different place indeed.

Still today visitors to Linderhof can revel in the splendid isolation of this magical palace, the water from its fountains glittering against a truly breathtaking Alpine backdrop. The splendour of the Rococo interior provides an exciting contrast to the more rugged structures in the park and the Oriental pavilions. It is precisely Ludwig's artistically crafted stage sets which make the park at Linderhof the most historically significant of its kind.

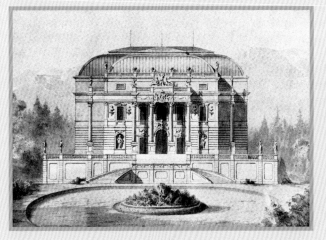

Left and above:
In 1875 Ludwig's architect Georg von Dollmann designed this theatre for Linderhof (left). Ludwig's court artist Ferdinand Knab executed this sketch (abowe) with the linden in the foreground. King Ludwig II failed to carry out the project, not because the design didn't appeal to him but because he felt that Carl Joseph von Effner's landscaped gardens were enough of a "backdrop" and that a "real" theatre would only spoil it.

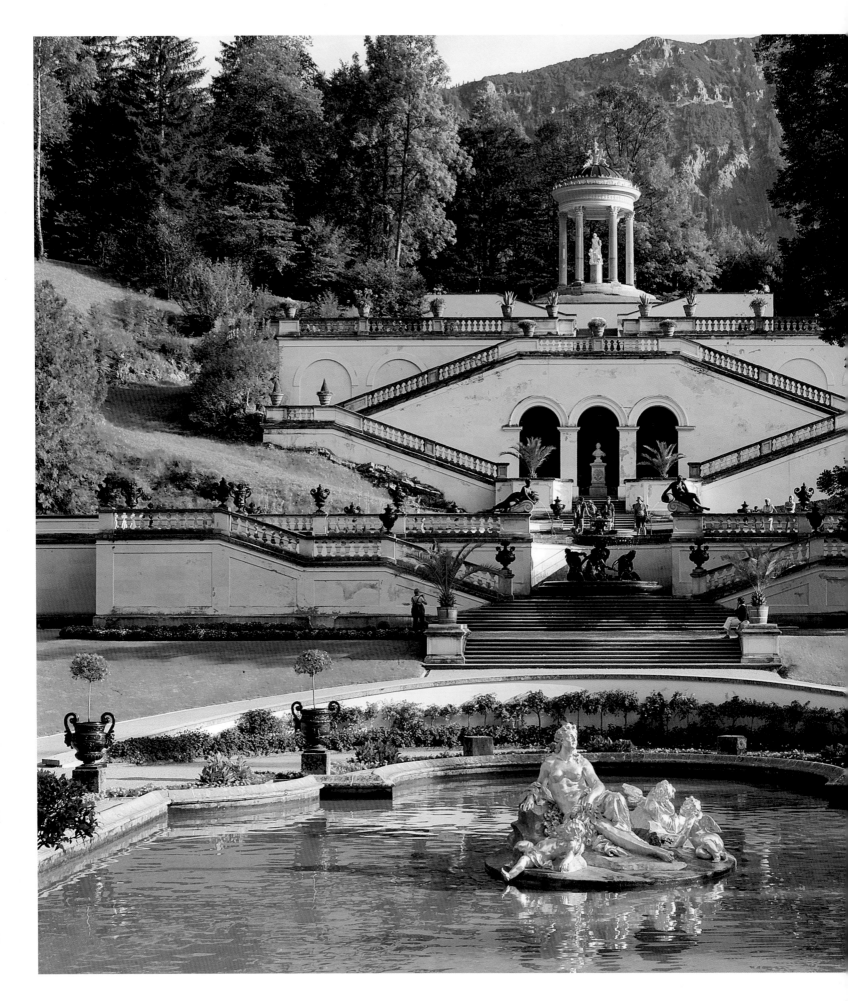

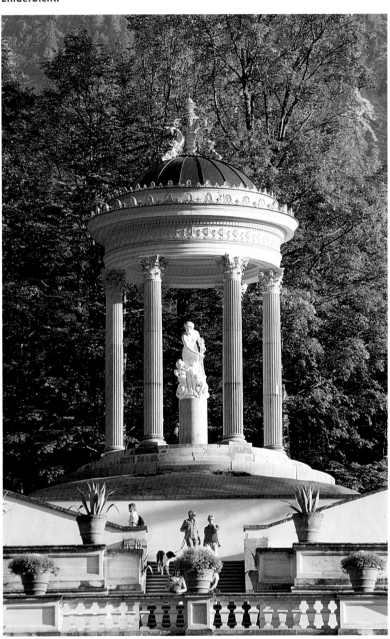

Left and below:
The strict axial symmetry of the steps leading up to the Temple of Venus is only interrupted by the royal linden tree. Down in the parterre fountains the Roman goddess Flora looks up to her colleague Venus, the goddess of love, up on the Linderbichl.

Page 78/79:
At the place where a theatre was once planned for Linderhof is now a round Greek temple featuring a large-than-life statue of Venus. She is flanked by two smaller amoretti or goddesses of love. The sixth (now the fifth) day of the week was named after Venus, as "Vendredi" in French, for example, demonstrates. The Germanic languages make reference to their goddess of amour, Freya, in "Freitag" or Friday.

In the middle of the Eastern Parterre in the palace gardens of Schloss Linderhof Venus and Adonis are surrounded by allegories of the four elements. The goddess of love is deep in conversation with her lover, the god of beauty, while a gilt Cupid fires arrows of love in the background.

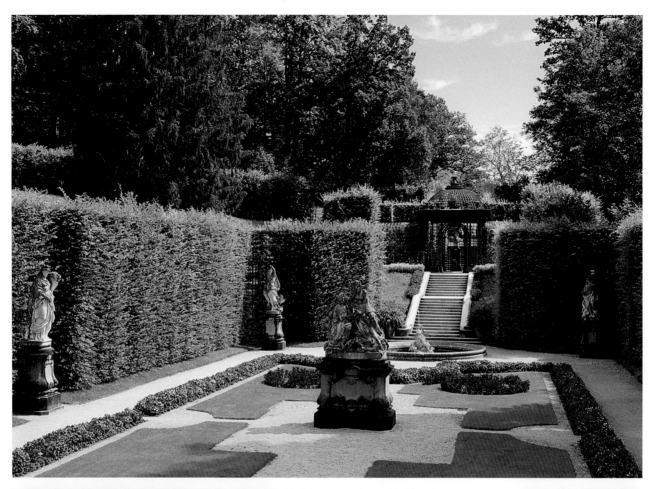

From this perspective we can only see Venus and Adonis, protected by a shady hornbeam hedge, with Cupid hidden behind them.

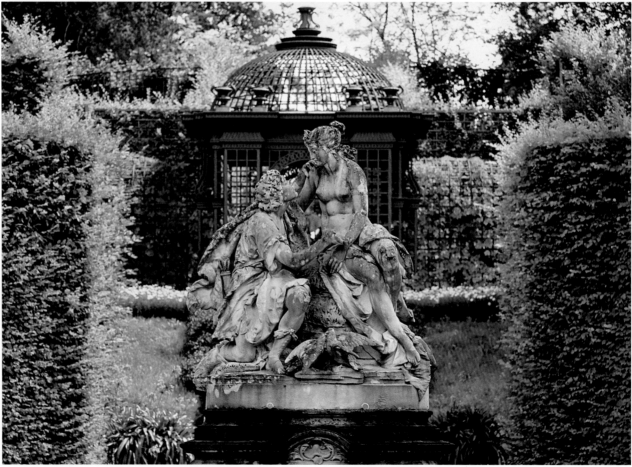

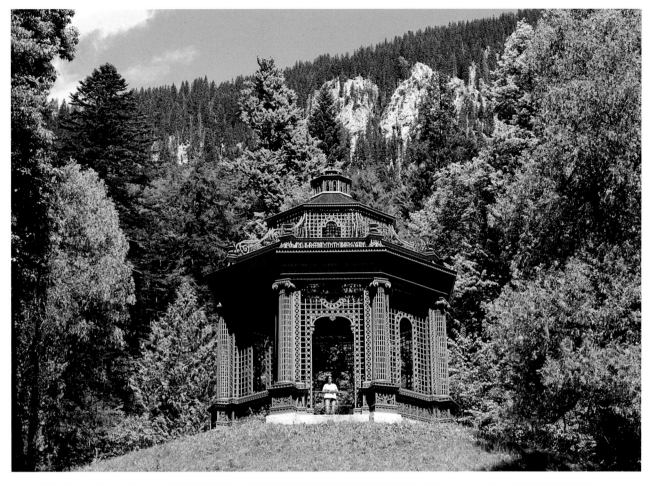

The Music Pavilion acts as a northern viewpoint with grand vistas of Schloss Linderhof, the gardens, the Temple of Venus and the mountain of Kuchelberg beyond.

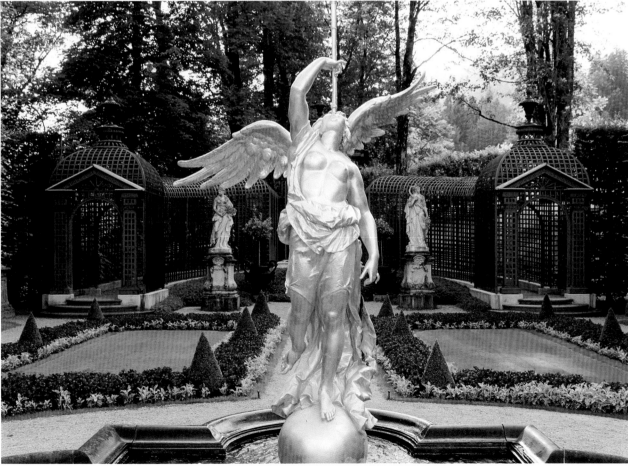

Fama, the goddess of fame and gossip in Roman mythology, trumpets truth and lies into the air, her wings serving to aid the rapid spread of tittle-tattle. Respite from her malicious fanfares can be sought under the pergolas behind her...

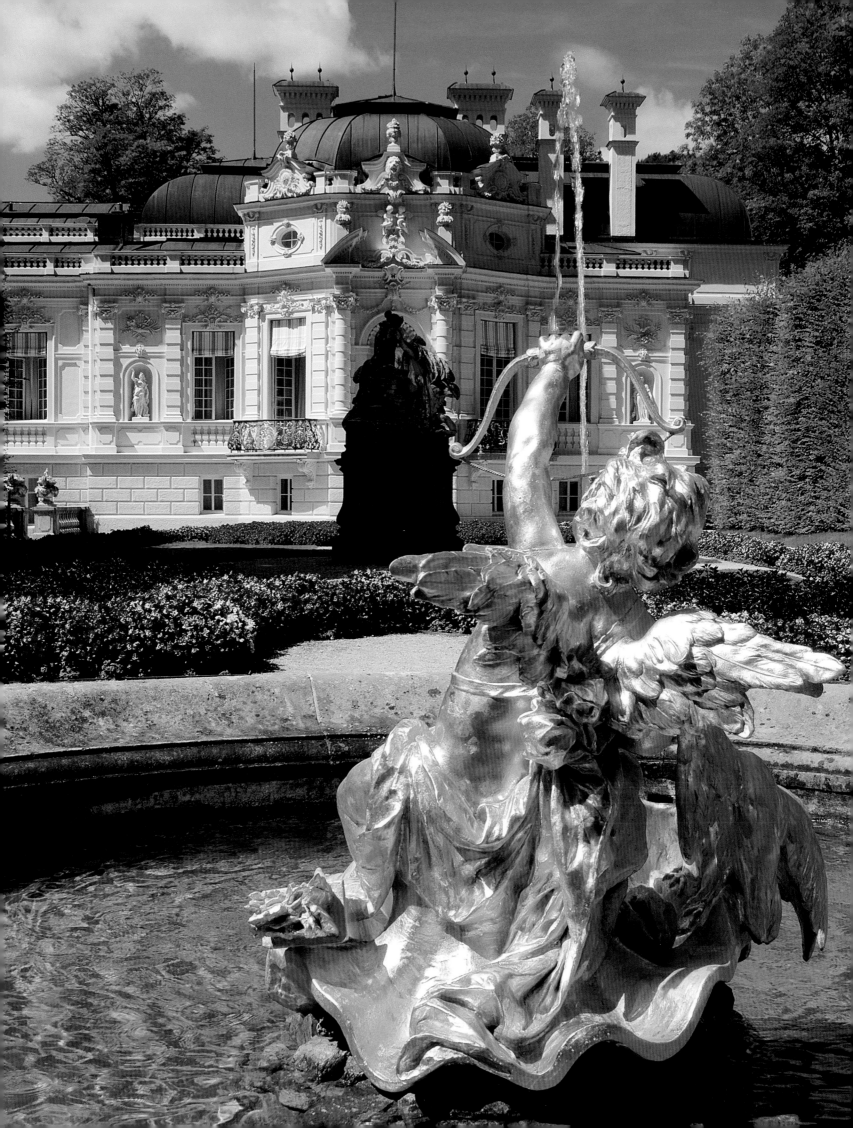

Left page:
Cupid aims his bow at the east facade of Schloss Linderhof. Behind it is the Dining Room where King Ludwig II could 'receive' Cupid's messages of love several times a day.

Seen from our modern perspective the Moorish Kiosk is one of two particularly exotic buildings in the park at Schloss Linderhof. In Ludwig's day and age, however, things Oriental were all the rage; the king's acquisition was thus nothing out of the ordinary in the late 19th century.

Hidden behind the trees, the main gable of Schloss Linderhof sports a statue of Atlas who, according to Greek mythology, was one of the Titans who battled with the gods. In punishment for his taking part in the fighting Zeus condemned him to carry the world on his shoulders for all time.

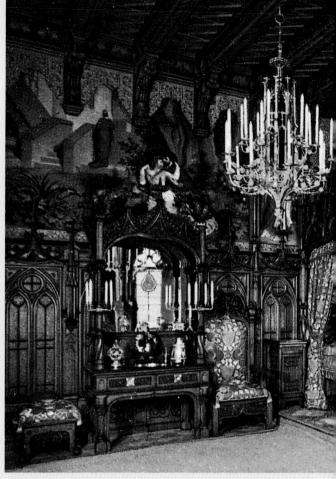

MY KINGDOM FOR A CASTLE – LUDWIG II AS AN ARCHITECT

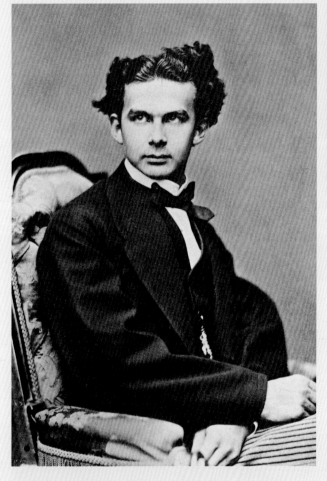

Center:

The bedroom is the only neo-Gothic room in the otherwise neo-Romanesque castle of Neuschwanstein. Modern building techniques, such as the iron pillar, were decoratively hidden. Here we can see the painting of Tristan's farewell.

Right:

Three years after his ascension to the throne in 1867 King Ludwig II seems to signal strength and determination in this portrait by court photographer Joseph Albert. By this time Richard Wagner, whom Ludwig loved for his music, had been forced to leave Munich at the end of 1865, the unpopular "war of brothers" between Prussia and Austria had been settled in 1866 and Ludwig II was free to devote his energies to his passion for building.

Ludwig II has bequeathed to us a fabulous array of fairy-tale castles which have to date remained unsurpassed. In Edgar Allan Poe's *The Masque of the Red Death*, published in 1842, the writer describes a prince with extraordinary taste, one who loves the effect of colour but hates cheap props, one whose unique and exotic intellect hatches out clever and powerful plans. Like in the case of Ludwig II, in Poe's tale there are people who think the prince mad and others who know this is not the case. The king of Bavaria was an admirer of Poe's yet it is unlikely that he based his life on the author's short story. In retrospect it's uncanny how perceptive Poe's words now seem in reference to the life and work of King Ludwig II.

His grandfather, himself not adverse to redesigning the odd castle or two, was delighted to note that as a child Ludwig was very good with his building bricks. Unlike Ludwig I, however, Ludwig II didn't interact with his personnel directly. If he didn't like something, which was often the case, he derided the work as "tasteless". This may be why he was once referred to as the "king of kitsch". Yet the term "taste"

as it was understood by the Historicists of the 19th century didn't necessarily mean a reduction in artistic quality but instead indicated the level of acceptance an item met with amongst a bourgeois clientele who had suddenly become *au fait* with art and architecture.

King Ludwig II knew the sagas of Richard Wagner off by heart. His library contained several thousand volumes, many of which supplied him with an encyclopaedic knowledge of the French kings Louis XIV, Louis XV and Louis XVI unmatched by any of his contemporaries. He thus became something of a pedantic, fussing over the tiniest details, prompting him to once complain that the hair on a figure of Venus was "too much like a cook's".

All of his castles are overtly ornate and beautifully mysterious, tinged with a wistful melancholy and strange surrealism. But one feature of all his various homes is decidedly lacking: a queen's bedroom. A royal female partner had no place in Ludwig's dream world. After Ludwig had failed to have his theatre in Munich approved in 1865, he lost interest in discussing the architectural requirements of the public. He set no great store by the current architectural theories of the day; in his view his own personal artistic visions were the only acceptable norm.

The artists themselves commissioned with carrying out Ludwig's requests were secondary. They were not employed to design individual and independent works of art which is the essence of creative activity. Ludwig II required that his craftsmen realise his ideas – and his alone – and in his prolific distribution of orders he helped many a workshop and manufacturer's in Munich and beyond to a success they could never have hoped for without his custom.

King Ludwig II built dream homes which were just that – houses for dreaming but not for practical living. His periods of residence were rare and brief; any prolonged sojourn would have destroyed the illusion in time. On our short visits today, however, we are able to fully revel in the magic of what this truly unusual mind has created.

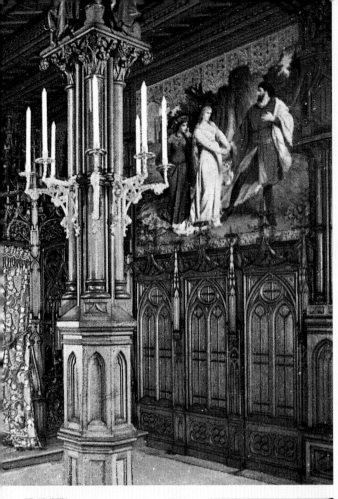

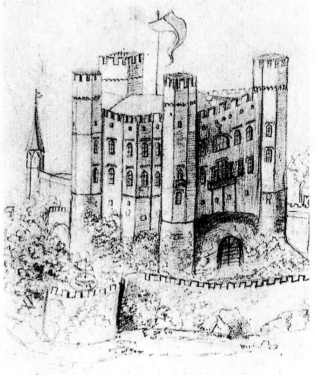

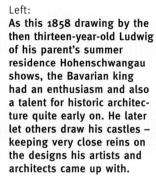

Left:
As this 1858 drawing by the then thirteen-year-old Ludwig of his parent's summer residence Hohenschwangau shows, the Bavarian king had an enthusiasm and also a talent for historic architecture quite early on. He later let others draw his castles – keeping very close reins on the designs his artists and architects came up with.

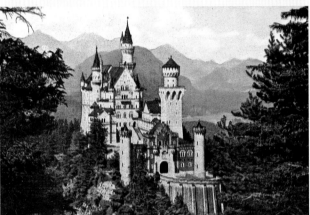

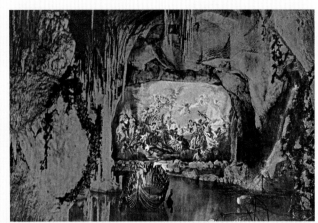

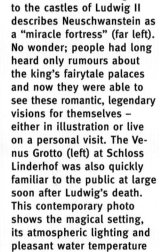

Left and far left:
One of the first travel guides to the castles of Ludwig II describes Neuschwanstein as a "miracle fortress" (far left). No wonder; people had long heard only rumours about the king's fairytale palaces and now they were able to see these romantic, legendary visions for themselves – either in illustration or live on a personal visit. The Venus Grotto (left) at Schloss Linderhof was also quickly familiar to the public at large soon after Ludwig's death. This contemporary photo shows the magical setting, its atmospheric lighting and pleasant water temperature powered by 24 then state-of-the-art dynamos.

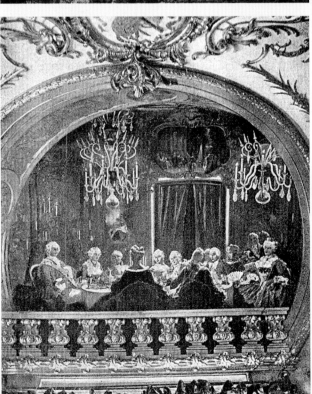

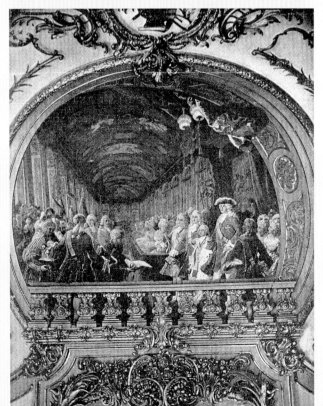

Left and far left:
The lunette painting in the study of Schloss Linderhof shows a dinner at Versailles (far left). The scene was executed by Joseph Watter who was also known for his humorous genre paintings. He also painted this scene above another door in the Linderhof study (left), in which King Louis XIV of France is shown receiving a Turkish delegation. Both Schloss Linderhof and his Bavarian Versailles on the Herreninsel are devoted to the French kings whom he absolutely revered and saw as his "rightful" predecessors.

85

Right page:
The Staircase at Schloss Linderhof is lit by a glass roof, an absolute novelty in its day and age. From the Vestibule below doors lead off to the servants' quarters which is why the entrance hall is rather small for a royal palace.

The Yellow Cabinet is a through room adjoining the Audience Room at Schloss Linderhof. The portrait shows the Duke of Belle-Isle (1684–1761), a successful general and marshal of France.

King Ludwig II of Bavaria also had his bedroom at Schloss Linderhof furnished with a state bed. He was never to see the room in its present state as the extension and redesign he ordered in June 1886 was incomplete by the time he died.

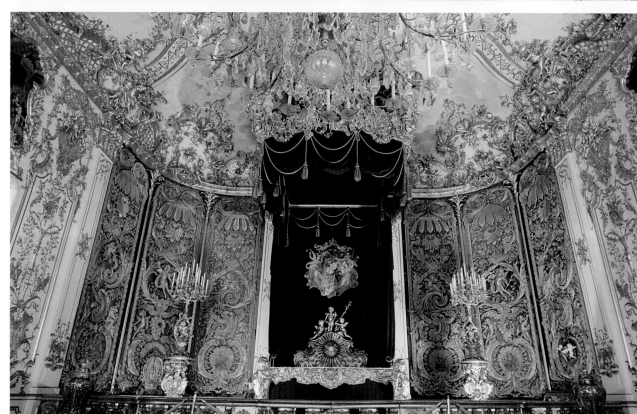

Page 88/89:
Even if there was no throne in the palace itself, the king was nevertheless reluctant to do without a baldachin over his desk in his Audience Room. As Ludwig saw Linderhof more as his private abode than as a place of royal representation and prestige no audiences were ever actually held here during his lifetime.

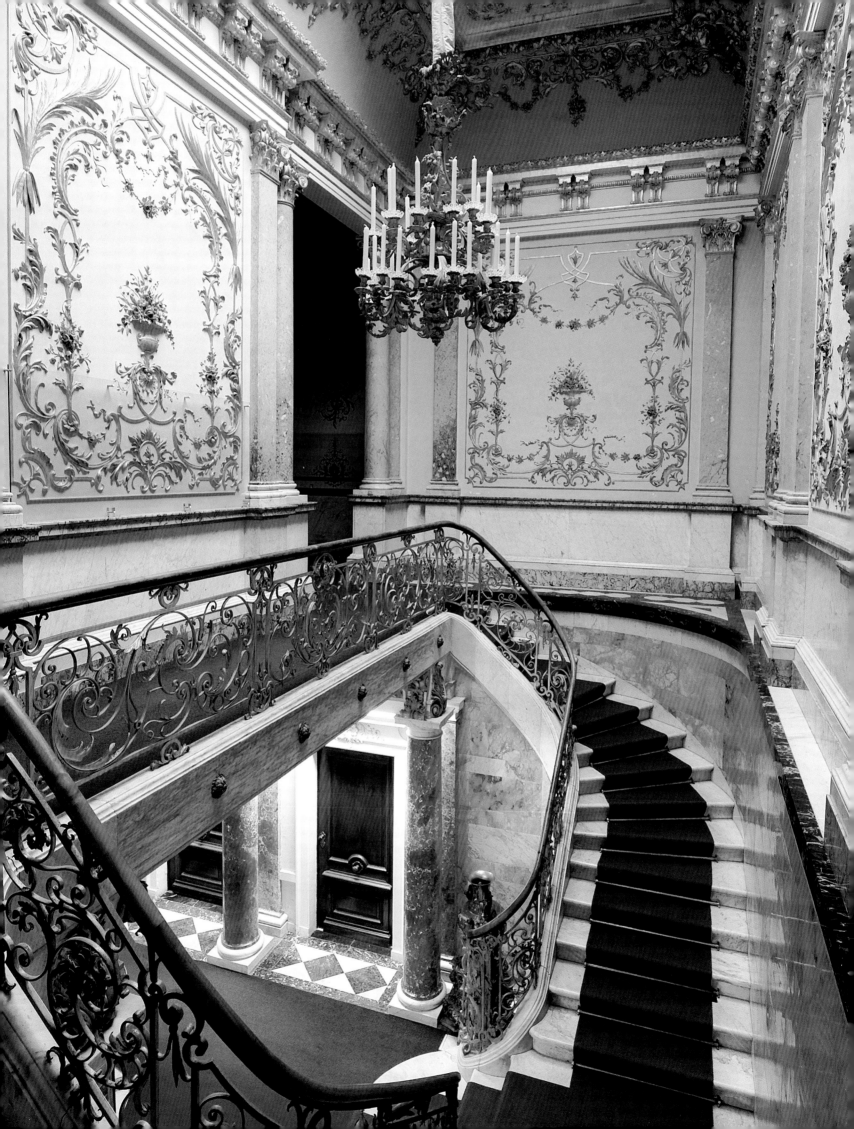

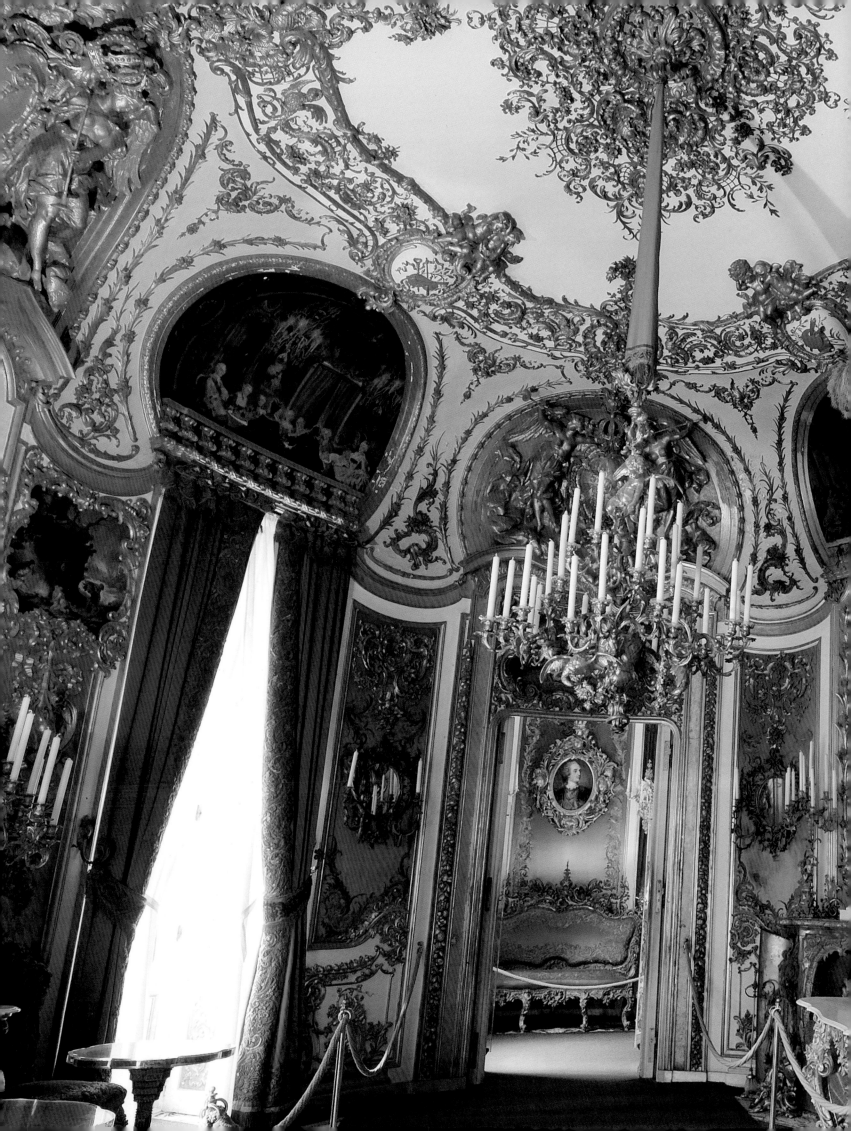

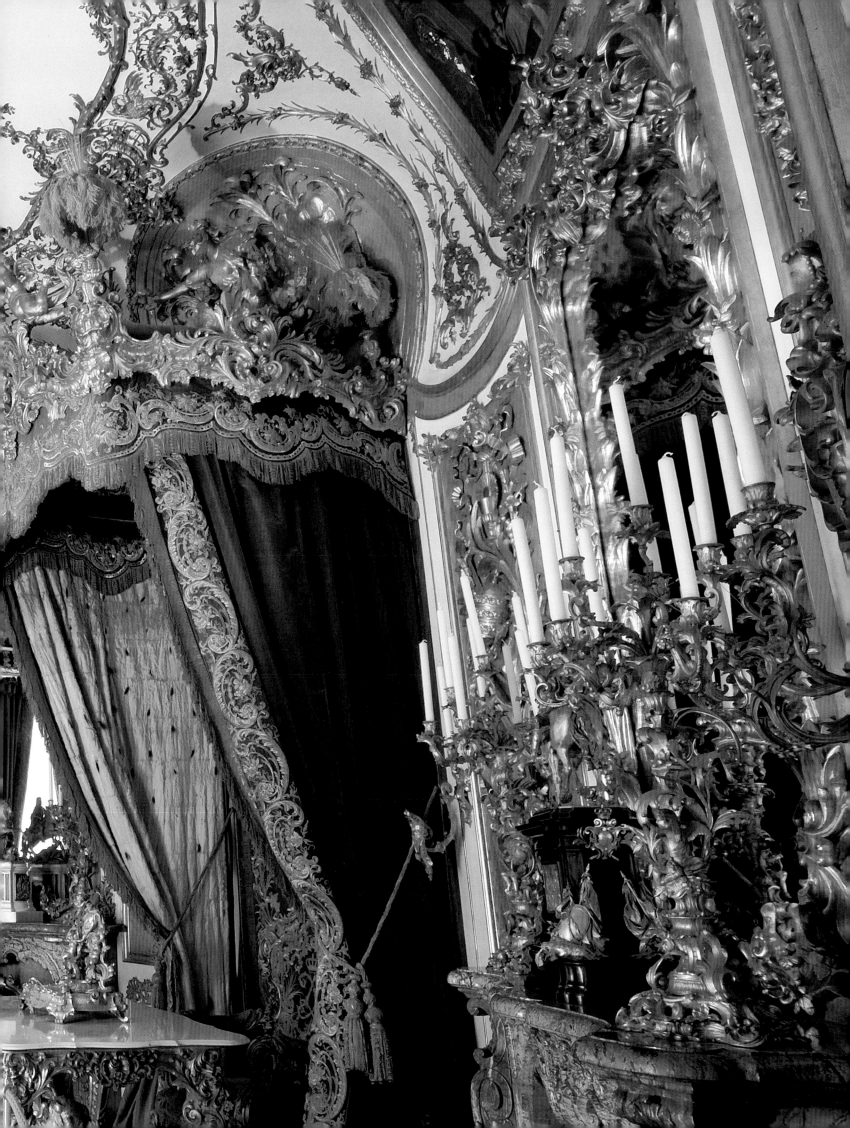

The white Meißen porcelain chandelier is suspended like a crown over the table of the Dining Room at Schloss Linderhof. It forms a charming contrast to the vivid colouring of the ceiling and the gilt stucco. The carvings on the panelling and the stucco on the ceiling depict the activities which once decked the royal table: hunting, fishing, agriculture and horticulture.

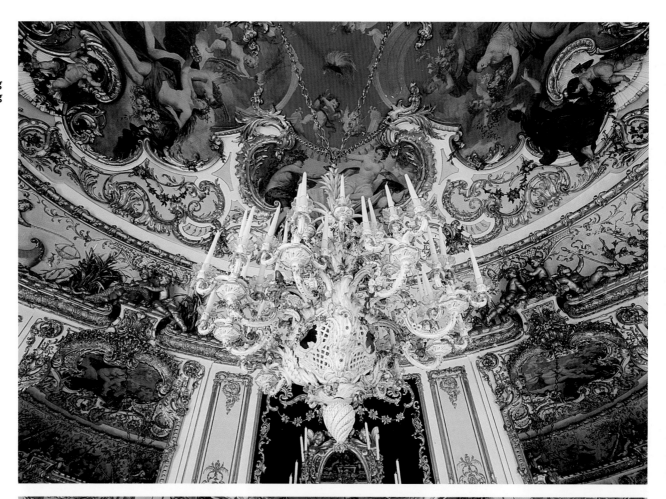

Above each of the two fireplaces made of Tegernsee marble in the Dining Room at Schloss Linderhof is a mirror with an elaborately carved frame. The candles on the fireplaces and the chandelier are reflected in these two mirrors and in a third tucked in between the windows, flooding the room with a warm and atmospheric light. The mirrors also reflect the gilt stucco and many paintings in this sumptuous room.

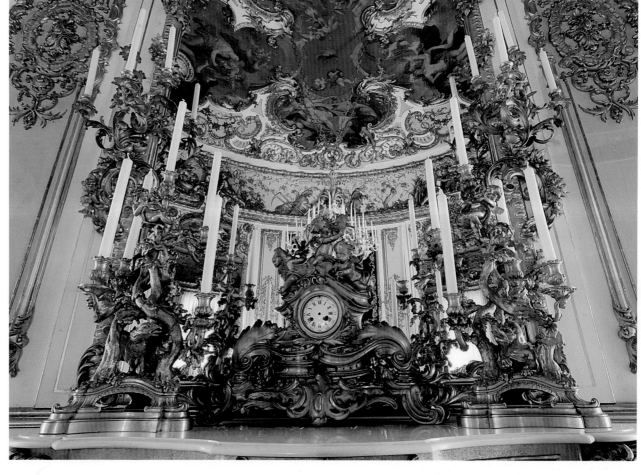

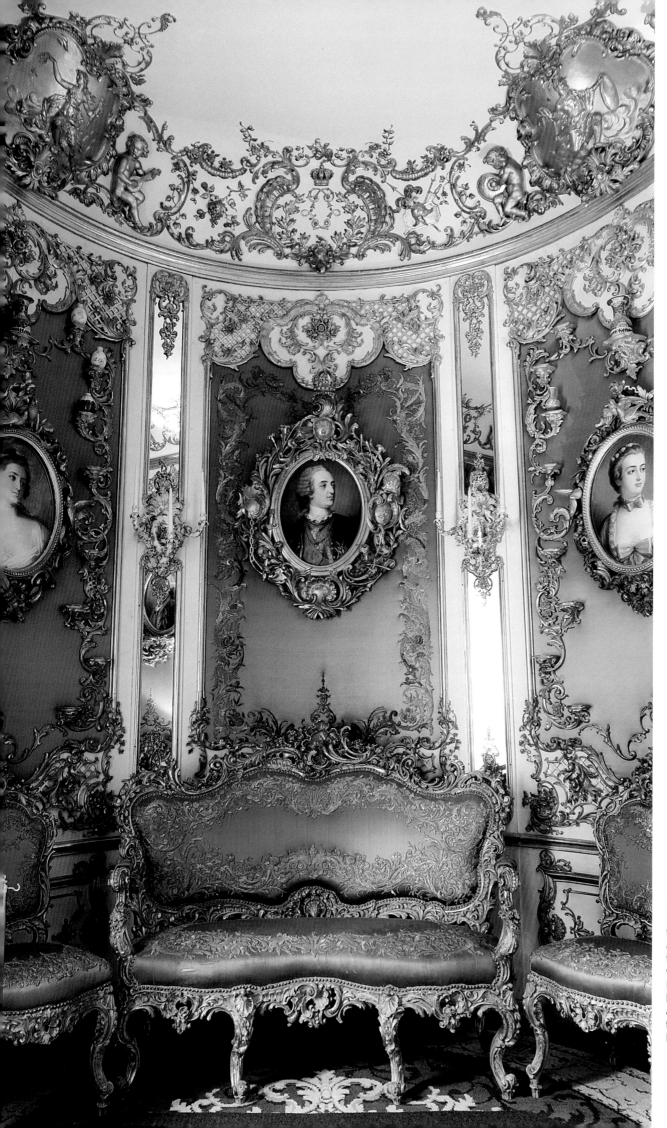

Linderhof's Lilac Cabinet is also a homage to the kings of France. The pastels of King Louis XV of France and his mistress Madame de Pompadour have been given particularly lavish gold frames. The king's lady love was prudent enough to win the favour of the queen and become her lady in waiting.

Page 92/93:
Ludwig II had the interior of the Moorish Kiosk refurbished according to his specifications. This is where we find what was missing in Schloss Linderhof: a throne. It could hardly be any more opulent and is thus one of the most famous attractions of all of Ludwig's castles.

91

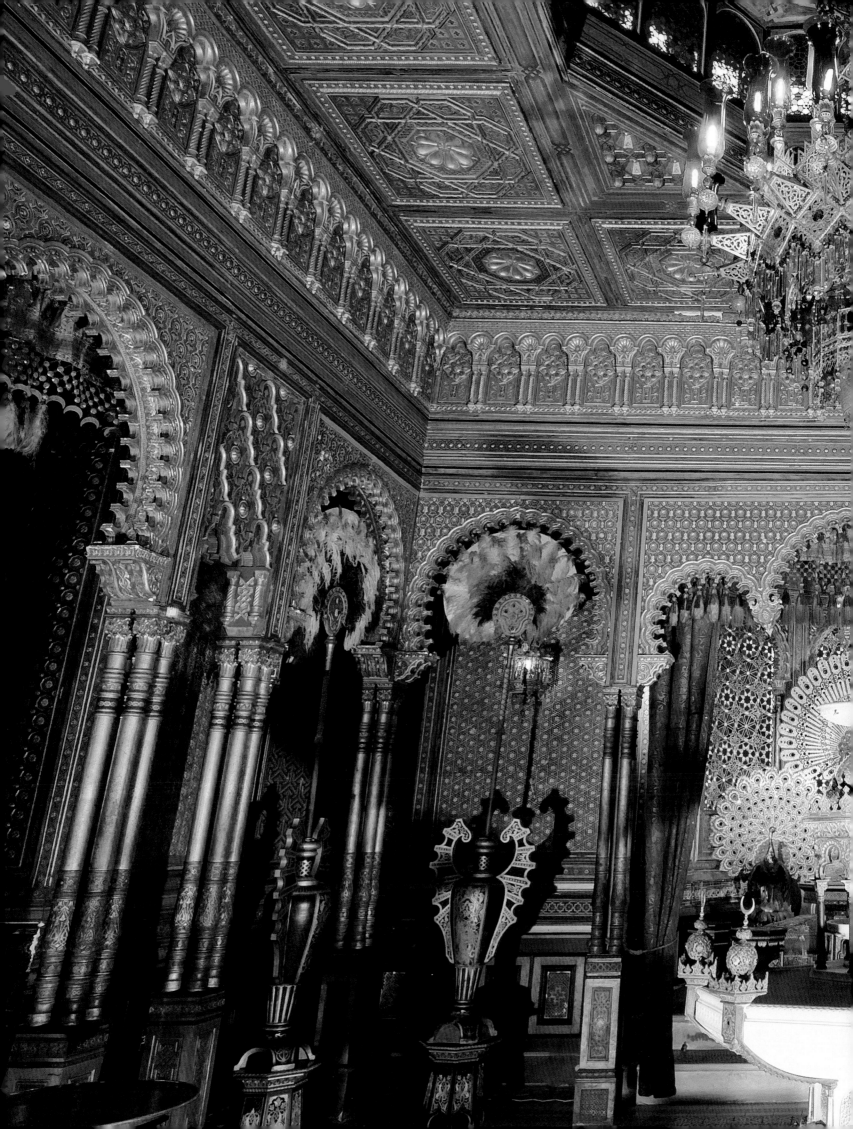

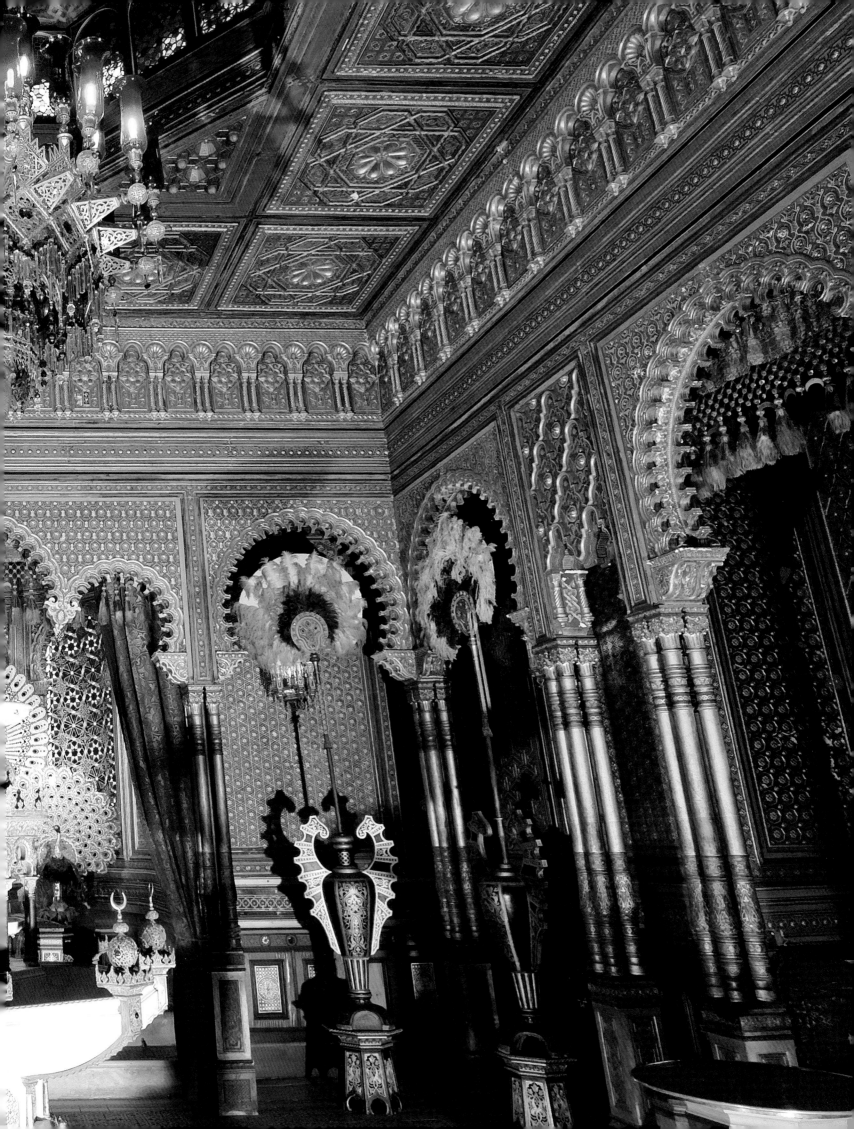

MONARCHISTS IN BAVARIA AND MANGA IN JAPAN – THE MYTH LIVES ON

Center:
King Ludwig II landing at Schloss Berg on his steamer Tristan. In stark contrast to the famous castles, the little palace was Ludwig's favourite residence from whence he could paddle out to the Rosen-insel on the Starnberger See. It was here that Ludwig was to spend his final years – or rather, hours...

The young Bavarian monarch looks like he has just stepped out of a historic novel in his splendid Order of the Knights of St George robes. This decorative early portrait of Ludwig did much to cement the image of the "ideal" king in the hearts and minds of his subjects.

In Bavaria there are countless clubs and societies of loyal fans dedicated to keeping the memory of Ludwig II alive. And if you think that Ludwig's fame in far-off Japan is a product of 20th-century mass tourism, you're very much mistaken! In 1890 a narrative on the king was published whose linguistic exoticism still makes it a popular read today. Yet we don't have to travel that far at all to explore the myth of 'Mad' King Ludwig II.

In July 1886 Karl May's novel *Der Weg zum Glück. Höchst interessante Begebenheiten aus dem Leben und Wirken des Königs Ludwig II. von Baiern* (The path to happiness. Extremely interesting episodes from the life and times of King Ludwig II of Bavaria) began to be serialised by a publishing house in Dresden. In the 109 stories which filled 2,616 pages, issued

every Saturday, the author provided his readers with great excitement and entertainment. In later novels Ludwig II met with Sherlock Holmes and films made by directors such as Helmut Käutner and Luchino Visconti have also greatly boosted his popularity.

On August 1 1886 the gates of Ludwig's palaces were thrown open to a public they had never been built for. On August 4, 1886, just four days later, the first guide was published in Augsburg – prior to the launch of the official guide book. People flocked in their masses to these new attractions. The king himself had made the biggest contribution of all to their mystery; his total isolation and rumours of the magnificent palaces he had created fascinated his contemporaries and helped build the myth which everybody now wanted a part of.

The myth lives on – whether in adverts for mattresses, upon which, it's claimed, you can "Sleep like King Ludwig!", or in the musicals staged regularly in Füssen. Former royal cook Theodor Hierneis also played his part in keeping Ludwig in the headlines, as did hangers-on such as fashion magnate Moshammer in Munich, who like his hero died under similarly mysterious circumstances.

The yearly festivals and events commemorating the king's birthday and the day of his untimely demise are not just rooted in Bavaria's legendary enthusiasm for a good party. More and more new memorials are being erected to the king and the numerous souvenirs and devotional objects from beer mats to handkerchiefs to umbrellas carry his likeness to all four corners of the globe.

Ludwig in death is at home all over the world – and at the moment back in in Japan. A few years ago a manga was published here, a Japanese comic in three parts. Black and white pictures tell the tale of the Bavarian king's life and death.

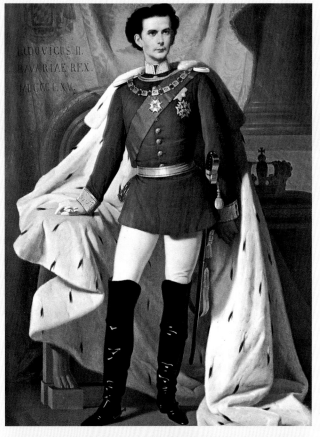

One year after his ascension to the throne in 1865 Ferdinand Piloty painted Ludwig II in the uniform of a general, his coronation robe draped around his shoulders.
This picture of a handsome, proud young man did much to promote the fame of the new king of Bavaria. It is one of the portraits which has been most frequently reproduced to date, helping to preserve the myth of the fairytale king.

The eternally young Ludwig II has been drawn and written by a woman, You Higuri, and he has also been exaggerated as the genre demands. Like so many others this manga has also been translated into German.

Guests from foreign countries, whether from Japan, America or Russia, rarely leave Germany without going to Schloss Neuschwanstein. This Cinderella castle dreamt up by a lonely king, aloof and magnificent on its rocky precipice, never fails to mesmerise modern visitors. This is where they, like Ludwig himself, can escape – and where they can delve into the soul of a misunderstood yet deeply loved fairytale prince.

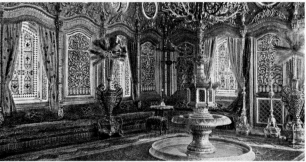

Left:
This is probably the most remote and possibly the most exotic of Ludwig II's homes: the Schachen hunting lodge in the Wetterstein Mountains. Ludwig had the Swiss-style chalet built ca. 2,000 m (6,500 ft) up – and elaborately embellished with a Moorish Hall. He retreated here every year on his birthday, putting as large a distance as possible between himself and the trials and tribulations of everyday life.

Left:
The Singers' Hall at Schloss Neuschwanstein was based on a similar room at the Wartburg. The king 'borrowed' the idea after a trip to the castle in Thuringia in May 1867. Not long afterwards he visited the Paris Exposition. Here he first saw the Moorish Kiosk which he would have bought had an rich industrialist not pipped him at the post.

BAVARIA'S ANSWER TO VERSAILLES – SCHLOSS HERRENCHIEMSEE

Schloss Herrenchiemsee is the last of Ludwig II's castles to be planned and built and probably his most mature work. It's the only palace not connected to his father, both in its conception and location. With the exception of the famous magic table (or Tischlein-deck-dich with a recessed top), the Hall of Mirrors which is longer than its Versailles model, and the ceremonial Paradeschlafzimmer (State Bedchamber), Herrenchiemsee's hidden charm only reveals itself if we take a closer look.

We have to approach it with care. Herrenchiemsee is the most remote of Ludwig's three distant castles although the lake is now on the motorway. The smooth crossing by boat is followed by a long, relaxing walk – or, if you prefer, a romantic ride on a horse-drawn carriage. You feel closer to the king on this little island than anywhere else where he once resided. For besides his rather bourgeois private apartment in the Altes Schloss there is also the King Ludwig II Museum which contains many pictures and objects taken from Ludwig's personal possessions. From his christening gown to a medal commemorating his untimely and sudden demise the exhibits at the museum bear witness to the restless existence of the Swan King of Bavaria. Ludwig II was buried in Munich; his heart was laid to rest in nearby Altötting. He himself lives on in the hearts of millions.

This shot of the facade of Schloss Herrenchiemsee gives no indication of the huge size of the complex. The palace would have been even larger if Ludwig's plans had been implemented in full – sadly thwarted by his untimely end.

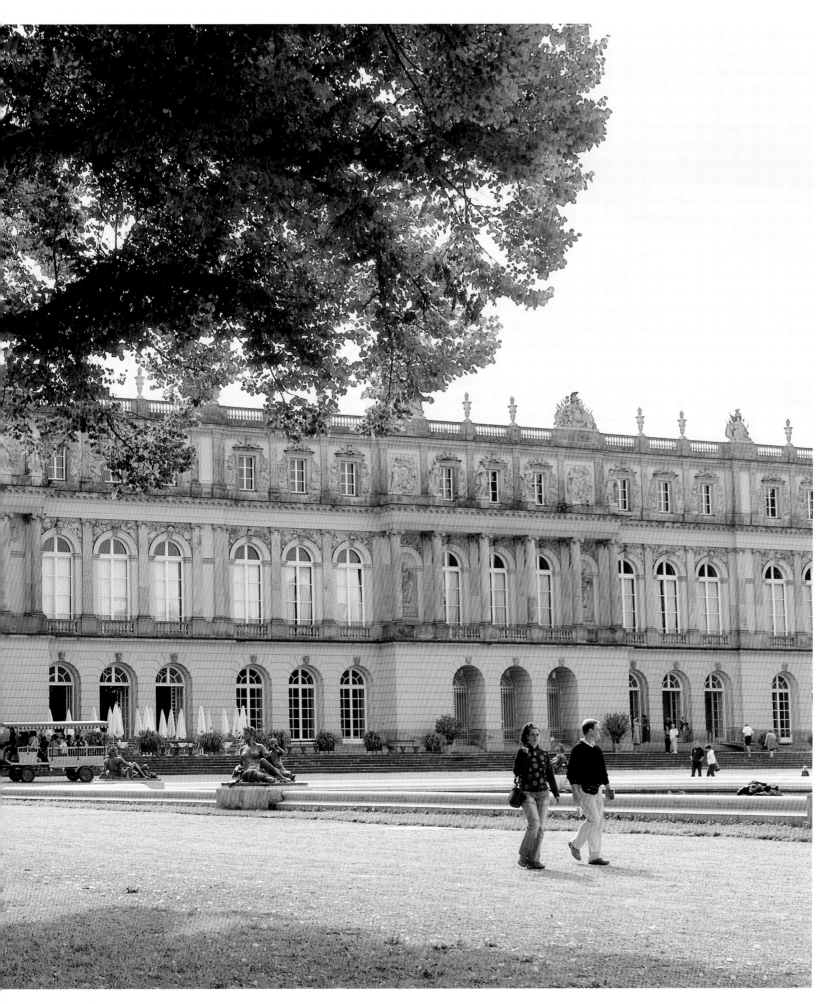

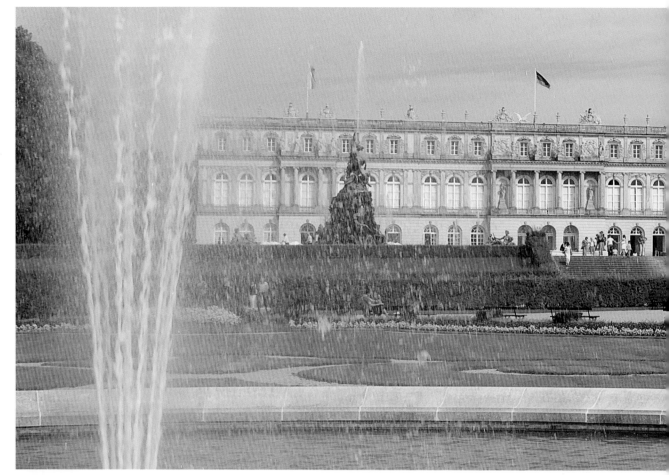

Right:
The fountains on the Herren-insel glitter in the sunlight once again. King Ludwig II didn't live to see them in action; after his death they were removed. They were reconstructed at the end of the 20th century and are now one of the highlights of a visit to the island in the middle of the Chiemsee or "Bavarian Sea".

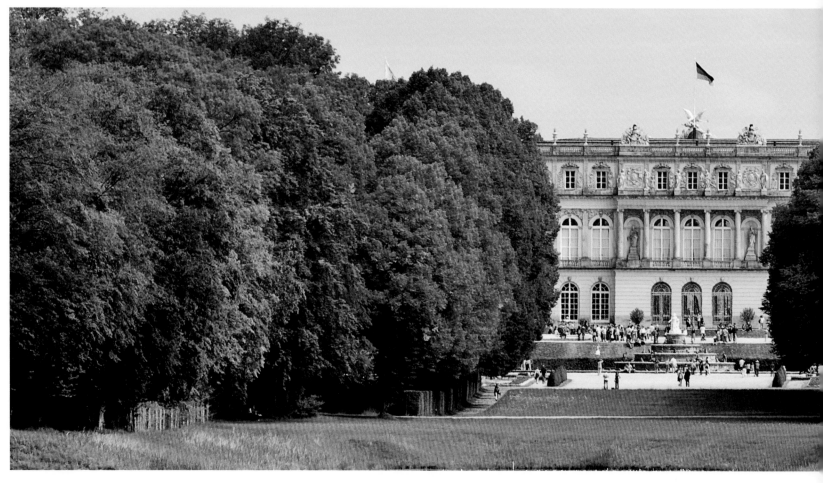

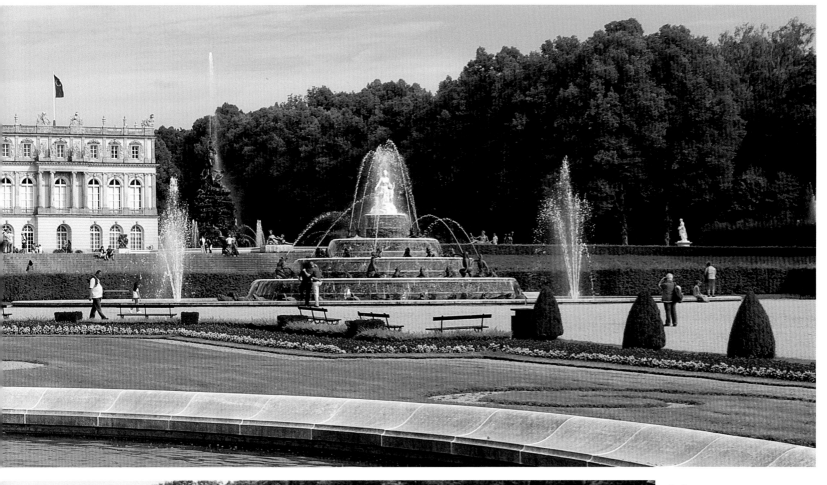

Left:
West view of the palace from the lake. It's worth keeping your eyes peeled on a trip on one of the Chiemsee pleasure boats; from on deck you might catch a glimpse of the magnificent facade long before you reach it on foot or on one of the horse-drawn carriages laid on for visitors.

Beyond the Latona Fountain lies the Chiemsee. One of Latona's children was Apollo, the god of light and the sun, spring and the arts. He is the namesake of a number of institutions, among them NASA's space programme, various automobiles, music groups, cabaret shows, cinemas and theatres.

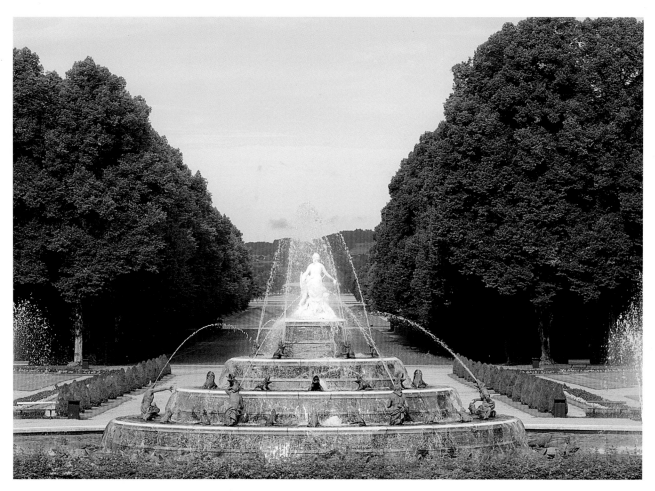

The arrangement and theme of the statues on the edge of this fountain in the park at Herrenchiemsee echo their models in Versailles. They symbolise the major rivers of France.

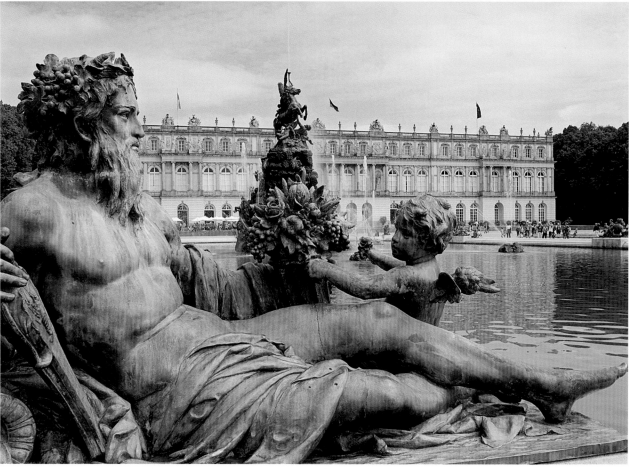

The ridge of the roof above the court d'honneur of Herrenchiemsee is crowned by statues representing war (left) and peace (right). Fama triumphs over the two allegories, a laurel wreath in her hand in readiness for the departing of good tidings to people all over the world.

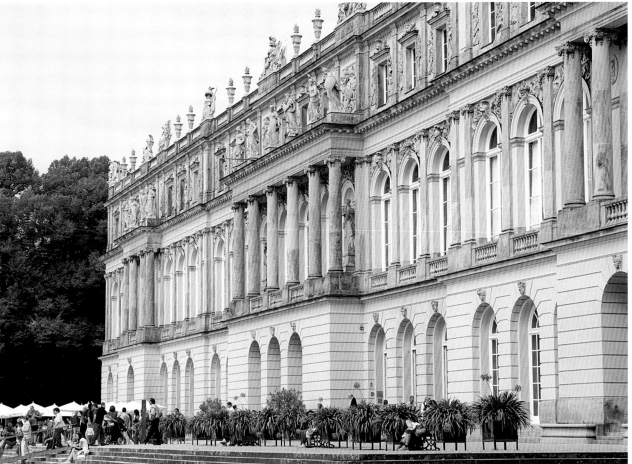

This side of Schloss Herrenchiemsee could be referred to as the garden facade although it's missing its counterpart – a city facade – common to Versailles and many other palaces. On its solitary island Herrenchiemsee is just about as far away from the city as you can get...

Page 102/193:
The State Staircase at Schloss Herrenchiemsee was based on the Ambassadors' Staircase of Versailles although this was dismantled as early as 1752. This detail goes to show that Herrenchiemsee isn't and was never intended to be just a copy of the grand French palace.

101

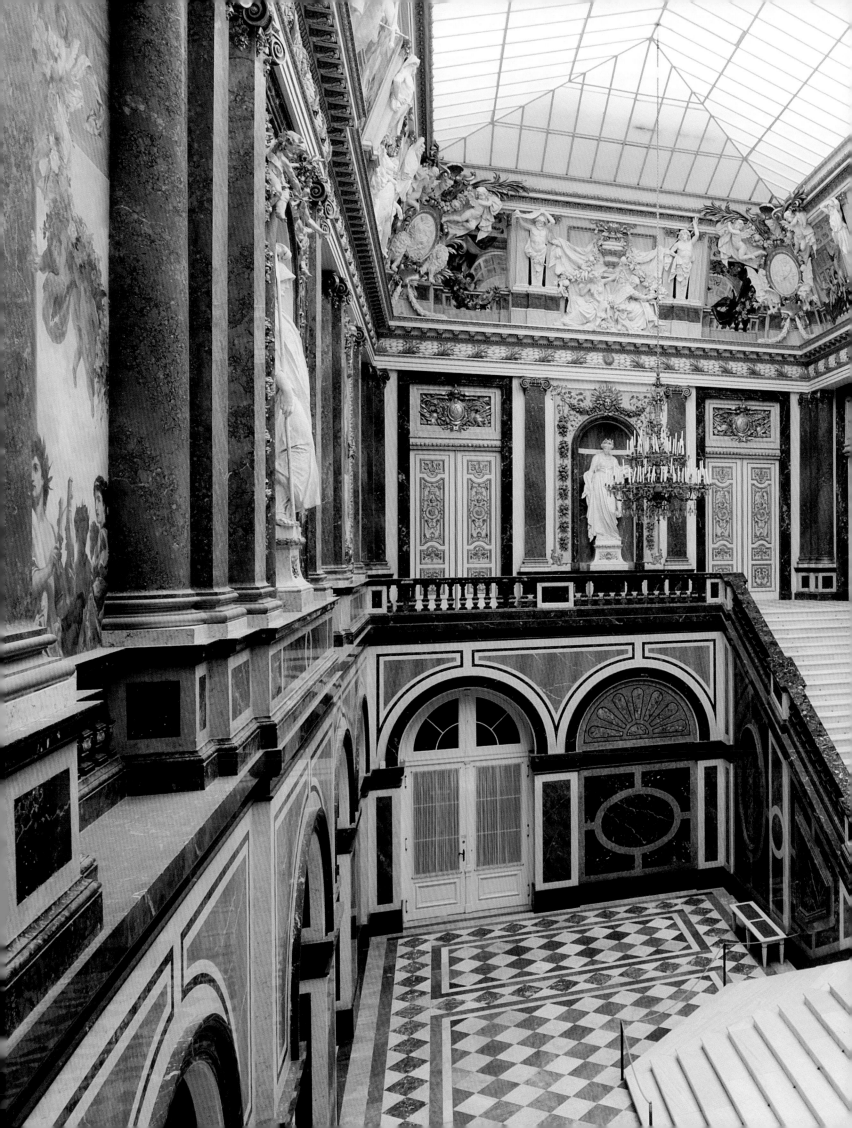

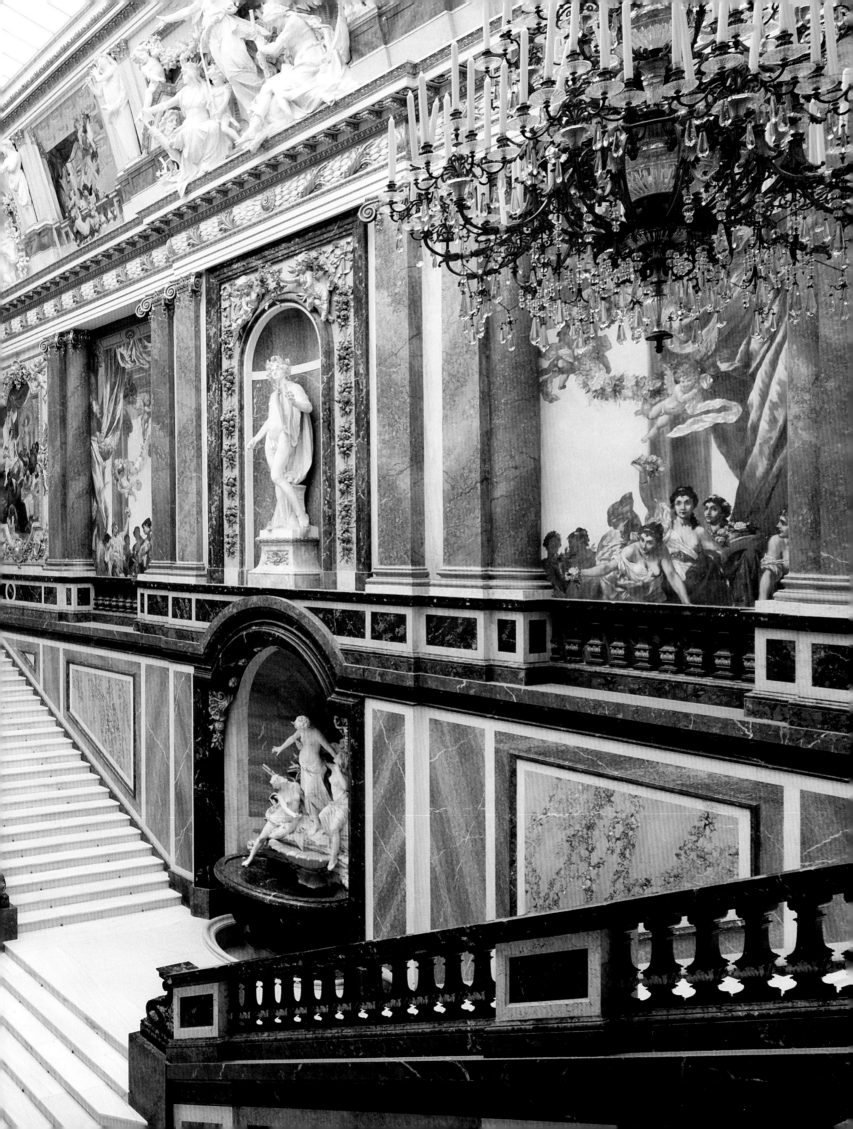

FROM BED CHAMBER TO ROYAL PALACE – HERRENCHIEMSEE

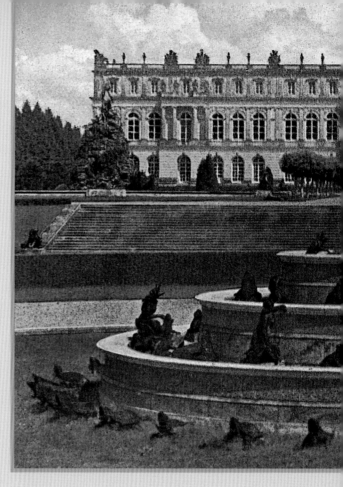

Center:
The Latona Fountain in the park of Herrenchiemsee was created by Johann Hautmann in 1883. During the construction of the palace the king's impatience became legendary; he even had the unfinished bits of the terracing rebuilt in a kind of Potemkin village where he could escape into his dream world before the palace proper was finished.

In the 17th and 18th centuries the palace of Versailles was the all the rage; every self-respecting aristocrat wanted one. Some wished merely to copy the architecture, others to superimpose the infamous ways of the French court onto their own more humble establishments. Schleißheim near Munich, Schönbrunn in Vienna and Peterhof Palace outside St Petersburg: all bask in the transposed glory and magnificence of the Sun King. The fun didn't last, however; the French Revolution put an end not just to absolutism but also threatened to depose many a king and emperor in the general wave of unrest to sweep through Europe.

In one of the first guidebooks to the royal palaces it was described as a "state bedroom for guests". Today we know that King Ludwig II of Bavaria had this room built

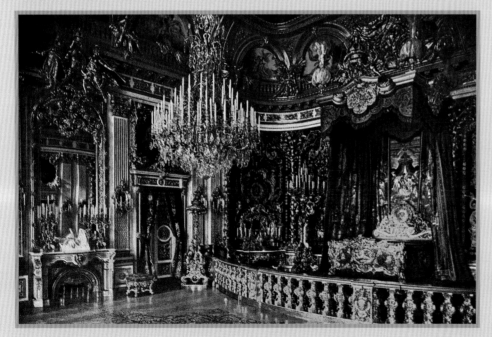

and furnished in reminiscence of the French Sun King Louis XIV. It was the first room to be finished; the rest of the palace was literally built round it.

The centrepiece of the palace of Versailles and indeed of the entire country was the king's state bedchamber. Only those of rank and high standing were permitted to enter – and those of especial favour were allowed to slip in through

the back door. King Ludwig II of Bavaria had the misfortune to be "born late"; he not only missed being an absolutist monarch but in 1886 and again in 1870/1871 had lost more of his sovereignty than he could bear. By way of compensation he wanted to at least try and recreate some of this aura of splendour for himself, to create a symbol of power and prestige which had helped cement the success of his eminent predecessors. His Versailles underwent its initial development at Linderhof in the narrow and secluded Graswangtal; in 1873 the king found a more suitable location in the middle of the Chiemsee lake in Upper Bavaria.

FROM OLD TO NEW: THE PALACES

Herrenwörth, as the island was then called, was an ancient monastic site. The abbey itself had been turned into a brewery; the old trees dotted about the island were now earmarked for the chop. The locals rebelled – and the king sided with them. He had a comfortable Biedermeier apartment installed in the former convent in what's now

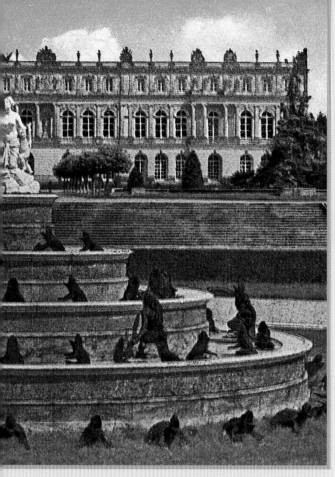

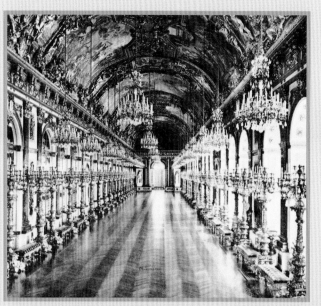

Left:
At 89 m (292 ft) the Hall of Mirrors at Schloss Herrenchiemsee is considerably longer than the one at Versailles near Paris. Outside regular opening hours concerts are often held in this marvellous setting. This photograph from c. 1886 is credited to Joseph Albert.

Below:
In c. 1886 Joseph Albert also photographed the Council Chamber at Schloss Herrenchiemsee. The room is based on the Salle du Conseil at Versailles.

called the Altes Schloss (old palace) from whence he could monitor the progress of his new abode. The foundations were laid on May 21, 1878, but his detailed plans were way ahead of themselves. In February of the same year the company Jörres had already begun embroidering the curtains and throws of the state bedroom. The architectural partitioning of the interior thus had to be rescaled to fit the finished wall coverings.

Schloss Herrenchiemsee was thus literally built around the bedroom. Originally just this room and the Spiegelsaal or Hall of Mirrors were planned. The 13th plan for Linderhof was turned into the 1st plan for Herrenchiemsee – and this, too, wasn't the final version, changing frequently not just due to the replacement of architect Georg Dollmann by Julius Hofmann. The Hall of Mirrors grew and grew until it was longer than the Versailles original. The Kleines Apartment or Small Apartment also crept into the plans, something Versailles doesn't have; Herrenchiemsee is thus not a direct copy but a quote of its French model. Whether exactly true to form or not, it duly pays homage to the French Sun King, Louis XIV.

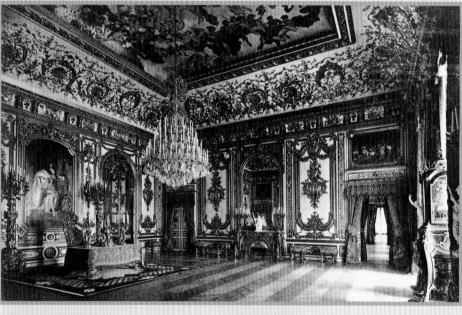

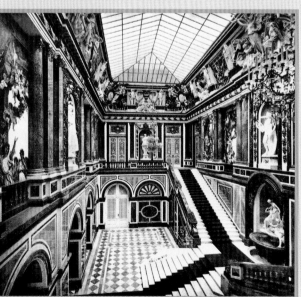

Left:
The Southern or State Staircase at Herrenchiemsee was also snapped by Joseph Albert in c. 1886. As opposed to the Northern Staircase – still just a shell – it was finished during Ludwig's lifetime. The popular tours of the palace start here.

LEVER AND COUCHER

Center:
In addition to the State Bedroom, more theatrical backdrop than a place to sleep, the king needed a bed on which to lay his weary head. He thus had this sumptuous bedroom erected in his living quarters or the Small Apartment. The blue nightlight is another legendary item at the palace, Ludwig's artists having to experiment long and hard to find just the right shade of blue which satisfied the king.

Ludwig II was familiar with the terms lever (to rise) and coucher (to bed) – and not just from the famous letters penned by Liselotte of the Palatinate. In them she describes – in no uncertain terms – the various rituals religiously performed by the court of Louis XIV. Protocol was writ large – even down to who was allowed to hand the king his shirt and who not. The ministers in Bavarian Munich had absolutely no time whatsoever for Ludwig's imaginary and very private revival of such ceremony – although or maybe because their knowledge of history and art wasn't a patch on their ruler's.

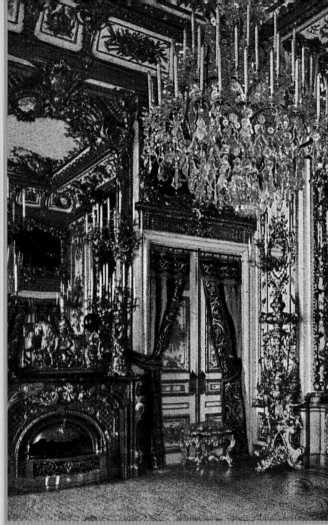

Above:
By way of embellishment to his bathroom at Herrenchiemsee Ludwig II had "Diana at her Bath" painted after the work of French artist François Boucher (1703–1770), famous for his frivolous and sensual pictures and thus a favourite of Madame de Pompadour. Ludwig's version was executed by Historicist painter Augustin Geiger.

Where did this leave the Bavarian king? He was up to his neck in debt but still bent on building his dream home. He spent more money and took up more loans. He literally turned night into day. Visitors today may wonder why the colours are so bright, even lurid; Ludwig had not planned that the palace be seen in daylight. The man who was otherwise such a keen advocate of technological progress didn't even have electricity installed. The Moon King wanted to have his own Versailles lit by a thousand candles. Here, isolated from the real world, he was at peace to find his true self.

A VERSAILLES IN THE MIDDLE OF THE LAKE

The fantastical settings inside the palace were echoed in the park. Ludwig had the island festively illuminated – probably with the first electrically lit Son et Lumière. Despite considerable technical difficulties a power network serviced by three steam engines went into operation in 1884. This supplied the colour spotlights; the men operating the spots were even linked by telephone. The man responsible, Alois Zettler, was a pioneering electrical engineer and duly bestowed with the title of "first royal illuminator".

In 1876 director of the royal gardens Carl von Effner estimated it would cost one and a half million guilders to lay out the palace park. The king didn't live to see his fountains. Over the decades they fell into decay and were only restored at the end of the 20th century.

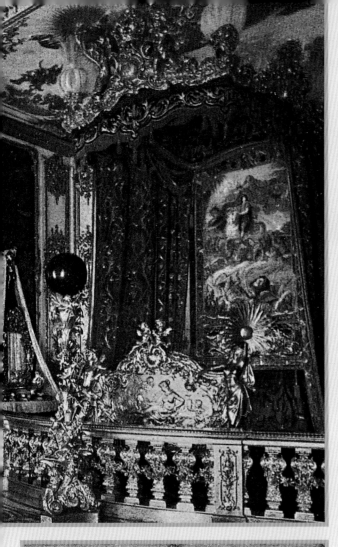

Illustrations in the palace reveal just how grand and carefully though out Ludwig's Gesamtkunstwerk is. They show Astraos, the night or the moon, and Aurora, the symbol of morning or the sun who, according to legend, together made the morning star. With his palace-cum-theatre King Ludwig II has created a brilliant star for Louis XIV, an artistic and historical gem which – for years unrecognised as such – will never lose its sparkle. Like Marie Antoinette's boudoir, added later, Ludwig II's dressing room is in pink. Is this an indication that he identified himself with her or that he perhaps saw his own end drawing near? Did he deliberately stage this aspect of his life – as he did the rest of it? We will never know.

The long sides of the State Staircase in Herrenchiemsee are decorated with various frescos. "Agriculture", shown here, depicts the harvesting of the grape and the grain. King Ludwig II also had thousands of lilies and roses strewn about the staircase on his rare and meticulously timed visits to this part of the palace.

Above:
At first sight you might think that the artists working on the ceiling fresco of the State Staircase in Schloss Herrenchiemsee had made life easy for themselves. If there are four elements and four seasons, then there must be just four continents... Yet we are still arguing about just how many continents there are. Four, five, six or even seven? Should we include the Antarctic? Was that Eurasia or Europe plus Asia? The hypothesis continues. At Schloss Herrenchiemsee the artistic community settled on just four: Europe (represented by the bull), Africa (the lion), America (an American Indian with a buffalo) and Asia (the tiger). This depiction corresponds to the ancient division of the world – with the addition of America. Despite the gold rush and British colonisation of the 19th century, Australia remains 'undiscovered'. However many continents you count today, Australia is now always included.

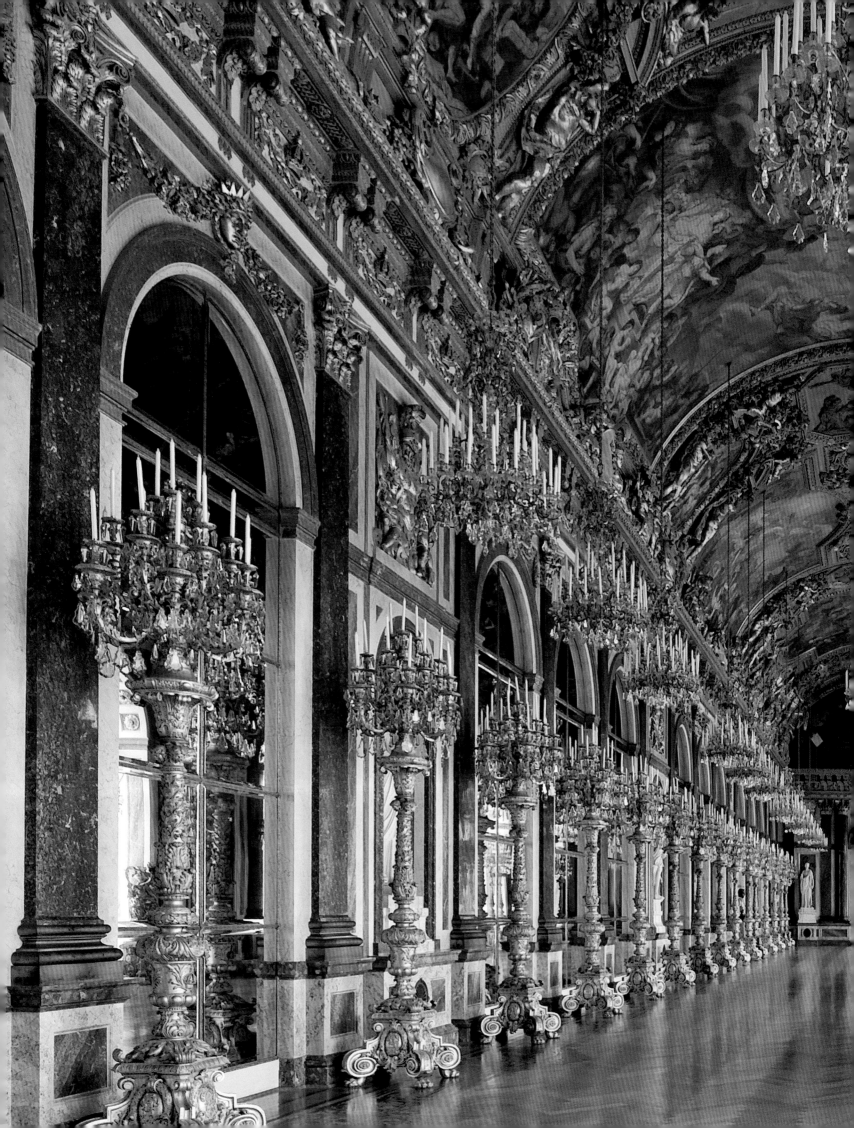

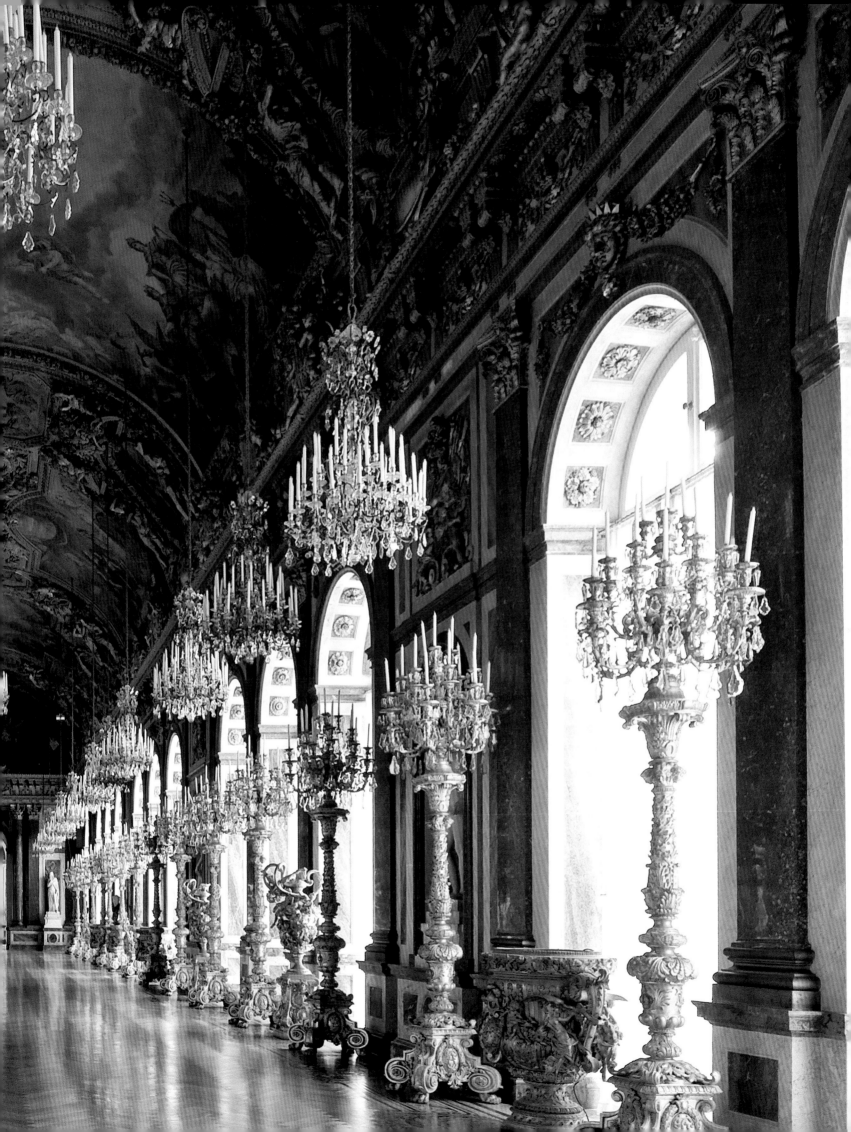

Page 108/109:
Up until the death of King Ludwig II only a select few were allowed to marvel at the proportions of the Hall of Mirrors at Schloss Herrenchiemsee. And today? Only a select few are permitted to enjoy the splendour of this room alone, as the king once did.

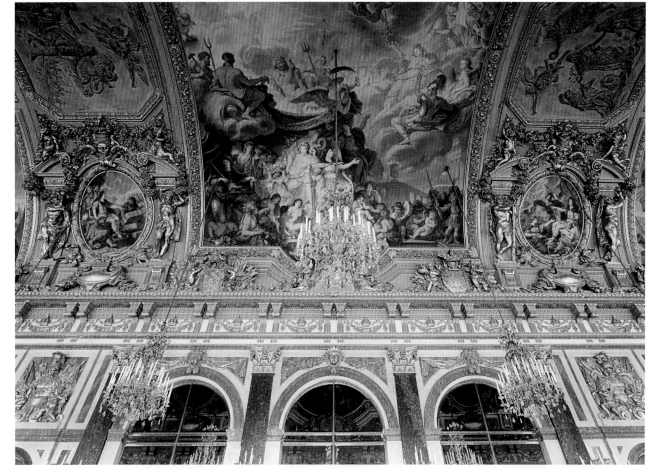

The ceiling and upper wall in the Hall of Mirrors at Herrenchiemsee are smothered in frescos and stucco. They depict the deeds and actions of King Louis XIV of France.

The candelabra in the Small Gallery of Herrenchiemsee depict a raptus group of gilt bronze, reflected many times over in this photo. In the fine arts raptus or raptio is the depiction of an abduction or rape; in psychology a raptus is a (sudden and unexpected) seizure or attack of rage.

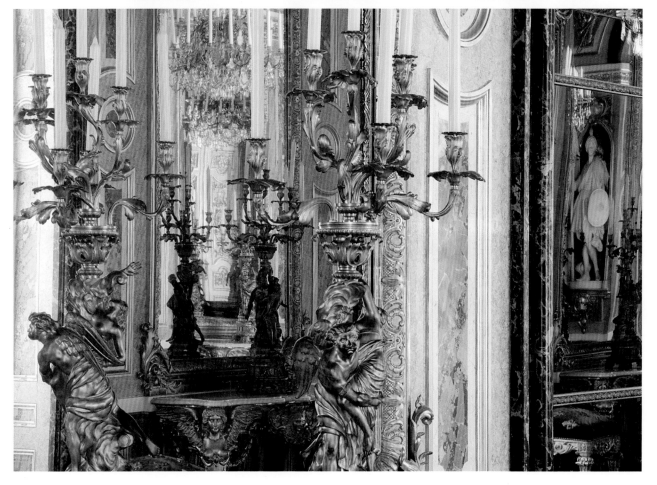

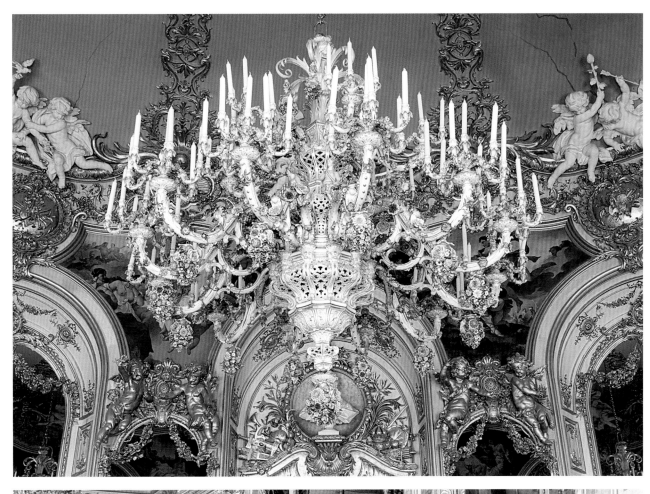

The eighteen-arm chandelier of Meißen porcelain in the Dining Room of Schloss Herrenchiemsee holds 108 candles. At the express wish of Ludwig II all of the moulds and models were destroyed to avoid this work of art ever being copied.

The mirrors in the Small Gallery at Herrenchiemsee create many interesting and unusual perspectives. The niches contain statues of the four continents of Europe, America, Africa and Asia. The Petite Galerie of Louis XIV in Versailles, upon which Ludwig's version is based, sadly no longer exists.

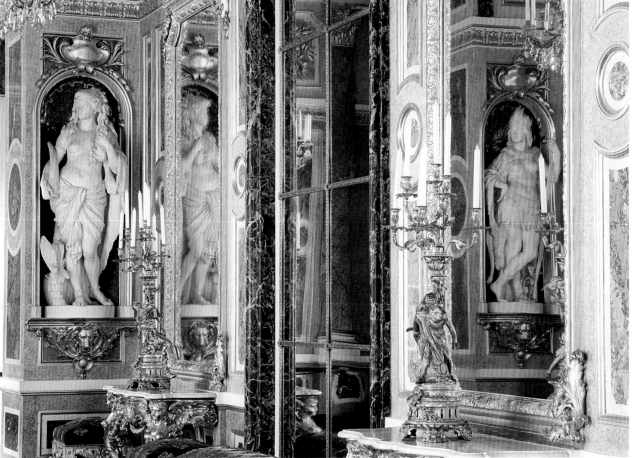

Page 112/113:
The particularly lavish embroidered wall hangings in the State Bedroom of Schloss Herrenchiemsee were begun before the shell of the palace had even been completed. The king never wanted to actually sleep in the bed of state; for him it was simply a homage to the French Sun King and to the court protocol of "lever" and "coucher" when the king received the first and last audiences of the day.

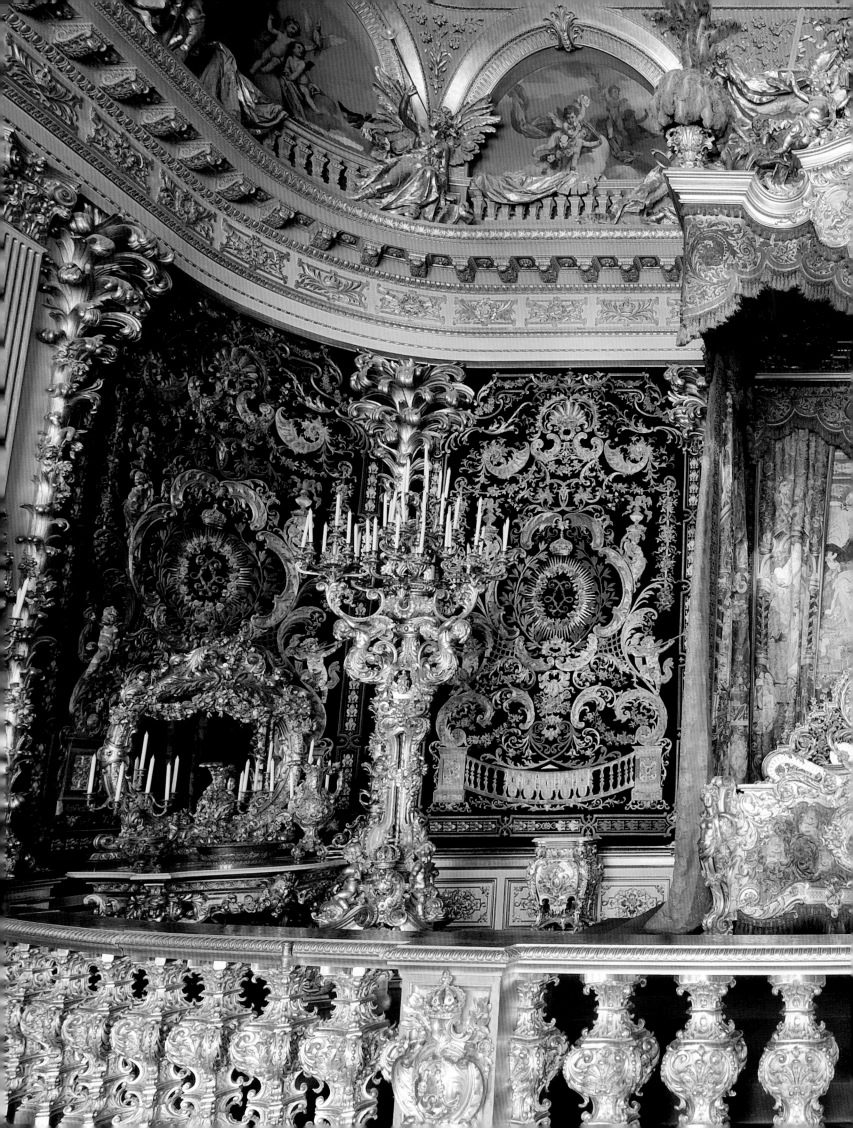

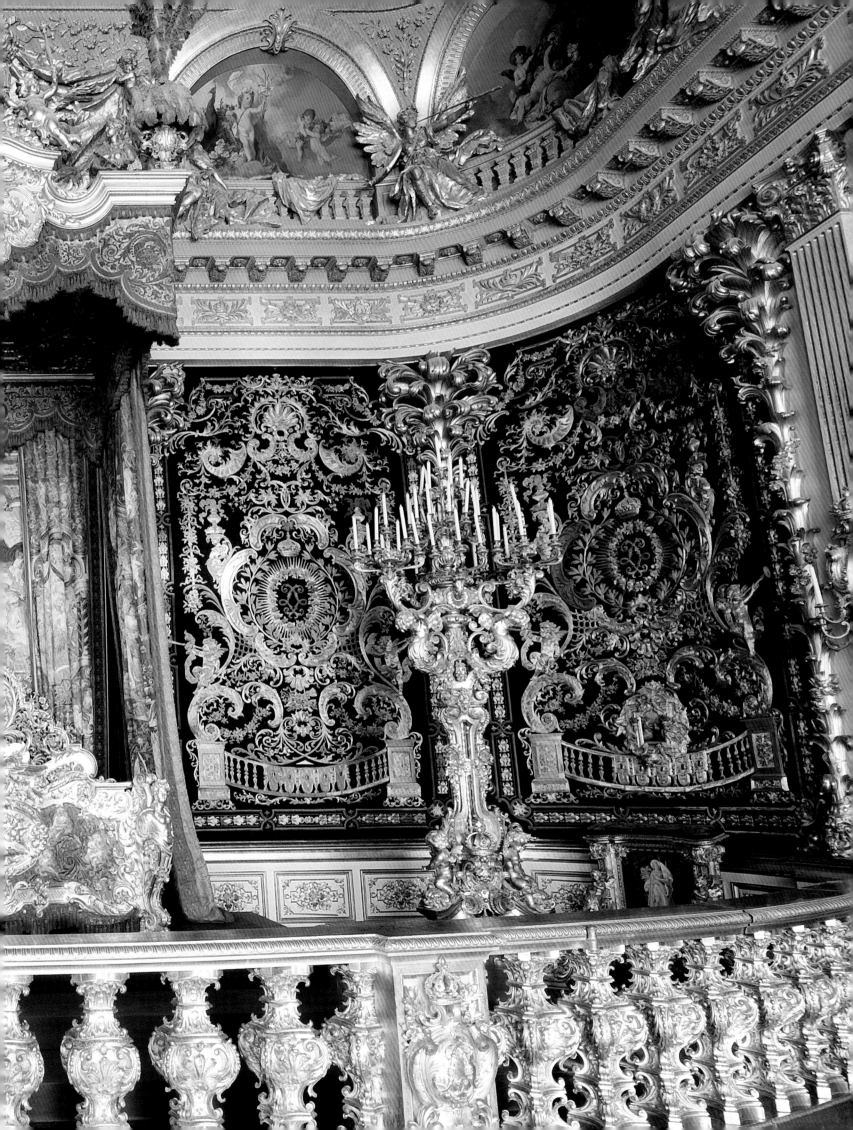

DEPLETED ROYAL COFFERS FAIL TO STOP THE KING

Center:
Munich's royal coach builder Johann Michael Mayer made the legendary sledge whose crown was lit by electricity, making it the first electrically illuminated vehicle in the world. This oil painting was executed in the 1880s and is attributed to Rudolf Wenig who has depicted one of Ludwig's nocturnal sleigh rides from Neuschwanstein across the Schützensteig to Linderhof. At the turn of the 19th century Ludwig's sleigh rides were popularised as touched-up postcards and tin figures.

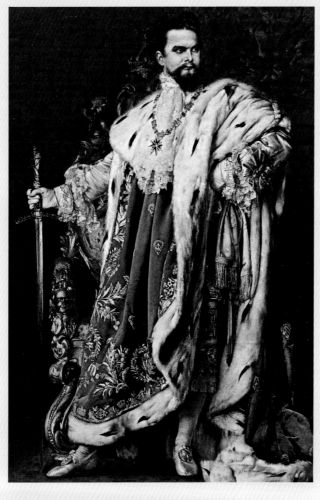

Right:
King Ludwig II in the regalia of the Order of the Knights of St George. This monumental portrait was painted by Gabriel Schachinger in 1887 – after Ludwig's death.
In 2007 the motif was used to welcome a French football player to Germany's FC Bayern München as the "new king of Bavaria". The image was placarded onto the facade of the Theatinerkirche in Munich – a feat which caused quite a stir in the Bavarian capital.

The king's debts were one of the chief reasons given by Ludwig's opponents for his incapacitation. There is much to indicate that the monarch did indeed take too little care over the state of the royal coffers in his last few years. His parents, in keeping with the disastrous fashion of the day, had kept their children on such a short leash financially that not only was the princes' pocket money unusually low for royal offspring but meals was also heavily rationed, prompting the boys to beg food from the servants. Thus a few days after his ascension to the throne King Ludwig II announced: "It is my desire that an end be put to all exaggerated economy and stinginess!"

He kept his word. He wasn't only generous when it came to giving presents; the best wasn't even good enough for himself and his favourite toys, his castles. Such things cost money – lots of it. As king he was on the civil list and entitled to a salary. In his first years as regent he had to pawn much of this off onto his grandfather; the monies also had to cover the various activities of the court. Ludwig I died in 1868 and Ludwig II began cutting down on his representational outgoings.

As a countermove he poured more and more of his financial means into his castle building. The cost for Schloss Herrenchiemsee spiralled to a giddy 16.6 million gold marks, of which just 5.7 million had been 'approved' by the cabinet treasury. Herrenchiemsee illustrates perfectly just how interest and can eat up a non-existent capital. When offers were tendered for specific jobs, the more expensive option was usually favoured – if the company was willing to extend the period of payment. Bills were often settled long after work had been completed. The decorators Hauschild, for example, weren't able to invoice services rendered in 1875 to 1879 until the year 1883.

The king was especially fond of construction manager and wealthy entrepreneur Franz von Brandl who gave the cabinet treasury generous credit. After Ludwig's death he was allotted partial responsibility for the royal debt. The king's ministers, however, were just as guilty for not taking suitable measures sooner – so that they could hold on to their jobs. And these debts – in 1886 these amounted to 14 million gold marks – could have been paid back from the king's yearly private income plus state budget of 4 million marks with a normal life expectancy of the king of a further 30 years.

Through the careful management of Ludwig's estate it was possible to meet all financial commitments by 1899. This went hand in hand with a huge sale of the late king's effects. 60 crates of artefacts were taken and sold from Linderhof alone. The museum of arts and crafts in Strasbourg, founded in 1887, purchased eight cart loads of goods for 45,000 marks; another prolific collector was the American Vanderbilt. Even the then king Otto I was made to pay up, 'donating' two million marks from his personal savings.

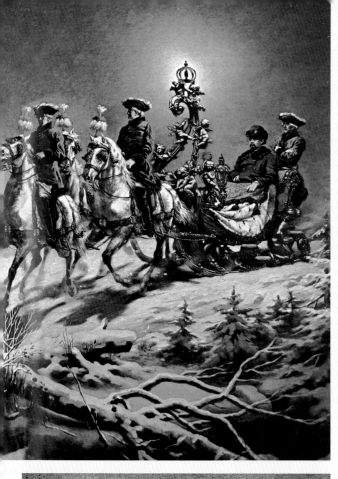

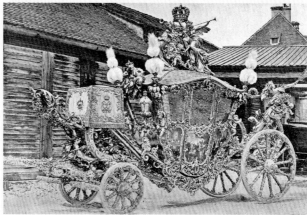

Above:
The conservatory at the residential palace in Munich was to be much higher, bigger and more splendiferous than the more economical versions of his father, King Maximilian II. And it was! This photo by Joseph Albert was taken in c. 1870.

Left:
This large golden coach was designed by Franz Seitz and built by royal coach maker Franz Gmelch. These ceremonial vehicles and others like it can be viewed at the Marstallmuseum or stable museum at Schloss Nymphenburg in Munich.

Far left:
This elephant clock of silver-plated bronze with a gilt rug cost 6,800 marks. It was made by Munich clockmaker Carl Schweizer and is on display at Schloss Herren-chiemsee. Allegedly the king had lost a "live" elephant at some point in time and this ornament was to act as his replacement...

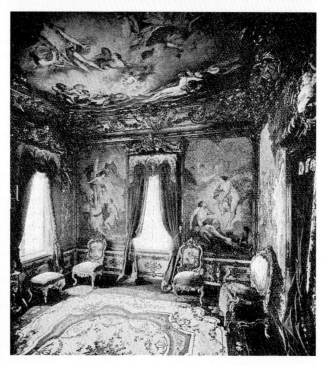

Left:
Both of the tapestry rooms at Schloss Linderhof were designed by architect George Dollman in 1874. Pictures were painted on coarse canvas to look like tapestries and inserted in gold panelling.

The Small Gallery of Herren-
chiemsee is one of the most
exquisite state rooms in
the palace. The five glass
chandeliers hold 180 candles
which are reflected in the
many mirrors inserted into
the walls.

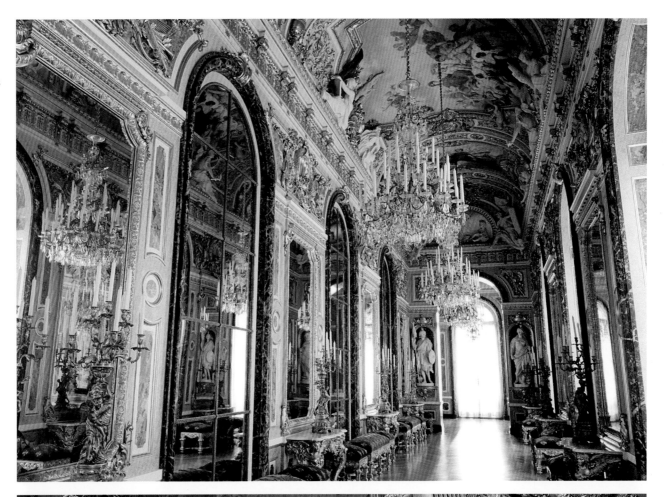

On the fireplace in the
Bedroom at Herrenchiemsee
is a statue of the sleeping
Ariadne based on a figure
at the Vatican. In German
her name means "most holy
one"; she has been painted
by Titian and Tintoretto,
as "Ariadne on Naxos" by
Lovis Corinth and her legend
put to music in an opera of
the same name by Richard
Strauss.

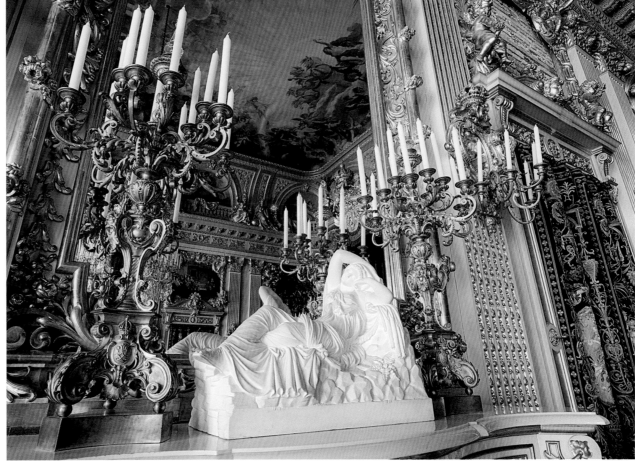

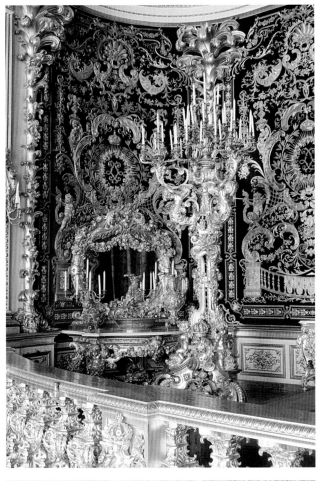

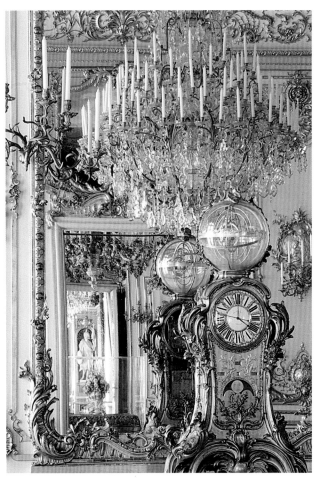

Far left:
The huge candelabra next to the State Bed at Schloss Herrenchiemsee is not only wonderful to behold; its many candles also create the right atmospheric lighting. The many "arms" of the candlestick have given rise to the German word "Armleuchter" (branched or poor light) which in colloquial use also means "dimwit".

Left:
In the Study at Herrenchiemsee the king's astronomical cock shows the hours and minutes and also the position of the sun, moon and stars. The voluminous glass chandelier with its 96 candles, mirrored around the room, once provided Ludwig with an impressive light by which to work by at his favourite time of the day – the night.

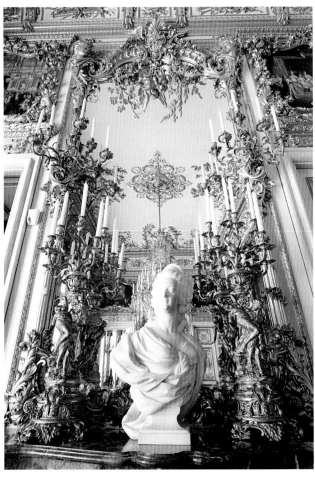

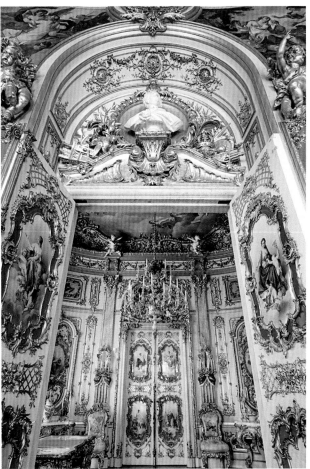

Far left:
The Small Apartment was the king's private residence at Schloss Herrenchiemsee. On the mantelpiece in the bedroom stands a marble bust of Madame Pompadour. She was Louis XV's mistress and the first 'official' royal concubine in France ("maitress en titre"). Such is her infamy that she's even had a famous handbag named after her.

Left:
View from the Dining Room of the Porcelain Cabinet at Herrenchiemsee. The porcelain paintings on the doors show allegories of the sciences and the seasons. The lunette, the stucco above the door, is also a fabulous piece of art work in its own right.

French rivers are sometimes male and sometimes female, prompting their symbolic depiction as Neptune or water nymphs. The serene figures of this fountain represent the fruits they yield and the fields and meadows they water.

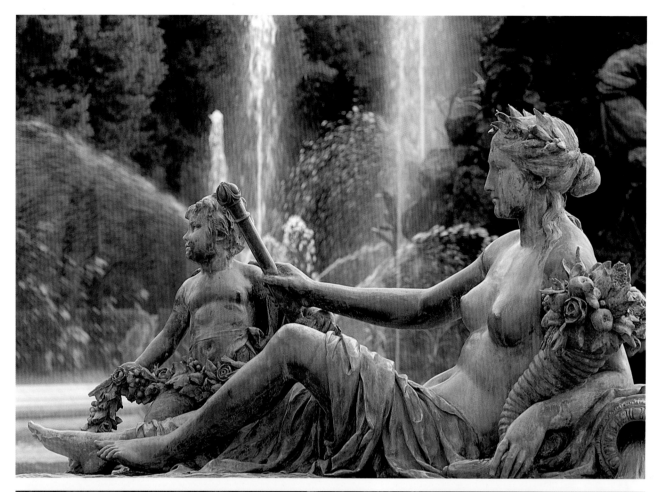

Playful cherubs hover on the water's edge of this fountain in the park at Schloss Herrenchiemsee. These decorative statues of children, usually little boys, are a familiar motif in the sumptuous baroque churches of Bavaria and elsewhere.

Right page:
The winged figure of Fama doesn't only 'sound' her trumpet to depart the latest news to all and sundry; she also spouts a long jet of water up into the blue skies above Herrenchiemsee. Fama celebrates the fame of poetry here, in which the poets ride Pegasus, the famous winged horse of Greek and Roman mythology.

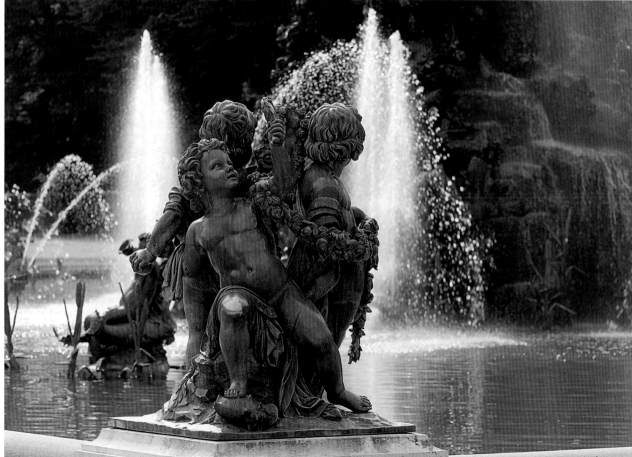

118

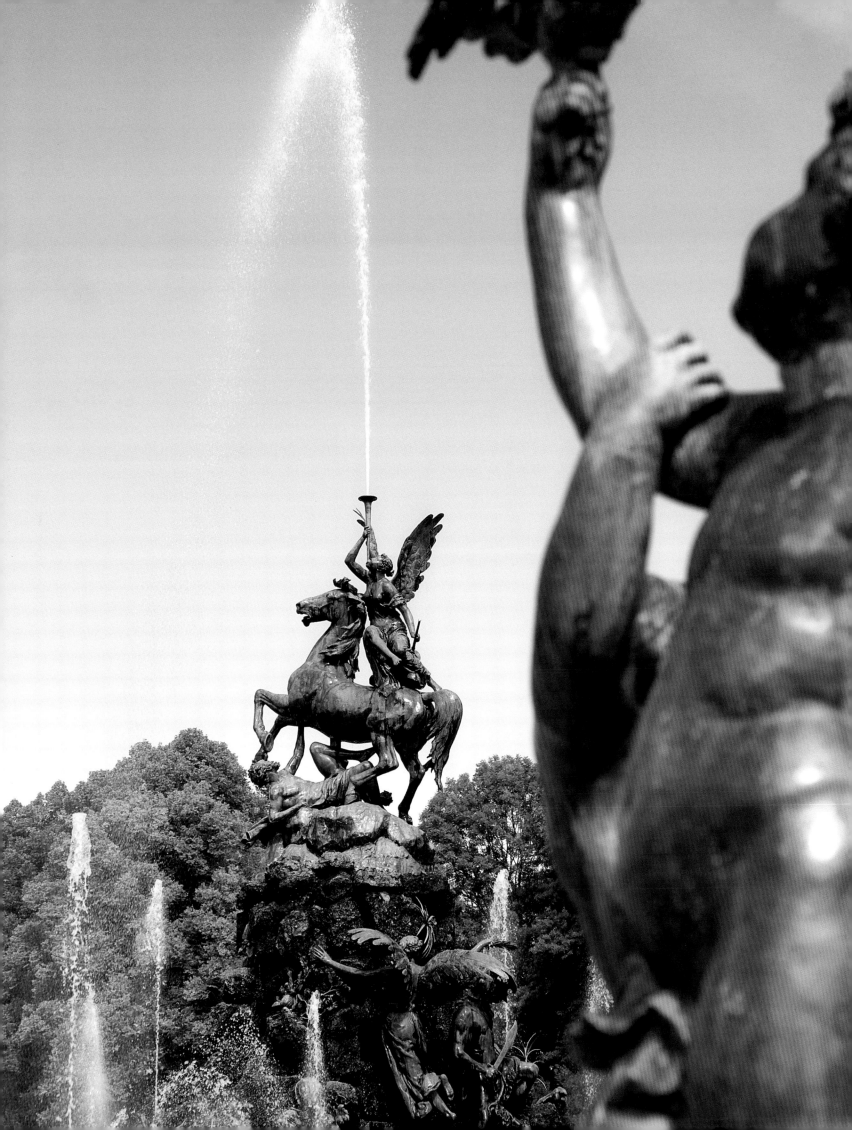

FROM SUSPECT MEDIC TO MYSTERIOUS DEATH – LUDWIG II'S SORRY DEMISE

Center:
King Ludwig II was laid out on a bed of state in the black robes of the Grand Master of the Order of St Hubert. This pastel is by Josef A. von Koppay. In his hand the king holds a branch of jasmine which Empress Elisabeth of Austria had picked for him.

Right:
A memorial cross, replaced several times in its history, has been erected at the spot in the Starnberger See where the king died. In 1887 the king's mother Marie had a mock Gothic pillar, a "death lantern", installed at the place of her son's death. Many monuments dotted about the towns and villages of Bavaria, some of them quite recent, pay their respects to their beloved former king.

The loss of royal sovereignty by proclamation of the emperor in Versailles in 1871 not only devastated King Ludwig II but also greatly affected his brother Otto. The latter was first diagnosed with a "softening of the brain" due to syphilis as he had allegedly sought out "public girls" several times a week, something which was forbidden. He was prescribed "baths of steel", cold showers both morning and night, the omission of which would surely lead to a premature death. The patient had other ideas; he outlived his older brother by thirty years and the diagnosis was changed to schizophrenia.

In their reports on the king the newspapers, especially those outside Bavaria, soon began to include gentle but lasting references to his "mentally ill" brother. Bavarian publications sidestepped possible accusations of lèse-majesté by quoting their 'foreign' colleagues. It's possible that these accounts were put out by the ministerial bureaucrats of Munich to gradually prepare the readership for a coup d'état which was on no account to be publicly recognised as such.

The psychiatric report given by Dr Gudden – without him personally interviewing his patient – and the amateurish efforts of the commission of arrest in Neuschwanstein suggest that this was more a display of bungling stupidity than a cunning act of state. The people in and near Füssen were beside themselves with anger and in an attempt to avoid any further scandal King Ludwig II was carted off to Schloss Berg instead of Linderhof. Like Otto's palace at Fürstenried, Ludwig's stately home had been turned into a prison fit for a king. The monarch was to spend the rest of his days here.

The fact that these days were reduced to mere hours is still a huge mystery. It's possible that Ludwig did indeed contemplate suicide, having been robbed of his freedom by the suspect account of his medic. Yet if we consider that all of his minsters stood by and watched while the king drove himself deeper and deeper into debt until they themselves feared for their jobs, then there would be enough motives for the murder of King Ludwig II of Bavaria.

The first to visit one of Ludwig's castles were those who took their leave of him on June 14, 1886, in Berg. On the procession of the body from the Residenz in Munich to the Michaelskirche all of the spectators crowding the route were dressed in black, even those seated on the rooftops and leaning out of the windows. Munich's clothes stores had stocked up for the occasion in advance, advertising items of mourning from black armbands and hatbands to funereal parasols.

As in 1865 at the burial of the first king of Bavaria and in 1864 at the memorial service for Ludwig's father Maximilian I, in 1886 a very special band of mourners were present. The *Gugelmänner* who accompanied Ludwig on his final journey date back to the Middle Ages, when men donned special black hoods which covered their entire faces (*Gugel*) and a black shroud. It's these *Gugelmänner* – among other – who even today are still trying to find proof of the fact that Ludwig was maliciously murdered.

Left:
Dr Bernhard von Gudden was the doctor who was instrumental in penning the damming medical report which claimed that the king of Bavaria was mentally ill. At the time psychiatry was still in its infancy and maybe this is why the doctor didn't deem it necessary to personally examine his patient before putting pen to paper. Gudden died with the king in the Starnberger See – just how will forever remain a mystery.

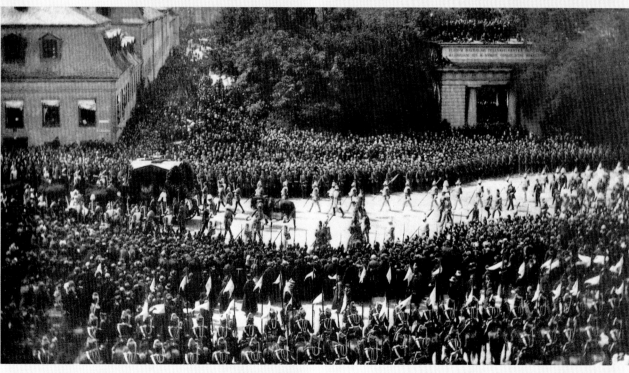

Left:
Franz Hanfstaengl photographed the state funeral of King Ludwig II on June 19, 1886, in Munich. Huge crowds of people lined the streets; medieval "Gugelmänner" were among the chief mourners.

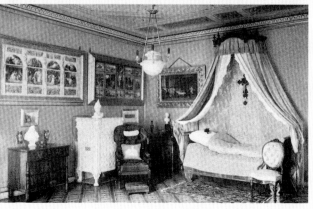

Bottom left:
After his body had been recovered King Ludwig II was laid out at Schloss Berg on the Starnberger See. On June 14, 1886, just one day after his death, people came from far and wide to take their leave of their monarch.

Left:
Ludwig II's sarcophagus was placed in the royal crypt of St Michael's Court Church in Munich and has been and still is visited by many, many loyal fans. In keeping with an ancient custom the urn bearing his heart was taken to the chapel of rest in Altötting.

121

Right:
The idyllic gardens of Herrenchiemsee. This avenue opens out onto tinkling fountains which invite you to come and peruse the magic of King Ludwig II away from the crowds.

Right page:
On the north shores of the Herreninsel, once called Herrenwörth and the site of a famous monastery, is the baroque chapel Zum Heiligen Kreuz. It was erected between 1697 and 1700.

Right:
The Latona Fountain in the park at Herrenchiemsee has a grand total of 74 statues which spew water. The photo shows Latona with her children Diana and Apollo. Apollo was one of the twelve chief gods of the Greek Pantheon; Diana was the goddess of hunting.

Far right:
The symbolism of this particular fountain is far less peaceful than it first appears. Flora, in white marble, may seem very innocent; at her feet a lead panther is in the throes of killing a bear... Summer is a great time to stroll around the gardens of Herrenchiemsee and take in the magnificent vistas and cool spray of the many impressive water features.

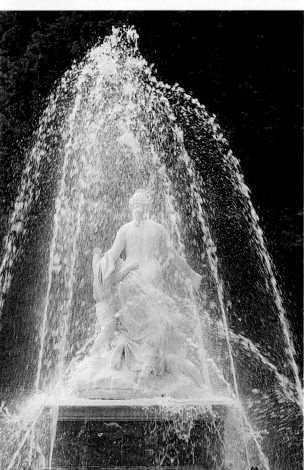

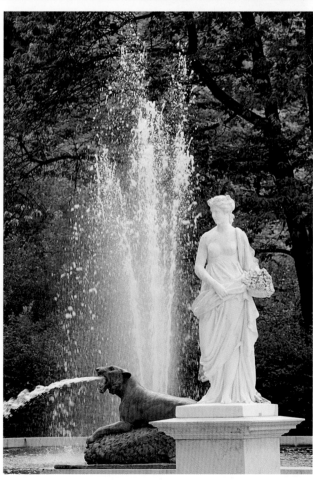

Herrenchiemsee:

Information:
Schloss- und Gartenverwaltung Herrenchiemsee
D–83209 Herrenchiemsee
Tel.: +49 (0) 80 51 - 68 87-0
Fax: +49 (0) 80 51 - 68 87-99
Email: sgvherrenchiemsee@bsv.bayern.de
Internet: www.herrenchiemsee.de

Opening times:
Neues Schloss (New Palace):
April to October: daily from 9 am to 6 pm
November to March: daily from 9.40 am to 4.15 pm

King Ludwig II Museum:
April to October: daily from 9 am to 6 pm
November to March: daily from 10 am to 4.45 pm

Closed on:
New Year's Day, Shrove Tuesday, 24, 25 and 31 December

Entrance fees:
Combined "Insel" ticket (Neues Schloss with King Ludwig II Museum, Augustinian Monastery (museum and galleries)):
Full adult: EUR 9.00
Concessions: EUR 8.00

Information on prices for concessions, parties etc. can be found on the website: www.schloesser.bayern.de

Guided tours:
Neues Schloss:
Tours in various languages lasting about 35 minutes (max. 50 people) take place throughout the day.
Last tour: April to October at 5 pm
November to March at 3.40 pm.

Fountains:
From the beginning of May to 3 October daily from 9.35 am to 5.25 pm every 15 minutes.

Information for the disabled:
The palace has a lift and a toilet for the disabled. Please ask at the ticket desk.

Linderhof

Information:
Schloss- und Gartenverwaltung Linderhof
Linderhof 12
D–82488 Ettal
Tel.: +49 (0) 88 22 - 92 03-0
Enquiries:
Tel.: +49 (0) 88 22 - 92 03-49
Fax: +49 (0) 88 22 - 92 03-11
Email: sgvlinderhof@bsv.bayern.de
Internet: www.linderhof.de

Opening times:
April to 15 October: daily from 9 am to 6 pm
16 October to March: daily from 10 am to 4:30 pm

Closed on:
New Year's Day, Shrove Tuesday, 24, 25 and 31 December

Entrance fees for the palace and park buildings:
Full adult: EUR 8.50
Concessions: EUR 7.50

In winter only the palace can be visited:
Full adult: EUR 7.50
Concessions: EUR 6.50

Information on prices for concessions, parties etc. can be found on the website: www.schloesser.bayern.de

Guided tours:
Tours in English or German lasting about 25 minutes (max. 40 people) take place throughout the day.
Other guided tours are available on request.

Ticket bookings:
Schloss Linderhof has a modern ticketing and reservation system which allocates visitors a fixed entrance time and tour when they purchase their ticket. For an additional fee parties can book tickets in advance by fax or letter.

Information for the disabled:
Wheelchairs can be borrowed from the ticket desk. The palace has a toilet for the disabled but only limited wheelchair access.

Left below:
The fountains on the Water Parterre at Schloss Linderhof are a popular motif and it's worth the climb up the steps to the Temple of Venus to snap them. The view from the top is both romantic and spectacular.

Below:
A ride in a horse-drawn carriage from the village of Hohenschwangau to the castle of the same name is a glorious experience indeed, the journey to the higher-lying Schloss Neuschwanstein practically a must! The road up to the castle is rather steep and those who brave the incline have to walk slalom to avoid stepping in the offerings the horses leave in their wake…

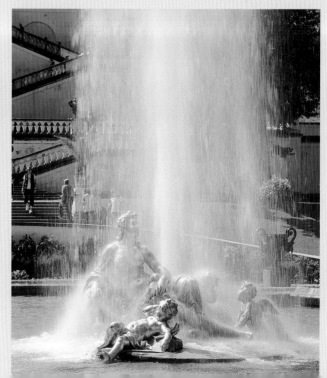

Neuschwanstein

Information:
Schlossverwaltung Neuschwanstein
Neuschwansteinstr. 20
D–87645 Hohenschwangau
Tel: +49 (0) 83 62 - 9 39 88-0
Fax: +49 (0) 83 62 - 9 39 88-19
Email: svneuschwanstein@bsv.bayern.de
Internet: www.neuschwanstein.de

Opening times for Schloss Neuschwanstein:
April to 15 October: daily from 9 am to 6 pm
Ticket desks open from 7:30 am to 5 pm

16 October to March: daily from 10 am to 4 pm
Ticket desks open from 8:30 am to 3 pm

Closed on:
New Year's Day, 24, 25 and 31 December

Entrance fees and tickets:
Tickets are only available from the ticket centre in
Hohenschwangau at the foot of the castle. From here the
walk up to the castle takes about 30 minutes. Tickets can
be reserved up to one day prior to your visit to the castle
on payment of an additional fee.

Ticket centre Neuschwanstein – Hohenschwangau
Alpseestraße 12
D–87645 Hohenschwangau
Tel.: +49 (0) 83 62 - 9 30 83 - 0
Fax: +49 (0) 83 62 - 9 30 83 - 20
Internet: www.ticket-center-hohenschwangau.de

Entrance fees:
Full adult: EUR 12.00
Concessions: EUR 11.00

Combined "Königsticket" for Schloss Neuschwanstein und
Schloss Hohenschwangau (visited on the same day):
Full adult: EUR 25.00
Concessions: EUR 23.00

Information on prices for concessions, parties etc.
can be found on the website: www.schloesser.bayern.de

Guided tours:
Tours in English or German last about 30 minutes.

Information for the disabled:
For reasons of organization we ask wheelchair and walker users
to book their guided tour beforehand at the Ticketcenter Hohen-
schwangau. Near the castle there is a toilet for the disabled.

Horse-drawn carriages
service the Herreninsel in
the summer. They gently
transport their passengers
from the landing stage to
the palace, giving visitors
plenty of opportunity
to admire the scenery at
their leisure.

The Ludwig Fessler paddle
steamer first went into oper-
ation in 1926 and is still
working the Chiemsee.
The recently restored Salon
is particularly splendid and
takes you back to the days
when your granny may have
foxtrotted aboard one of
these leisurely craft. The
man the boat is named after
built the steam tramway
from Prien to the harbour of
Stock in 1887 which is still
up and running and a big
attraction for guests both
big and small.

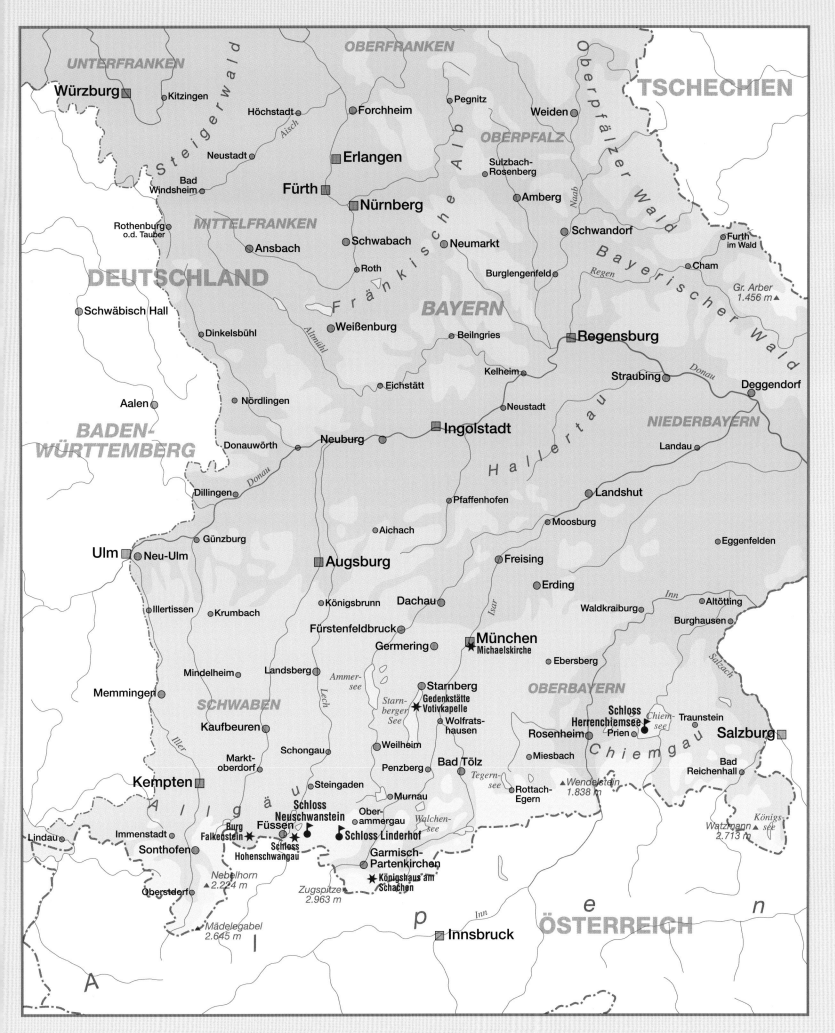

UNTERFRANKEN

Würzburg • Kitzingen
Höchstadt • • Forchheim • Pegnitz
OBERFRANKEN
Weiden
OBERPFALZ

Neustadt • Erlangen
Bad Windsheim • Fürth Sulzbach-Rosenberg
Nürnberg Amberg
MITTELFRANKEN
Rothenburg o.d. Tauber Ansbach • Schwabach Schwandorf
Furth im Wald
DEUTSCHLAND Roth Neumarkt
Burglengenfeld Cham
Schwäbisch Hall BAYERN Regen
Gr. Arber 1.456 m ▲
Weißenburg • Beilngries Regensburg
Dinkelsbühl
Kelheim Straubing Donau
Aalen Nördlingen Eichstätt Deggendorf
Neustadt NIEDERBAYERN
BADEN-WÜRTTEMBERG Donauwörth Neuburg Ingolstadt
Dillingen Donau Pfaffenhofen Landau
Hallertau Landshut
Günzburg Moosburg
Ulm Neu-Ulm Aichach Eggenfelden
Illertissen Krumbach Augsburg Freising
Königsbrunn Dachau Erding Inn Altötting
Fürstenfeldbruck Waldkraiburg Burghausen
Mindelheim Germering München Salzach
Memmingen Landsberg Michaelskirche Ebersberg
Ammer-see Starnberg OBERBAYERN
SCHWABEN Lech Gedenkstätte Votivkapelle Schloss Herrenchiemsee Chiem-see Traunstein
Kaufbeuren Starn-berger See Wolfrats-hausen Prien
Schongau Weilheim Rosenheim Salzburg
Markt-oberdorf Penzberg Bad Tölz Miesbach Chiemgau Bad Reichenhall
Kempten Steingaden Murnau Tegern-see Rottach-Egern Wendelstein 1.838 m ▲ Watzmann ▲ 2.713 m Königs-see
Allgäu Schloss Neuschwanstein Ober-ammergau Walchen-see
Lindau Immenstadt Burg Falkenstein Füssen Schloss Linderhof
Sonthofen Schloss Hohenschwangau Garmisch-Partenkirchen
Nebelhorn ▲ 2.224 m Königshaus am Schachen
Oberstdorf Zugspitze 2.963 m A l p e n
Mädelegabel ▲ 2.645 m Inn Innsbruck ÖSTERREICH
A

TSCHECHIEN

Oberpfälzer Wald

Bayerischer Wald

Fränkische Alb

Steigerwald

Aisch

Naab

Altmühl

Looking up to the Terrace Gardens under the Temple of Venus you can fully appreciate the unique setting of Schloss Linderhof. Elegant and harmonious landscaping sensitively blends in with the cragged, wild scenery beyond. The oldest tree in the Graswangtal greatly impressed the king and he left it standing exactly where it was, hence its name of Royal Linden.

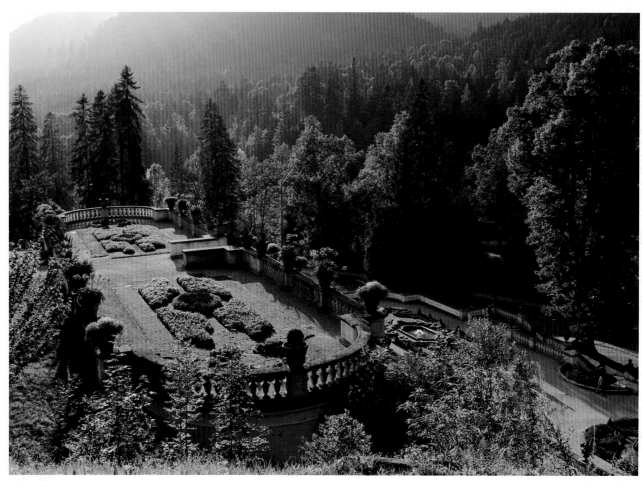

Credits

Design:
hoyerdesign grafik gmbh, Freiburg
www.hoyerdesign.de

Map:
Fischer Kartografie, Aichach

Translation:
Ruth Chitty, Stromberg
www.rapid-com.de

Printed in Italy
Repro: Artilitho snc, Lavis-Trento, Italy
www.artilitho.com
Druck/Verarbeitung: Grafiche Stella srl, Verona, Italy
www.grafichestella.it
© 8th 2018 Verlagshaus Würzburg GmbH & Co. KG
© Photos: Ernst Wrba
© Text: Michael Kühler

ISBN 978-3-8003-1868-1

Details of our programme can be found at
www.verlagshaus.com

Photographer
Ernst Wrba studied photo design and now works as a freelance photographer. The castles and palaces of Germany and their gardens are one of his specialist fields. He has had numerous illustrated books on regional and international topics published.
www.ernstwrba.de

Author
Michael Kühler, born in Landshut in 1962, trained in Slavonic and literary studies in Berlin. He now lives and works in Stuttgart. Besides organising educational holidays he also works as an author, his main focus being regional studies and travel.

Photo credits:
All photographs are by Ernst Wrba with the exception of the black-and-white illustrations and those given below:
Front cover: © iStockphoto.com/din Alt;
Page 4/5: © iStockphoto.com/AVTG;
Page 8/9: © iStockphoto.com/ingmar wesemann;
Page 18: © iStockphoto.com/Steven Phraner;
Page 32: © iStockphoto.com/brue;
Page 38: © iStockphoto.com/Eline Spek;
Page 39: © iStockphoto.com/Vera Tomankova;
Page 40 top left: © iStockphoto.com/Dave Logan;
Page 40 top right: © iStockphoto.com/Mary Lane;
Page 40 bottom: © iStockphoto.com/Manuela Weschke;
Page 41: © iStockphoto.com/Werner Moser;
Page 56/57: © iStockphoto.com/photo75;
Page 62/63: © iStockphoto.com/ingmar wesemann.

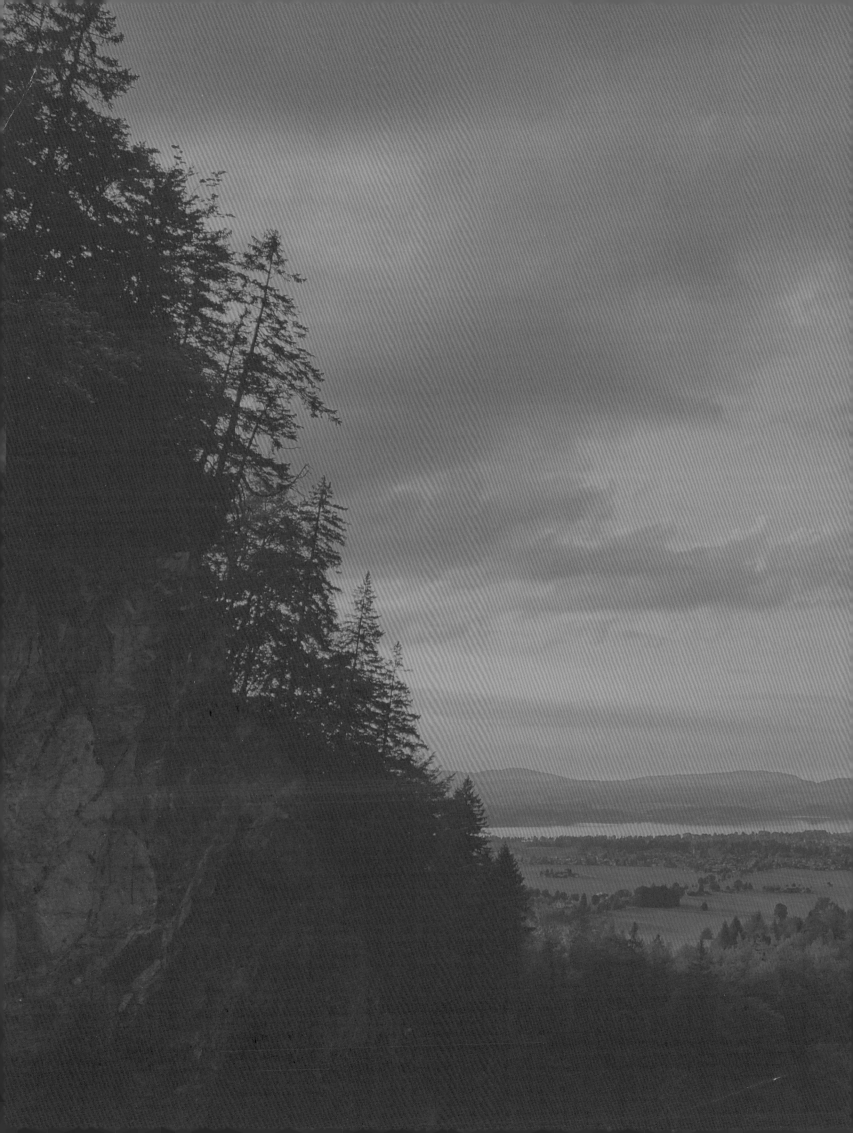